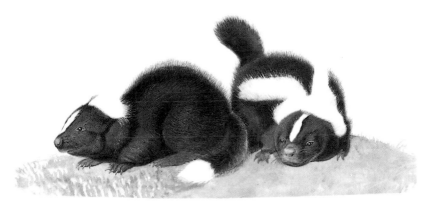

John James Audubon in the West

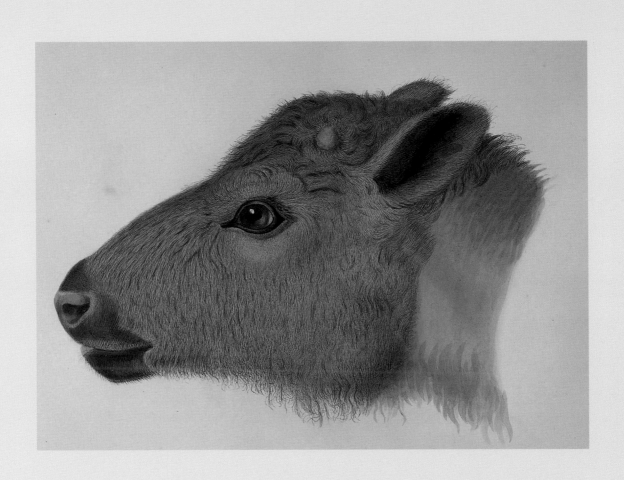

John James Audubon in the West

The Last Expedition

Mammals of North America

Sarah E. Boehme

With essays by
Annette Blaugrund, Robert McCracken Peck, and Ron Tyler

Harry N. Abrams, Inc., Publishers,

in association with the

Buffalo Bill Historical Center

The exhibition has been organized by the Buffalo Bill Historical Center, Cody, Wyoming

EXHIBITION DATES

Buffalo Bill Historical Center, Cody
June 23, 2000–September 24, 2000
Academy of Natural Sciences, Philadelphia
October 29, 2000–January 21, 2001
Houston Museum of Natural Science, Houston
March 24, 2001–May 28, 2001
Autry Museum of Western Heritage, Los Angeles
June 23, 2001–September 30, 2001

FOR HARRY N. ABRAMS, INC.:
Project Manager: Harriet Whelchel
Copy Editor: Richard Slovak
Designer: Judith Michael

FOR BUFFALO BILL HISTORICAL CENTER:
Project Coordinators: Barbara Foote Colvert and Renée Tafoya
Associate Registrar: Elizabeth M. Holmes

In referring to titles of works of art we have used, wherever possible, the title that is used by the owner for paintings and drawings and the published title for the specific work for prints. Collectors of the original paintings use different sources for the titles. The names of the animal often varied in the folio edition and the octavo edition, and spellings were sometimes changed in different printings.

HALF TITLE:
John James Audubon
Common American Skunk
1842. Watercolor and pencil on paper, 33 x 24½".
The Pierpont Morgan Library, New York, 1976.12:3

FRONTISPIECE:
John James Audubon
Head of a Buffalo Calf
1843. Watercolor on paper, 24 x 28".
Private Collection

PAGE SIX:
John James Audubon
Four-Striped Ground Squirrel
(detail)
1841. Watercolor on paper, 14½ x 21".
Princeton University Library, Princeton, New Jersey

LIBRARY OF CONGRESS CATALOGING-IN-PUBLICATION DATA

Boehme, Sarah E.
John James Audubon in the West: the last expedition mammals of North America /
by Sarah E. Boehme ; with essays by Annette Blaugrund, Robert McCracken Peck, and Ron Tyler.
p. cm.
Includes bibliographical references (p.).
ISBN 0-8109-4210-0
1. Audubon, John James, 1785-1851. 2. Mammals—North America. I. Title.

QL31.A9 B65 2000
599'.0978—dc21
[B] 00-29995

Published in 2000 by Harry N. Abrams, Incorporated, New York
No part of the contents of this book may be reproduced without the written permission of the publisher

Printed and bound in Japan

HARRY N. ABRAMS, INC.
100 FIFTH AVENUE
NEW YORK, N.Y. 10011
www.abramsbooks.com

Contents

Foreword
B. Byron Price 7

Preface
Sarah E. Boehme 8

"My Style of Drawing"
Audubon and His Artistic Milieu
Annette Blaugrund
11

Omega: John James Audubon's
Final Artistic Journey
Sarah E. Boehme
35

Audubon and Bachman:
A Collaboration in Science
Robert McCracken Peck
71

The Publication of *The Viviparous
Quadrupeds of North America*
Ron Tyler
119

Notes 183
Chronology 191
Bibliography 193
Index 196
Photograph Credits 200

Shell Oil Company Foundation,
on behalf of the employees
of Shell Oil Company, is pleased
to make possible the presentation
of the John James Audubon exhibition
to the American people.

Foreword

For most Americans, the name John James Audubon conjures up images of birds and issues of conservation. Audubon's best-known publication, *The Birds of North America,* occupies a treasured place in the pantheon of natural-history literature. Unfortunately, this rich volume has largely overshadowed his last book, *The Viviparous Quadrupeds of North America,* published from 1845 to 1848. Although less well known to modern readers, the latter work, the first devoted exclusively to North American mammals, proved a worthy capstone to the artist's stellar career.

When Audubon traveled up the Missouri River in 1843 to fulfill his lifelong dream of collecting and depicting western American animal life, he carried with him a well-founded belief in the value and power of first-hand experience and observation. The artist believed, not without reason, that collecting and documenting the animal life of the mountains and plains posed even greater challenges to his considerable skills as an artist-naturalist than did the birds. Some species, like the black-footed ferret, were already in danger of extinction, while others simply eluded him. The ambitious project sorely tested the physical and mental stamina of the aging artist, who faltered before he could complete the work. Fortunately for posterity, Audubon's two sons, along with his old friend and colleague, the Reverend John Bachman, and the talented Philadelphia lithographic company of J. T. Bowen finished the job.

The catalogue and the accompanying exhibition represent the first comprehensive look at Audubon's final expedition to the West. Given the ongoing debate over the future of wilderness and wildlife in this special region, it is a particularly timely inquiry. In another context, this exhibition, which connects art and science, signals the commitment of the Buffalo Bill Historical Center to imaginative interdisciplinary studies.

Like Audubon's works, exhibitions of this magnitude are the happy products of many minds and hands. The Buffalo Bill Historical Center is especially grateful to the Shell Oil Company Foundation for its generous support of the exhibition and its national tour. We also thank museum trustee Nancy-Carroll Draper for funding the initial exhibition research and for her unflagging enthusiasm for the study of natural history of the West. Dr. Sarah Boehme, Robert Peck, Dr. Annette Blaugrund, and Dr. Ron Tyler are responsible for the sound scholarship and creative approach that characterizes this project. Thanks are also due our partners at the Academy of Natural Sciences of Philadelphia, Pennsylvania; the Houston Museum of Natural Science, Houston, Texas; and the Autry Museum of Western Heritage, Los Angeles, California, for hosting this show and making it available to a larger audience. Finally, we are indebted to the many outstanding lenders who have graciously shared their works for this landmark exhibition.

B. BYRON PRICE
Executive Director
Buffalo Bill Historical Center

Preface

The Buffalo Bill Historical Center began planning this exhibition and its accompanying catalogue on the work of John James Audubon several years ago. To some observers, the conjunction of the Center's mission to "advance knowledge about the American West" and the art of Audubon might at first seem incongruous. Although the name of John James Audubon resonates with associations to the geographic regions of the American South and East, it does not always immediately spring to mind in listing the pantheon of the major artists of the American West, such as George Catlin, Albert Bierstadt, Frederic Remington, and Charles M. Russell. Yet in 1843, Audubon made an important trip to the West, traveling up the Missouri River as far as the trading post of Fort Union. He saw many of the same sites as did Catlin and others who also portrayed the region in the early nineteenth century. The journey was crucial in accomplishing the publication of Audubon's second great publication, *The Viviparous Quadrupeds of North America*, completed by his son John Woodhouse Audubon.

Just as important as the actual trip to the West is what propelled Audubon westward: an approach to art that would be echoed in the careers of later artists of the West. An examination of Audubon's life and work thus both celebrates his own accomplishments and introduces insights that are important in analyzing western American art, particularly within the development of American art of the nineteenth century.

John James Audubon was the epitome of a frontier artist. In the very early years of the nineteenth century, Audubon set out to discover the unknown. His goal was to catalogue and document comprehensively the wildlife in America. It was important that, whenever possible, he encounter his subjects personally and in their natural habitat. To do this meant spending many hours in the outdoors, away from the distractions of civilization, directly studying nature. He believed it was important to know his subjects well and to represent them accurately, yet he also approached his subjects with a romantic sensibility.

As an artist, Audubon was essentially self-taught, like many of the American artists who are associated with the West. Lacking the advantages of academic training, he nevertheless developed into one of America's most accomplished artists of the nineteenth century. In her essay "'My Style of Drawing': Audubon and His Artistic Milieu," Annette Blaugrund sets the stage for understanding his late work by analyzing his early accomplishments in *The Birds of America*. She traces his artistic development, showing how his dramatic personality and seemingly unfailing energy contributed to his success. She also introduces the importance of Audubon's collaboration with others in completing his publications.

Accuracy and authenticity were important in Audubon's art, and they would come to be hallmarks of western American art. "Omega: Audubon's Final Artistic Journey," explores Audubon's transition from the bird paintings to his late work on the subjects of mammals. It follows his journey up the Missouri River in search of first-hand experience with his subject matter. It becomes a bittersweet story as Audubon faces the limitations of advancing age and the realities of the western landscape.

Audubon's art must also be seen in the context of its relation to scientific inquiry. Audubon knew his work would be evaluated not only upon his artistic accomplishments, but also upon his contributions to knowledge about the natural world. In producing *The Viviparous Quadrupeds of North America*, the artist would especially need the skills and knowledge of others. In his essay "Audubon and Bachman: A Collaboration in Science," Robert Peck weaves the intriguing story of the complex relationship between Audubon and his partner in this project, The Reverend John Bachman.

Collaboration emerges as a key theme in the story of John James Audubon's career. It is true that Audubon's ability to take on the roles of artist, naturalist, and businessman to create a unique persona contributed immensely to his success. His final accomplishments, however, are the results of the work of many contributors. In his essay "The Publication of *The Viviparous Quadrupeds of North America*," Ron Tyler reveals the important balance between Audubon's individual energies and excellence and the way he drew upon the skills, talent, and energies of his family, friends, colleagues, and the printmaking firm of J. T. Bowen.

Collaboration is also an important theme in the organizing of any exhibition and publication. Many individuals and institutions have contributed to this exhibition through research, loans, reproductions, and other support. Among those are staff members of the Alabama Department of Archives and History; the American Museum of Natural History, especially Mary LeCroy; the American Philosophical Society; the Audubon Memorial Museum, Don Boarman; Walter Audubon; the Boston Athenaeum; the Charleston Museum; Chase Bank of Texas, Julie Seyler; Cincinnati Museum Center, Jane McKnight; Cummer Museum of Art and Gardens; Fine Arts Museums of San Francisco; Gilcrease Museum, Anne Morand; Harvard University; the Hingham Public Library; Houston Museum of Fine Arts, Emily Neff; J.N. Bartfield Galleries; Johns Hopkins University, Bett Miller; Joslyn Art Museum; Louisiana State University Libraries; the Massachusetts Audubon Society; Milwaukee Art Museum; Mongerson Wunderlich Galleries; the Museum of the City of New York; the National Academy Museum; the National Audubon Society, Frank Gill; National Museum of American History, Bill Baxter, Helena Wright; National Gallery of Art; National Museum of Wildlife Art; NationsBank; the New-York Historical Society, Kimberly Terbush; Pierpont Morgan Library; Princeton University Library, William L. Joyce; St. Louis Art Museum; Wadsworth Athenaeum; William Reese Company; and private collectors.

The essayists—Annette Blaugrund, Robert Peck, and Ron Tyler—provided essential advice and counsel to the project. Museum staff members at the Buffalo Bill Historical Center, especially Eugene W. Reber, Robert Pickering, Joanne Patterson, Elizabeth Holmes, Becky Menlove, Charles Preston, Deborah Steele, Rebecca West, Marguerite House, and Barbara Colvert were tireless and essential contributors to the publication and exhibition.

Trustee Nancy-Carroll Draper provided the initial funding that began the research. Her encouragement, and that of the other members of the Whitney Advisory Board and the Board of Trustees, has been essential. Special thanks go to Shell Oil Company Foundation for generous support of the exhibition.

SARAH E. BOEHME

"My Style of Drawing"
Audubon and His Artistic Milieu

ANNETTE BLAUGRUND

Captain Jean Audubon was an adventurer, a seafaring man who traveled to distant foreign ports, owned a plantation in Saint-Domingue (now Haiti), bought a farm near Philadelphia, traded in sugar and slaves, and made a small fortune in these and other endeavors. His son, the great artist and naturalist John James Audubon (1785–1851), was also an adventurer, but of another sort. In his pursuits of observing and recording the birds of North America, he was both innovative and adventurous. It must have been in the genes.

John James Audubon eventually gave up all conventional business enterprises to earn his living as an artist-naturalist, resolving that "Without any Money My Talents are to be My Support and My enthusiasm my Guide in My Dificulties [sic], the whole of which I am ready to exert to keep, and to surmount."[1] With great determination he accomplished the Herculean task of producing a complex print series, The Birds of America (1827–38), comprising 435 ornithological images depicted lifesize in their natural habitats. To conceive of and complete such hand-colored aquatint etchings, printed on the largest paper then available—double elephant sheets (39½ by 29½ inches)—was unprecedented during the early nineteenth century. Moreover, at the time of the project's completion, Audubon had already embarked on his next grand enterprise, The Viviparous Quadrupeds of North America (1845–48). Audubon's unique achievements resulted from his energy, his tenacity, and his sense of romance and adventure—characteristics that, combined with his natural talent, were indomitable.

11

Born in Les Cayes, Saint-Domingue, on April 26, 1785, the illegitimate son of a French chambermaid named Jeanne Rabine who died a few months after his birth, John James Audubon was transported in 1788 to Nantes, France, to be brought up by Jean Audubon's wife. Anne Moynet lovingly accepted the boy and his stepsister, the child of an octoroon woman with whom Audubon senior had also consorted in Les Cayes. By the age of three, the young Audubon had lost his real mother, traveled alone across the Atlantic, and moved in with a new family in a foreign country, circumstances that inevitably shaped his personality.

Audubon's upbringing in France fostered his talents and natural curiosity. He was afforded the training of a country gentleman, including drawing,

music, fencing, and dancing, at which he excelled, and a classical education from which, whenever possible, he escaped into the woods to observe nature, collect specimens, and draw. At the age of eleven, John was enrolled in the naval academy at Rochefort-sur-Mer, where he spent three years proving to his father that he was not cut out for a life on the sea. Most likely he received further instruction in drawing at the naval academy. From early childhood he seemed to have been obsessed with documenting and studying wildlife—mammals as well as birds—which he rendered in pastel and graphite on paper.

Pastel was very popular in eighteenth-century France, as both a serious medium for professional artists and one favored by amateurs. Prominent pastelists of the period, Maurice Quentin de La Tour (1704–1788), Jean-Baptiste Perronneau (1715–1783), and Jean-Baptiste-Siméon Chardin (1699–1779), demonstrated that pastel was an exquisite medium in the hands of professionals. Nevertheless, works in pastels and in watercolors were generally stigmatized as a feminine pastime. Audubon could have seen examples at the Nantes Museum of Fine Arts, which opened in 1801. It is possible that he learned to use pastels at the Free Academy of Drawing in

No. 5.
La Mésange à longue queüe — d. Buffon. Criniale qui nau
the Long tailed Mountain tit-Mouse. la queüe de poile
L 22 Janvier 1805.

John James Audubon
**Long-Tailed
Mountain
Titmouse**
*1805. Graphite
and pastel,
12 ³/₈ x 9 ⁵/₈".
Houghton Library,
Harvard University*

Nantes or through manuals tailored to amateurs.[2] The Audubon family supplied their children with books of various sorts, which may have included such manuals. Probably because of its availability, portability, and facile handling, as well as his access to good models, Audubon preferred pastel in his youth.

Early attempts—for example, the *Belted Kingfisher* of July 15, 1808—reveal static profile images, which nonetheless are precisely observed and accurately rendered. Some, like the *Long-Tailed Mountain Titmouse,* dated January 22, 1805, are amateurish, patterned after illustrations he had seen in *Histoire naturelle, générale et particulière* by Georges-Louis Leclerc, comte de Buffon (1707–1788). Audubon may also have been exposed to the work of the court painter to Louis XV, Jean-Baptiste Oudry (1686–1755), whose pictures of hunting scenes of animals and still lifes with game decorated royal palaces and châteaus, as well as Sèvres porcelain and Gobelins and Beauvais tapestries. Audubon's claims that he had studied with Jacques-Louis David (1748–1825) cannot be substantiated, and it seems more likely that he was

influenced by the prevalent Neoclassical style of clear outlines and geometric compositional framework inspired by David. Given David's importance and popularity in France during Audubon's formative years, it is no wonder the young naturalist chose to associate himself directly with David.[3] Whatever artistic experiences inspired the young Audubon, he soon developed a singular perspective that matured with time.

William Dunlap (1766–1839), the first chronicler of American artists, citing various tales about Audubon's birth, stated that the naturalist himself had written that he " 'received life and light in the new world;' but this is little more definite than saying he was born on the globe; he leaves us to fix the spot between the north and south poles; but I understand he gives New Orleans, or at least Louisiana as the place of his birth, and the United States of America as his country."[4] Although Audubon was, in fact, born in the New World, he did not come to the United States until 1803 (the year of the Louisiana Purchase), in order to escape conscription into Napoleon's army. Napoleon was gathering forces to fight the English. France had gone through a bloody revolution not long before, and by 1792 the royal family had been deposed. The heir apparent, the seven-year-old dauphin, had been imprisoned as well, and he was said to have died in 1795, two years after the king and queen were executed. Many people refused to believe the reports, however, and like Audubon's purported association with David, or the question of his birthplace, the naturalist never denied the later rumor that he himself might be the so-called lost dauphin. Nevertheless, in 1812, he became a citizen of his beloved adopted country.[5]

In 1808, at the age of twenty-three, Audubon married Lucy Bakewell, whose family had recently emigrated from England and settled near Mill Grove, the Audubon property on the outskirts of Philadelphia. The young couple left the farm that Audubon's father had asked him to manage for other, seemingly better opportunities in Kentucky, then moved on to Louisiana as Audubon's various business ventures failed. The economy of the United States crashed in 1819, and Audubon declared bankruptcy after losing all of his and Lucy's possessions. With a wife and two sons— Victor Gifford Audubon (1809–1860) and John Woodhouse Audubon (1812–1862)—to support (two daughters had died in infancy, in 1817 and 1819), Audubon went into a deep depression. In his desperation he decided to risk his future on his inherent artistic abilities. He had been drawing as a hobby since childhood and had assembled a large number of watercolors of birds. *American Ornithology*, published between 1808 and 1814 by his precursor Alexander Wilson (1766–1813), was already outdated because of the discoveries of new species. Now Audubon, at the age of thirty-five, and with the encouragement of his stalwart wife, Lucy, decided to improve on Wilson's book. Without the help of this enterprising woman, who virtually brought up and supported their sons alone, Audubon's masterwork might never have been achieved. "My wife determined that my genius should prevail, and that my final success as an ornithologist should be triumphant."[6]

While Lucy took care of the family and even assisted in what had become the family business by handling correspondence and other administrative duties, her husband searched for new species of birds, promoted the project, sought new subscribers, and supervised the engraving and publication throughout the twelve years it took to complete. Lucy also taught and served as a governess in order to earn money.

During his formative years, Audubon struggled to improve his drawings. Because he did not have formal academic training, he continually experimented with different techniques in order to best capture the nuances of color and the texture of feathers and fur of the birds and mammals that were his primary subjects. He perfected his ability to translate onto paper a realistic approximation of the wildlife he so keenly observed. He sought the advice of such prominent portraitists as John Wesley Jarvis (1780–1840), Thomas Sully (1783–1872), Henry Inman (1801–1846), John Vanderlyn

ABOVE, LEFT:
John James Audubon
**Nicholas Augustus
Berthoud**
*c. 1819. Black chalk
on paper, 8 x 10".
Collection of
The Speed Art Museum,
Louisville, Kentucky.
Gift of Mrs. Hattie
Bishop Speed*

ABOVE, RIGHT:
John James Audubon
Peter McClung
*Pencil and charcoal
on paper,
11 ¼ x 8 ¾".
Courtesy of the
Pennsylvania Academy
of the Fine Arts,
Philadelphia,
Pennsylvania*

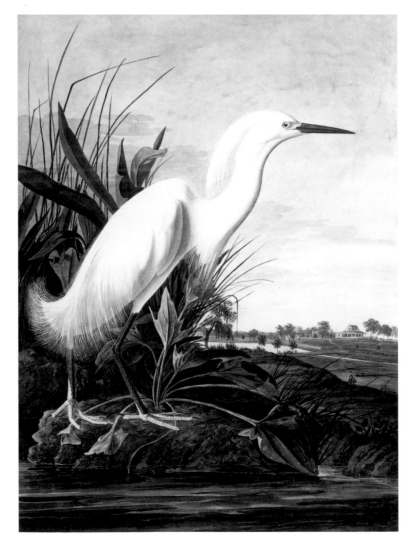

John James Audubon
Snowy Egret
*1832. Watercolor,
graphite, gouache,
and glazing,
29 ¼ x 21 ⁵⁄₁₆ ".
Collection of
The New-York
Historical Society*

*John James Audubon
in the West*

(1775–1852), and the lesser-known John Stein (active 1820s), a Pennsylvania portrait painter from whom he learned to paint in oils. Interestingly, Stein was probably the very same artist who inspired Thomas Cole (1801–1848), a founder of the Hudson River School of landscape painting.[7]

For a time, Audubon earned a living by executing portraits in black chalk, such as the one of his friend *Nicholas Augustus Berthoud* (about 1819), and by painting birds and animals in oil for quick sale or to give as gifts. The portraits sold for between five and twenty-five dollars and are not unlike those by other portraitists of the Federal period such as the French-born Charles-Balthazar-Julien Févret de Saint-Mémin (1770–1852). The strong profile outlines of Audubon's work in this period are also comparable in pose and linearity to his initial treatment of birds.

It took a number of years until artists on this side of the Atlantic established a national style and a national academy (1825). Along with the works of Cole and Asher B. Durand (1796–1886), acknowledged founders of the Hudson River School, Audubon's landscape backgrounds can also be counted as precursors of landscape painting in the United States. His hand-colored ornithological prints were as widely disseminated in the octavo edition (1844) as *Picturesque Views of American Scenery* (1819–21) by Joshua Shaw (1776/7–1860) and *Hudson River Portfolio* (1820–25) by William Guy Wall (1792–after 1864), which are often cited as informing and influencing American landscape painting.

Audubon could have seen landscapes by such early American painters as Cole and Thomas Birch (1779–1851), whose works were on view at the Pennsylvania Academy of the Fine Arts when Audubon revisited Philadelphia in 1824. Appreciation of the American wilderness and apprehension for its destruction were concerns Audubon eventually shared with Cole and others. Audubon documented not only birds and mammals but also their natural habitats, recording on paper the beauty of the country as well as the encroachment of civilization. The *Snowy Egret* of 1832 reveals a hunter (possibly Audubon himself) aiming at the bird, as well as a plantation in the wilderness. The background of this watercolor was painted to Audubon's specifications by George Lehman (c. 1800–1870), the artist's assistant in 1831 and 1832.

It was in 1824, after Audubon had completed a number of watercolors, that he went to Philadelphia to seek an engraver. Philadelphia was then the intellectual and scientific hub of the United States as well as a center for publishing. He must have known of or met Charles Willson Peale (1741–1827), the renowned artist-naturalist, who in 1786, in Philadelphia, had opened the first museum in the United States. There, visitors were exposed to natural-history specimens displayed along with portraits of American heroes and presidents and the *Exhumation of the American Mastodon,* which Peale painted in 1806–8 (now at the Baltimore Museum of Art). We know that Audubon was acquainted with Peale's artist sons Titian Ramsay

(1799–1885) and Rembrandt (1778–1860). Titian was at this time working on completing *American Ornithology*, which Alexander Wilson had left unfinished at the time of his death. (Audubon had met Wilson in 1810 while that artist was promoting his book in Kentucky, and it was then that the idea for Audubon's own ornithological series first germinated.)

Unable to find an engraver in Philadelphia or New York, in part because of his often tactless, abrasive manner, and also because so many of the people he approached were champions of Wilson, Audubon was advised to take his project to England, where engravers were equipped to handle large, complicated serial engravings. He took this advice and arrived in Liverpool on July 21, 1826. Eleven days later his work was exhibited at the Liverpool Royal Institution, to great acclaim. Armed with letters of introduction to influential people who encouraged and aided him, he found an engraver, William Home Lizars (1788–1859), in Edinburgh, Scotland; however, because of a strike by the colorists, Audubon switched to Robert Havell Jr. (1793–1878) and his father in London, where the majority of the work was completed.

Although Audubon had established his mature style before he went to England, he must have been influenced by British art, which was spread throughout the United States by the importation of paintings, prints, and books, as well as by the many English-trained artists working in America. The making of both prints and watercolors was in its heyday in early-nineteenth-century England. It was also a period of great interest in the study of natural history. Pioneering work was being done in the fields of botany and entomology as well as zoology, and the classification of quadrupeds, birds, and plants was established. Many books and treatises were published, and large collections of natural curiosities were assembled.[8] Audubon's work was certainly informed by earlier natural-history books, which were illustrated with beautifully engraved prints, hand-painted in watercolors. The pioneering two-volume *Natural History of Carolina, Florida, and the Bahama Islands* (1731–48), by the naturalist Mark Catesby (1682–1749), contained 220 etchings of North American flora and fauna and took nearly twenty years to complete. Audubon had also read *Travels through North and South Carolina, Georgia, East and West Florida, the Cherokee Country, the Extensive Territories of the Muscogulges, or Creek Confederacy, and the Country of the Chactaws* (Philadelphia, 1791), by William Bartram (1739–1823), and had the temerity to criticize it in a moment of overconfidence.[9]

When Audubon arrived in England, the horse portraits of George Stubbs (1724–1806), the romantic animal paintings of Edwin Landseer (1802–1873), the early work of Edward Lear (1812–1888), and the oils and watercolors of the renowned Joseph Mallord William Turner (1775–1851) were often on view at the Royal Academy of Arts in London or hung in the houses of some of Audubon's patrons, and they were widely available as prints. Turner produced a collection of closely scrutinized bird drawings for

his patrons, the Fawkes family at Farnley Hall in Yorkshire. The five-volume *Ornithological Collection* contains at least twenty bird drawings by Turner. There is no evidence, however, that Turner had more than a passing interest in natural history. His drawings "impress us with the virtuosity of their technique, but leave us little understanding of the structure of the individual species."[10] It is unlikely that Audubon knew these works, for they were exhibited publicly only once, in 1819, by Walter Fawkes at his London house, and Fawkes died in 1825, the year before Audubon arrived in England. Nevertheless, this linkage of artist with natural-history subjects is one of many examples that attest to period interests.

Stubbs, best known for his precise horse portraits, had some of his images incorporated into natural-history books and even produced his own etched illustrations in *The Anatomy of the Horse* (1766). These images were widely circulated through the expansion of less expensive methods of publishing.

Landseer, one of the most popular artists of the early Victorian period, specialized in romantic pictures of animals, anthropomorphizing his subjects in a manner that can be compared to that of Audubon. Both were products of their era and painted for audiences that understood and admired the attribution of human qualities to animals, as in Landseer's *Jocko with a Hedgehog*, exhibited at the Royal Academy in 1828, and Audubon's *Brown Thrasher*, 1829, showing the birds defending the eggs in their nest against the invasion of a black snake. Audubon wrote that "a whole party of them instantly rush for the snake to assist in chasing off the common enemy" and show "courage in defending their nest." Audubon's words were meant to inspire compassion and sympathy in the viewer and serve as a lesson of uniting to defeat a common enemy.[11] His empathy with his subjects is corroborated in his portrayal of the courtship of the *Passenger Pigeon,* 1824, about whom he wrote that "the tenderness and affection displayed by these birds toward their mates, are in the highest degree striking."[12] It is possible that exposure to the animal paintings of the renowned Stubbs and Landseer inspired or informed Audubon's work on *The Viviparous Quadrupeds of North America.*

Within a few years of Audubon's arrival in England, the nineteen-year-old Edward Lear published his first book, *Illustrations of the Family of Psittacidae, or Parrots.* He also worked on the famous *Birds of Europe* by John Gould (1804–1881). Lear's bold and accurate drawings of birds and animals were often compared to those of Audubon, but by the time Lear was twenty-five he had abandoned his ornithological work to devote himself to landscape painting.

Although Audubon's style of painting and his interest in natural history are consistent with the time in which he lived, his dedication and persistence in completing *The Birds of America* and his initiation of a second extraordinary project, *The Viviparous Quadrupeds of North America,* make him an outstanding figure in the tradition of series publications on natural history. Like Stubbs and Landseer, his work has endured because of his unique artistic

Edwin Henry Landseer
Jocko with a Hedgehog
1828. Oil on canvas,
39 5/16 x 49 3/16".
Milwaukee Art Museum.
Gift of Erwin C. Uihlein

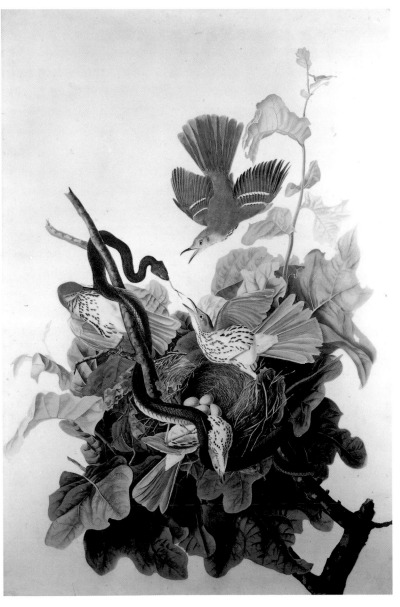

John James Audubon
Brown Thrasher
1829. Watercolor,
pastel, and graphite,
37 11/16 x 25".
Collection of
The New-York
Historical Society

John James Audubon
in the West

20

ability, his outstanding compositional sensibility, and his technical virtuosity. Less well known than his prints, which are ubiquitous in many bastardized forms, are the extraordinary watercolors made both for exhibition to potential clients and as prototypes for the watercolorists who added pigment to the aquatint etchings pulled by Robert Havell Jr.[13] No matter how trivialized by commercial enterprises Audubon's work has become, it retains its appeal; that is the enduring quality of great art. That he was accepted as an artist in his day is evidenced by the exhibition of his work in Edinburgh at the Royal Institution and the Society of Arts, and by his election in 1833 as an honorary member of the National Academy of Design in New York, a coveted mark of artistic distinction.

Audubon's early drawings are static portrayals of birds in profile placed centrally on the page, standing on what could be called a primal clump of earth or clutching a lichen-covered tree branch. These stiff, unanimated specimens (see pages 12 and 13) are rendered in pastel and graphite. As he matured, he experimented with not only how to set up his models but also how best to depict the nuances of texture and color, the iridescence of feathers, the appearance of soft down, the reflection of light, and the overall look of the living birds. He discovered that the most effective way to capture the natural position of the birds as he had scrutinized and sketched them in the wild was to shoot a large number of specimens, select the best of each—male, female, young, or those in molting stage—wire them into position, and place them on a gridded board for perspective and transference. He had to work quickly before the color of the feathers faded and the birds began to decompose. Although the majority of birds he painted had been studied live, he frequently used skins and mounted specimens for the *Quadrupeds*. By that time, however, he was able to give life to the skins, with the aid of written descriptions sent by the Reverend John Bachman (1790–1874), the naturalist who was his coauthor, and by others who supplied him with specimens. (Bachman provided not only skins and scientific text, but also focus and drive when Audubon began to deteriorate mentally, probably due to a stroke or, possibly, Alzheimer's disease.)

Just as he finally found a method of working with his models, so, too, did he perfect a style that satisfied his objective to portray wildlife in the most naturalistic manner possible. He evolved from using pastel and graphite alone to incorporating several mediums: watercolor, gouache, oil paint, metallic paint, chalk, ink, and glazes, which he combined with graphite and pastel and even collage. As time went on, probably by the early 1820s, his predominant medium became watercolor, which he layered and mixed with other mediums to achieve complex coloring and depth. In the *Great Gray Owl*, about 1834, he varied the shades of one color—brown—to reveal the subtle markings of plumage, while in the *Magnificent Frigatebird*, 1832, he nuanced and made richer the black pigment by using blue pastel highlights and graphite over the painted surface to delineate feathers; the graphite added iridescence. But he would often revert to pastel alone to sim-

ulate down feathers, as he did in the baby *Turkey Vulture,* probably painted at the end of 1820, an image that was never published in the *Birds of America.*

One of the most interesting characteristics of Audubon's watercolors is the asymmetry of his compositions. This oriental-like aesthetic is visible in the diagonal emphasis of the *Magnolia Warbler,* 1829; the off-center placement on the page, as in the *American Goldfinch,* 1824; the cropping of the branch on which the specimens in the *Tufted Titmouse,* 1822, play; and the simplification of form, as in the *Common Tern,* first painted in 1821 and revised about 1834. These elements are reminiscent of earlier Japanese, Chinese, and Indian pictures of nature, which were in fact available in prints and on porcelains and decorated furniture found in upper-class homes throughout England and the United States.[14] Audubon seems to have embraced the oriental aesthetic early on; these elements appear in his work of the 1820s. The skewed placement on the paper is not as apparent in the prints, because the backgrounds fill in the empty spaces and frequently camouflage the asymmetry and cropping.

Audubon would lay out the entire composition in graphite, using a light underdrawing just barely visible beneath the paint. Even when an assistant completed the background, the total conception was, for the most part, Audubon's. Toward the end of the project, expediency was necessary, and Audubon relied on written instructions to Havell, such as those found on the *Great Gray Owl* instructing him to "rise the bird about four inches in the copper, higher than in this drawing and put a landscape below of Wild Mountains and Woods." In this case, Havell did not follow Audubon's background recommendations in the print. In the watercolors the birds were often completed first and the backgrounds added by assistants or by Audubon himself. There is evidence, however, of instances in which the background was painted first, as in the *Northern Parula.* The stem of the flower, painted by Audubon's young assistant Joseph Mason (1808–1842), can be seen as a pentimento through the body of the bird.

In addition to Havell and Audubon's sons, who grew up working in the family business, three artists assisted Audubon in the making of *The Birds of America:* Joseph Mason, George Lehman, and Maria Martin (1796–1863). Studio assistants were a common practice in Audubon's day. A fourth, the Scottish artist Joseph Bartholomew Kidd (1808–1889), was hired to copy Audubon's watercolors in oils for exhibition and sale, but he did not participate in the actual print series. Mason worked with Audubon from 1820, when he was not yet thirteen but already an accomplished botanical artist, until 1822. He was a student of Audubon's in Cincinnati and showed sufficient talent for Audubon to hire him to paint backgrounds for his birds. In a letter to his wife dated May 23, 1821, Audubon wrote that Mason "now draws flowers better than any man probably in America."[15] Mason, who later continued to paint flower pictures and portraits, eventually charged that Audubon did not credit his work properly.

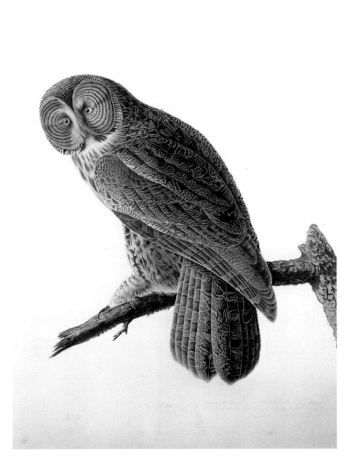

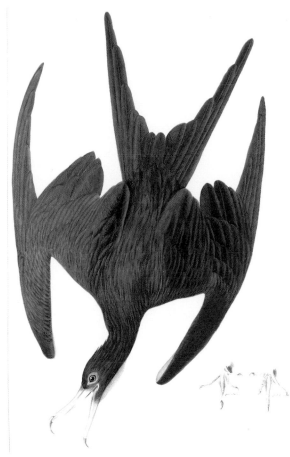

ABOVE:
John James Audubon
Great Gray Owl
*c. 1834. Watercolor,
graphite, and pastel,
34 ³⁄₁₆ x 25 ⅛ ".
Collection of
The New-York
Historical Society*

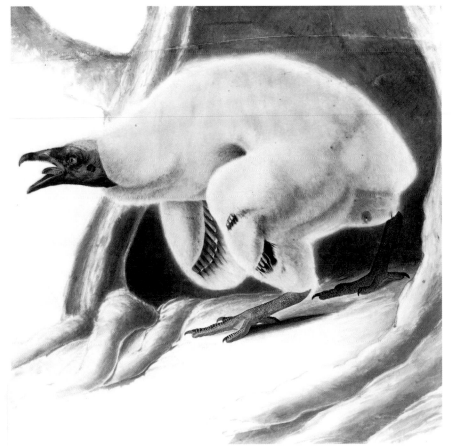

ABOVE:
John James Audubon
**Magnificent
Frigatebird**
*1832. Watercolor
and graphite,
38 ⅛ x 25 ⅛ ".
Collection of
The New-York
Historical Society*

LEFT:
John James Audubon
Turkey Vulture
*c. 1820. Watercolor,
pastel, graphite,
and gouache,
18 ⅝ x 18 ⁵⁄₁₆".
Collection of
The New-York
Historical Society*

*"My Style of
Drawing"*

23

Lehman worked with Audubon in 1831 and 1832. He was born in Lancaster, Pennsylvania, and became a competent but unimaginative professional artist who exhibited at the Pennsylvania Academy of the Fine Arts from 1825 to 1831. His hand is clearly discernible in many of Audubon's drawings of shorebirds, such as the *Long-Billed Curlew,* 1831, pictured with the city of Charleston, South Carolina, in the background. After he left Audubon's employ, Lehman formed two prominent Philadelphia lithography firms and painted and printed scenes of notable events and portraits of prominent people, including the popular frontiersman Davy Crockett, after a painting by Samuel S. Osgood (1808–1885). Lehman went on to execute the drawings for another natural-history book in 1840.[16]

Audubon met Maria Martin, sister-in-law of the Reverend John Bachman, in 1831. She was a gifted amateur watercolorist who specialized in botanical subjects and assisted Audubon on the floral backgrounds for a number of his later works. Perhaps because she was a woman, Audubon was able to express his sincere appreciation and admiration for Martin's work

more easily than for that of his other assistants. He named Maria's Woodpecker in tribute to her, noting, "I feel bound to make some ornithological acknowledgement for the aid she has on several occasions afforded me in embellishing my drawings of birds, by adding to them beautiful and correct representations of plants and flowers."[17]

From about 1840 on, Audubon spent long hours each day working on procuring animal specimens and painting them. He set aside a room in which to work at Minnie's Land, the estate he bought in New York City in 1841. His sons, Victor Gifford and John Woodhouse, eventually built their own houses on the property. They also became his closest assistants in the *Quadrupeds* project. The family business was further interconnected by the fact that Audubon's sons married two daughters of his coauthor, John Bachman. While each son had helped with backgrounds and occasionally

"My Style of Drawing"

*John James Audubon
in the West*

with birds in Audubon's first endeavor, they were actually coproducers of the *Quadrupeds.* Victor provided many of the backgrounds while also attending to the business aspects and supervising the production. John spent almost a year working from specimens in the British Museum and did about half of the animals for the imperial folio edition of the *Quadrupeds* (1845–48). He also added animals for the octavo edition (1851–54) after his father became incapacitated by 1847. Audubon's sons maintained independent careers as well, and both were elected to the National Academy of Design, where they exhibited frequently between 1840 and 1862. Victor was primarily a landscapist, and John a portrait painter who sometimes did animals. They collaborated at times, for example on a portrait of their father, about 1841. When Audubon could no longer motivate his sons, it was his coauthor and their father-in-law, John Bachman, whose persistence prevailed. Maria Martin, who became Bachman's second wife, assisted them with the drawing of plants, insects, and sometimes animals.

Audubon had always wanted to travel to the West, but his schedule did not permit it until 1843. At the age of fifty-eight, accompanied by friends and assistants and full of excitement, he embarked on this trip. He noted in his journal the diversity of the landscape and the animal life. Game was plentiful, and he and his party shot numerous animals for sport, specimens, and nourishment. Although the primary purpose of the eight-month trip was scientific, he discovered few new species of quadrupeds, but he did identify fourteen new species of birds, which were incorporated into later octavo editions of *The Birds of America.*

The group went up the Missouri River as far as Fort Union, near the mouth of the Yellowstone River along what is now the border between Montana and North Dakota, but the travelers were more preoccupied with buffalo hunting than with drawing and collecting specimens. One of Audubon's companions, the young artist Isaac Sprague (1811–1895), did some drawings; however, Bachman, who eagerly awaited their return, was disappointed with the output. Audubon himself noticed age creeping up on him.

A number of artists had documented the American West, and Audubon was aware of some of them. The Swiss-born Karl Bodmer (1809–1893) accompanied the German Maximilian, prince of Wied, on a scientific expedition up the Missouri River from 1833 to 1834 and portrayed the Indians and landscape of the Great Plains in precisely drawn watercolors and oils such as *Buffalo and Elk on the Upper Missouri,* about 1834, some of which resulted in aquatint engravings. Audubon and his party were housed in the same quarters that Prince Maximilian's group had occupied at Fort Union.

George Catlin (1796–1872) spent eight years, beginning in 1832, depicting Indian life. Catlin exhibited work like *Buffalo Chase, Mouth of*

George Catlin
Buffalo Chase,
Mouth of Yellowstone
1832. Oil on canvas,
24 x 29".
National Museum
of American Art,
Smithsonian
Institution.
Gift of
Mrs. Joseph
Harrison, Jr.

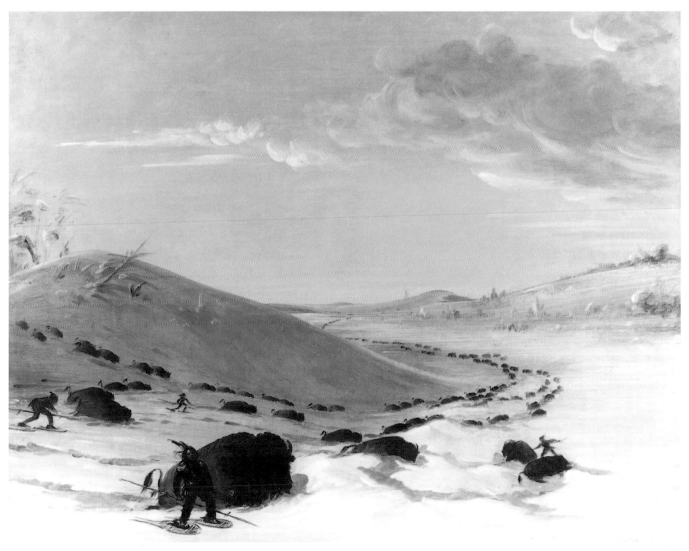

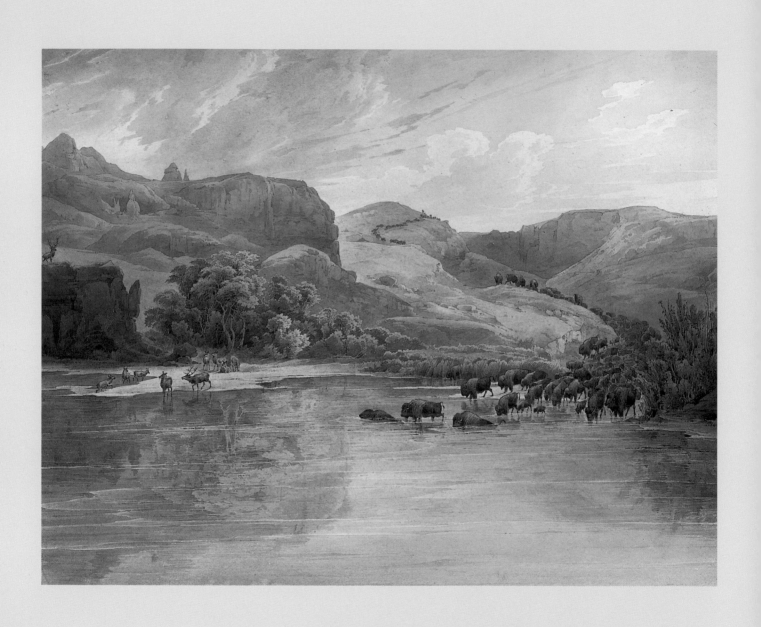

Yellowstone, 1832, in his traveling Indian Gallery in North America and Europe and began publishing his work by 1841. Audubon commented on those subjects in comparison to the Indians he saw after they had been involuntarily relocated from their land by the United States government: "When and where Mr. Catlin saw these Indians as he has represented them, dressed in magnificent attire, with all sorts of extravagant accoutrements, is more than I can divine."[18]

After Bodmer and Catlin, Audubon was among the first artists to visit and depict the animals of the West. Western life and scenery became the subjects of a number of American artists, but their goals were different from Audubon's. Among those working contemporaneously with Audubon were Charles Deas (1818–1867), a painter of romantic and dramatic western scenes such as *Long Jakes, the Rocky Mountain Man,* 1844; Alfred Jacob Miller (1810–1874), who recorded Indian life in watercolors and oils such as *A Surround of Buffalo by Indians,* painted between 1848 and 1858; and John Mix Stanley (1814–1872), who also painted western scenes such as *Buffalo Hunt,* 1853. There were others, too, who painted western subjects, including William S. Ranney (1813–1857); George Caleb Bingham (1811–1879); and later Albert Bierstadt (1830–1902), who focused on the landscape, exploiting the monumentality of the Rocky Mountains, which he popularized on both sides of the Atlantic.

Audubon's method and style of painting remained the same for the *Quadrupeds* as it had been for *The Birds of America.* The handling and composition of larger birds certainly informed his mammal pictures, but he had been painting all sorts of animals from the beginning. Mammals occasionally appeared in bird pictures, such as the print of the *Barred Owl* of about 1821. The eastern gray squirrel portrayed in this image is incorporated into Audubon's later picture of these squirrels for the *Quadrupeds.* He also portrayed mammals in some of the oil paintings he produced as gifts or for quick sale for ready cash, such as the *Entrapped Otter,* about 1827, of which he made multiple copies. His technique in oil, however, never approached the brilliance of his watercolors.

In examining the watercolor of the *Woodchuck,* 1841, one finds that the artist lightly sketched the subject and followed the outline closely, a technique similar to the one he used for the birds. Minor changes are visible, but for the most part the artist's initial vision remained intact. From feathers, his incredible ability to depict textures is transferred to skin and fur. Each hair seems to be painted separately. No sign of ink has been found, although the hairs are so finely delineated that they appear to be executed with a pen point rather than a pointed brush. He wrote, "No one, I think, paints in my method; I, who have never studied but by piece-meal, form my pictures according to my ways of study. For instance, I am now working on a Fox; I take one neatly killed, put him up with wires, and when satisfied with the truth of the position, I take my palette and work as rapidly as possible."[19] His palette remained primarily watercolor, enhanced by small dashes of

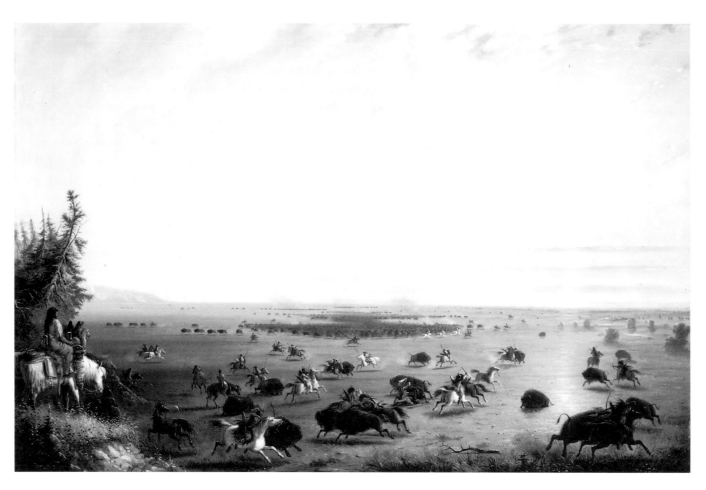

Alfred Jacob Miller
A Surround of Buffalo by Indians
1848–1858.
Oil on canvas,
30 ⅜ x 44 ⅛ ".
Buffalo Bill
Historical Center,
Cody, Wyoming.
Gift of
William E. Weiss

other mediums. Audubon continued to apply the same bold design and power of animation in his mammals that captivated admirers of *The Birds of America.*

Differences in popularity between the *Birds* and the *Quadrupeds* may be due to the fact that Audubon painted only about half of the mammals. Those completed by his sons, although handsome, lack the vitality and compositional genius of their father's work. That many of the mammals were drawn from specimens rather than real life may also account for their relative lack of animation. Nevertheless, they remain a remarkable tour de force in the tradition of the great master John James Audubon. Audubon died at Minnie's Land on January 27, 1851, at the age of sixty-five. *The Viviparous Quadrupeds of North America,* his last great adventure and accomplishment, deserves to be reexamined as a work of art as well as a scientific document. Despite any scientific contributions that he made, today Audubon's most significant and enduring legacy is as a remarkable artist.

OPPOSITE, ABOVE:
John Mix Stanley
Buffalo Hunt
1853. Oil on canvas,
30 x 39".
Private Collection

OPPOSITE, BELOW:
George Caleb Bingham
Boatmen on the Missouri
1846. Oil on canvas,
25 x 30". The Fine Arts Museums of San Francisco, California. Gift of Mr. and Mrs. John D. Rockefeller III

Bingham's paintings portrayed the culture of the boatmen on the Missouri River, the waterway that was crucial for exploration of the West.

John James Audubon in the West

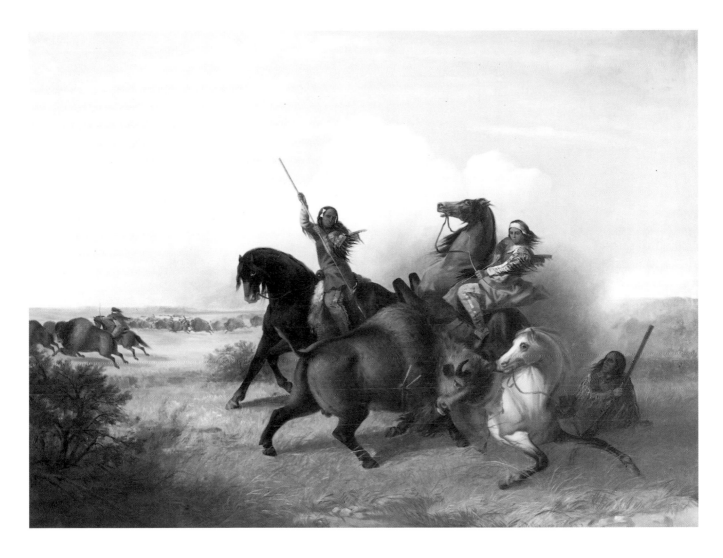

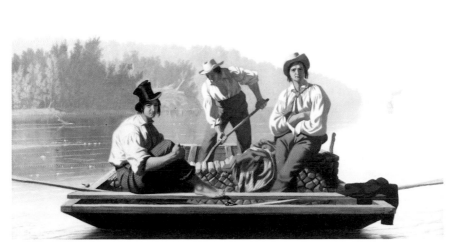

PLATE XI

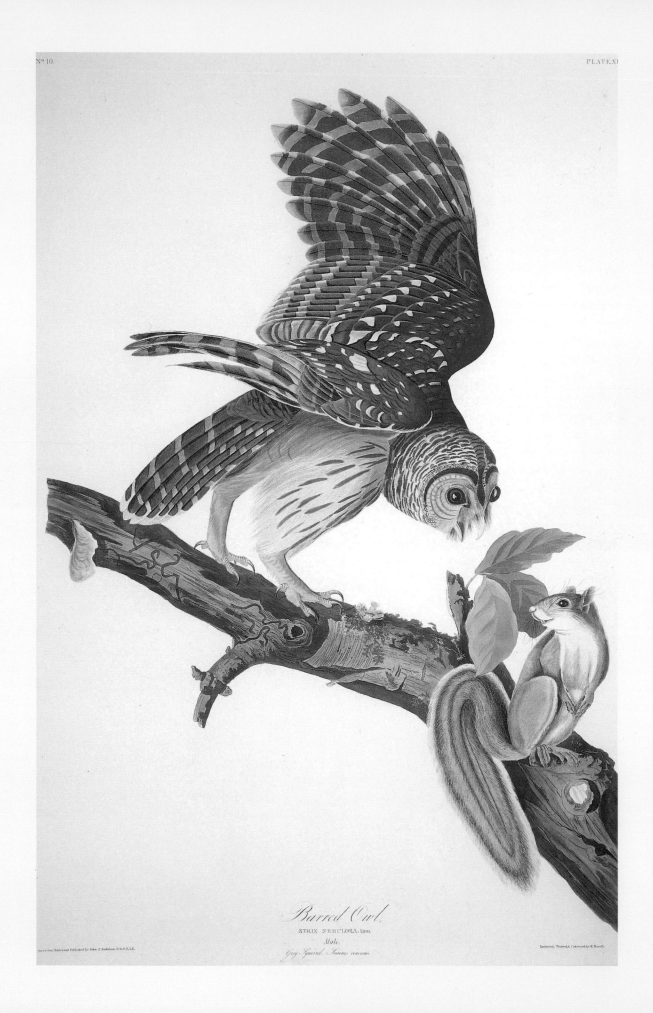

Barred Owl.

STRIX NEBULOSA. Linn.

Male.

Grey Squirrel. Sciurus cinereus.

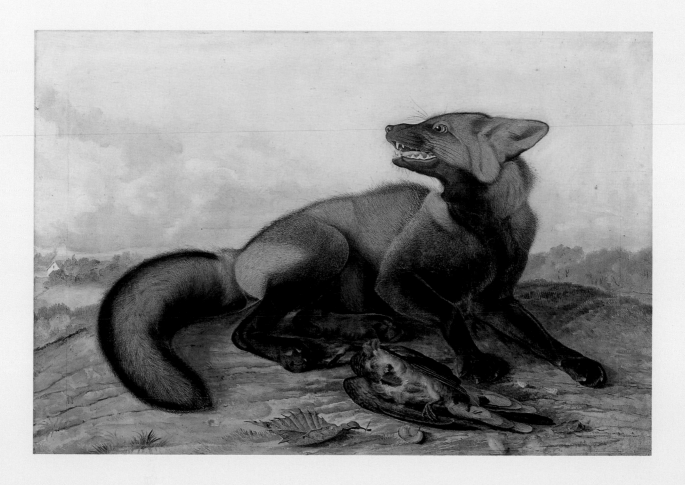

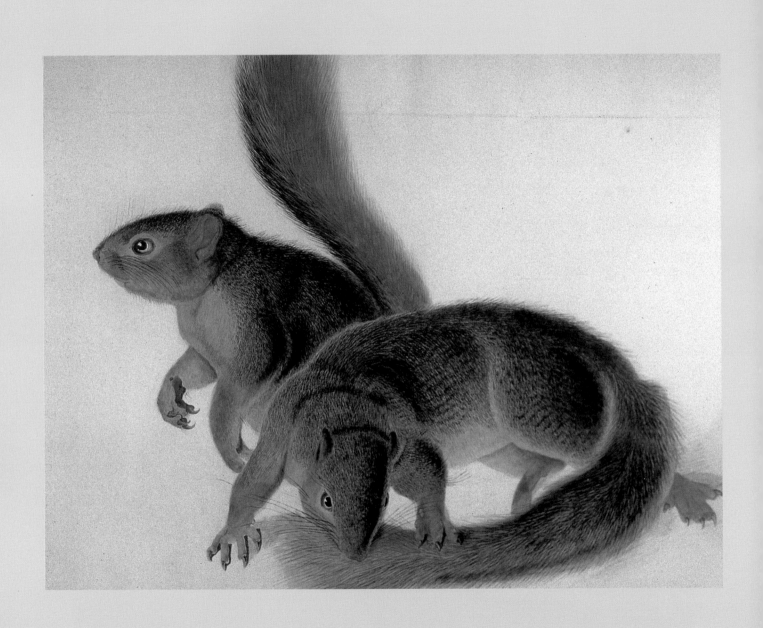

Omega: John James Audubon's
Final Artistic Journey

SARAH E. BOEHME

John James Audubon's 1843 trip up the Missouri River fulfilled a long-held dream to travel to the Far West and explore the distant wilderness and its exotic animal life. Like many dreams, the reality proved to be a different experience from the one imagined. Audubon's journey served an important purpose in his career, even though not all of his expectations were fulfilled. In an ironic touch, the steamboat that carried Audubon was aptly named the *Omega*—the final letter of the Greek alphabet, signifying the last. For this would be Audubon's final major field trip, his last work as an artist, and the culmination of his career.

The trip was necessary for Audubon to complete his second great work of artistry and natural history. After the publication of *The Birds of America*, the ambitious artist tackled the next logical project, a similar study of the mammals of the continent, which resulted in *The Viviparous Quadrupeds of North America*, a publication of 150 plates of four-legged animals that bear their young alive. For him to prepare this work, his long-postponed western journey was imperative.

Audubon's projects depended on his experiences as a field naturalist. His lack of conventional scientific training made it essential that he distinguish his work from that of others. He promoted the position that his authority rested on his extensive field experience, something that closet naturalists could not provide.[1] For the large mammals, a western trip was crucial because Audubon needed to establish his authenticity through experience. Buffalo, antelope, mountain sheep, and other wildlife could not be observed in the artist's eastern haunts.

As an artist, Audubon needed the western journey. His method involved

careful study of each subject, analyzing both its physical characteristics and its behavior. He expected his works to be judged on their veracity. Yet the field experience was only one part of Audubon's process. His artistic productions were workshop creations. He painted the primary focus of the imagery, the animal. He marshaled others to paint the backgrounds, and then his printmaker assembled the final product. In his method Audubon was characteristically American, because his approach to art was pragmatic. His art served a purpose: it provided information for scientific study. He used the best methods possible to produce the finest works. His vision guided the work, and his artistic mastery of color and form made it vital.

Like *The Birds of America,* his earlier work, *The Viviparous Quadrupeds of North America* was a natural-history publication in which the images were the primary form of presentation. Audubon's pictures struck a balance between description and narrative. His contribution in *The Birds of America* had been his representation of birds in action within natural settings, as opposed to the stiff profile presentations of his predecessors, and especially in contrast to the work of Alexander Wilson. He took the same approach in the *Quadrupeds* by presenting animals in action, integrated into landscape settings. Many natural-history publications preceding Audubon's showed animals in static profile poses, such as the illustrations in Georges-Louis Leclerc, comte de Buffon's *Histoire naturelle, générale et particulière avec la description du cabinet du roi* (1749–1804). Precedents for Audubon's approach appeared in European sporting art, where scenes of the hunt were part of the tradition of the fine arts. From his European travel, Audubon knew firsthand many examples of European fine-arts paintings with animal subjects.

Audubon's interest in mammals evolved from his passion for birds. Occasional examples such as the stolid drawing of a *Marmot,* from his earliest efforts as a youth in France, offer traces of interest. Crudely drawn, and dated June 6, 1805, the drawing shows that Audubon paid most attention to the delineation of the face, providing more detail and control in this area, an indication of his interest in portraying expressions and emotions through facial features. Mammals also appear as counterpoints of interest in *The Birds of America.* For example, Audubon incorporated his 1821 drawing of a *Squirrel* into his drawing of the *Barred Owl* for plate 46 in *The Birds of America,* the squirrel serving as potential prey for the owl. With its graceful pose, the squirrel appears to coyly hide behind the tree leaves. The drawing bears the inscription "Drawn from Nature by J.J. Audubon Louisianna [*sic*] July 22, 1821." This places it as being done at Oakley Plantation, home of James Pirrie, where Audubon was employed as a tutor for young Eliza Pirrie and where, in the bayou landscape, he found many examples of wildlife to depict. In his representation of the squirrel, Audubon showed the elegant composition and attention to detailing of texture that made his paintings of birds so masterful. The same drawing was later used for one of the squirrels in the *Quadrupeds:* plate 7, *Eastern Grey Squirrel.*

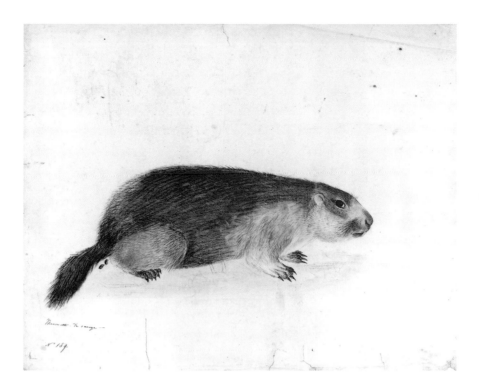

John James Audubon
Marmot
*1805. Pencil and
pastel on paper,
20 ¼ x 26 ¼ ".
Houghton Library,
Harvard University*

*This drawing is
Audubon's earliest
known depiction
of a mammal.*

*John James Audubon
J. T. Bowen,
lithographer*
Eastern Grey Squirrel
*1842. Hand-colored
lithograph,
26 ⅜ x 22 ⁷⁄₁₆ ".
Buffalo Bill
Historical Center,
Cody, Wyoming,
William E. Weiss
Purchase Fund*

*Audubon carried this
proof and presentation
plate with him on the
journey to Fort Union.
He presented it to
Lieutenant James
Henry Carleton of
the U.S. Dragoons.*

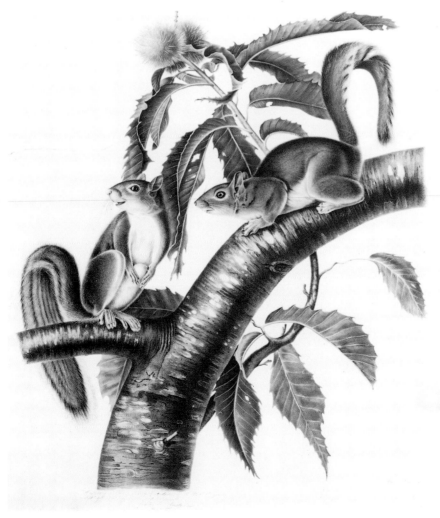

*Omega: John James
Audubon's Final
Artistic Journey*

37

Audubon's interest in mammals can be seen in a subject he repeated often in his career, *Entrapped Otter*, about 1827–30. One version of this subject was painted in 1826 (now in the University Art Gallery, Liverpool, England), and Audubon reportedly made as many as seven versions of this subject. His interest in the otter goes back to his years in Henderson, Kentucky. He painted a watercolor of an otter in a trap (unlocated) in 1812 from a specimen trapped at Long Pond, across the Ohio River from Henderson. The text for the Canada otter in the published *Quadrupeds* contains Audubon's description of this event. His observations of otters took place in an idyllic setting, while he was taking a break from his business duties. "We often used to seat ourselves on a fallen trunk, and watch in this secluded spot the actions of the birds and animals which resorted to it, and here we several times observed Otters engaged in catching fishes and devouring them." He then told of tracking the otters to their lair in a hollow tree

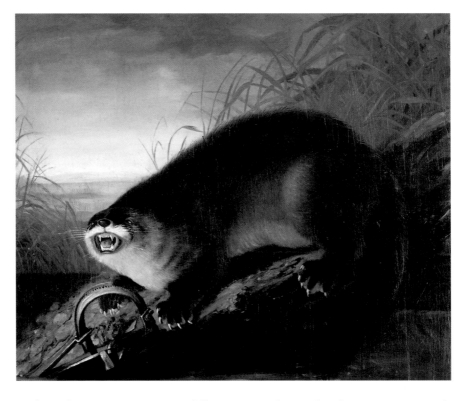

John James Audubon
Entrapped Otter
(Canada Otter)
c. 1827–30.
Oil on fabric,
24 ⅛ x 29 ½ ".
Milwaukee Art
Museum. Purchase,
Layton Art Collection

Related to plate 51.

and, with a companion, carefully pinning down the sleeping otters with pieces of saplings, killing them and thus obtaining specimens.[2]

It was while he was sketching one of these otters that his business partner and brother-in-law, Thomas Woodhouse Bakewell, came in and announced the failure of a commissary business in New Orleans that Audubon and Bakewell had founded. The War of 1812 between the United States and Great Britain contributed to the failure of the business. An autobiographical connection cannot be ignored. As he painted the otter, Audubon may have seen a parallel with his own life. Instead of freedom to pursue his own interests, he literally was trapped by business circumstances. But this would not be the last business partnership with Thomas Bakewell;

they joined together to build a gristmill and sawmill. The failure of this venture caused Audubon to go bankrupt, resulting in his serving time in prison in Louisville, Kentucky. The mechanical mill, designed for sawing logs and situated on the banks of the river in Henderson, and the trap on the log in his painting of the otter may well be related. It is one of his more violent images, and it also can be seen in the context of the genre of hunting and sporting art. In his painting Audubon portrayed the violence and the drama of the hunted animal, but he made it a modern subject. Human capture of animals is represented through a mechanical device, one that stresses the pragmatic use of the animal: Audubon does not represent hunting as a recreation, but rather shows the animal being captured for its fur. Audubon would use this composition for his plate in the *Quadrupeds,* and he placed it in the prominent position of the first image in the second volume of the publication.

In Europe, Audubon had the opportunity to view examples of animal paintings, and he commented on them in his journals. In his characteristic manner, he found much to criticize. At the Royal Academy in Edinburgh, he described the work of Flemish artist Frans Snyders (1579–1657): "I saw there a picture from the far famed Snyders, intended [to show] a Bear beset by Dogs of all sorts. The picture had a great effect, fine coloring and still finer finishing, but the Bear was no Bear at all and the Dogs were so badly drawn, distorted and mangled caricatures that I am fully persuaded that Snyders did not draw from specimens put up in real postures in my way."[3] In Edinburgh he also commented on seeing the work of the Dutch painter Melchior d'Hondecoeter (1636–1695): "We went to see a picture of the famous Hondekoeter. To me the picture was destitute of *life;* the animals seemed to me to be drawn from poorly stuffed specimens, but the coloring, the finish, the manner, the effect, was most beautiful, and but for the lack of Nature in the animals was a picture which commanded admiration and attention. Would that I could *paint* like Hondekoeter!"[4]

While visiting the Royal Academy, London, he scrutinized the work of English artist Edwin Landseer: "My eyes soon reached a picture by Landseer, the death of a stag. I saw much in it of the style of those men who know how to handle a brush and carry a good effect; but Nature was not there, although a Stag, three dogs, and a Highlander were introduced on the canvas. The stag had his tongue out and his mouth shut! The principal dog, a greyhound, held the Deer by one ear just as if a loving friend; the young hunter has laced the Deer by one horn very prettily, and in the attitude of a ballet-dancer was about to cast the noose over the head of the animal."[5] Audubon denigrated others' representations of animals' physical presence, including the veracity of their behavior and their lack of lifelikeness. His belief was that his own knowledge and observations of animal behavior provided superior images.

Audubon began the drawings for the *Quadrupeds* in 1840, before his journey west. He drew upon his contacts for specimens, and the *Common*

American Wildcat, 1842, would be the first plate in the new book (*Quadrupeds*, plate 1). Audubon began his publication with a large animal, and with a ferocious image: a cat with its teeth bared, the body gracefully crouched to indicate the possibility of sinuous movement. In seeking to portray mammals, Audubon was approaching a field of artistic endeavor in which numerous precedents existed, in contrast to his depictions of birds. European artists such as Landseer had romantically portrayed animals as wild beasts, and Audubon's depiction of the wildcat followed in that tradition. The depiction of this cat continued a pattern he had established in many of his most dramatic bird paintings, of having a bird look directly out of the composition, engaging the viewer directly. The cat's wildness is contradicted by the text: "The general appearance of this species conveys the idea of a degree of ferocity, which cannot with propriety be considered as belonging to its character."[6] The text provides details about Audubon's knowledge of the wildcat, including references to several specimens and also to his keeping a live wildcat for study. Thus, he provided the background that shows he knew his subject, especially the contradictory nature between its appearance and its behavior. This image establishes Audubon's direction for the *Quadrupeds*. He sought a pictorial approach that, first of all, portrays nature as its most vital point.

His paintings for the *Woodchuck*, 1841, which would become the second plate in the *Quadrupeds*, are important in showing how he would treat the smaller animals. These little quadrupeds did not lend themselves to be seen in the same artistic context as the larger animals; they had no connections with the iconography of the hunt. The woodchucks, squirrels, and mice presented Audubon with a challenge similar to that of the birds, yet these mammals were often less appealing than their ornithological predecessors in Audubon's work. In his best depictions of the small mammals, Audubon imparted a lively personality to them. One young woodchuck is shown in profile with all four feet on the ground; the work focuses on the physical appearance. The adult is also in a profile pose but stands up on its two hind feet, resulting in a more animated presence. The other small woodchuck has its teeth bared, giving it a menacing countenance. Audubon gave his animals character and a lively nature.

Sometimes Audubon's method of depicting the animals individually resulted in works that have passages of great beauty and meaning, even when not totally unified. One of Audubon's most poignant paintings is the *Gray Rabbit*, 1841, for plate 22 in the *Quadrupeds*. In this work he portrays an adult male, an adult female, and a young rabbit. The male seems to be leaping with its haunches in the air and its tail turned up, giving it an active character. The adult female crouches quietly. The young rabbit seems tiny and vulnerable, as it is placed below the leaping male. Audubon wrote the following on the verso of the watercolor: "I drew this Hare during one of the days of deepest sorrow I have felt in my life, and my only solace was derived from my labour—This morning our beloved daughter Eliza died at 2

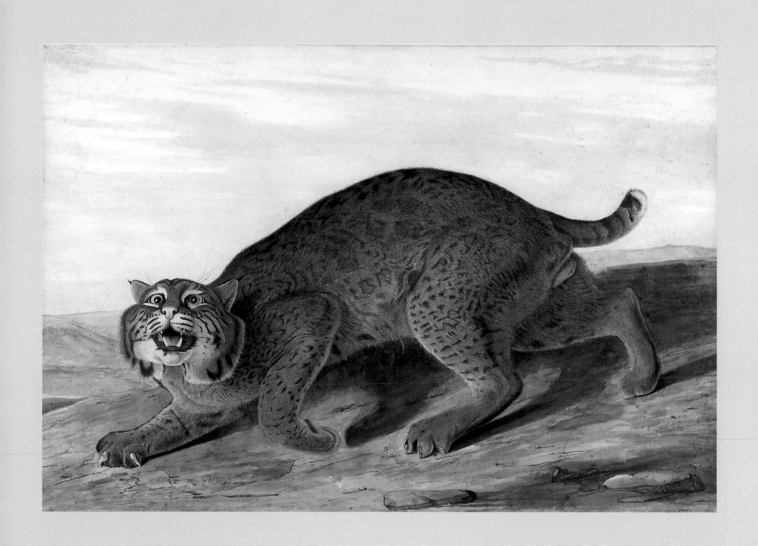

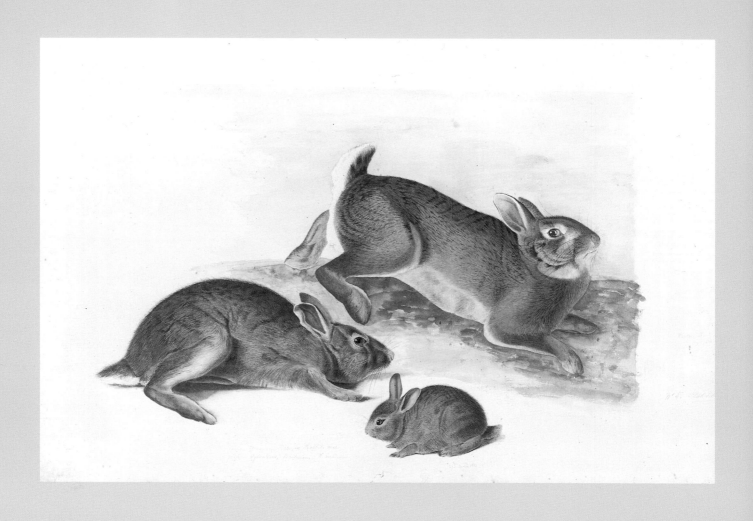

o'clock —She is now in Heaven, and may our God for ever bless her soul!" Eliza Bachman Audubon, the wife of Audubon's son Victor Gifford Audubon and a daughter of the Reverend John Bachman, died of complications from tuberculosis. Audubon's grief is tied to this image of the rabbits as a tender family group.

As he did in *The Birds of America*, Audubon often made separate drawings of portions of an image, which were combined later. To illustrate the *Northern Hare* in its summer coat, Audubon drew a figure of a mature male and one of a young female. The male is depicted with all legs outstretched as if running, a pose that shows the long legs of these rabbits. Victor Gifford Audubon painted the background for the hares, leaving blank the space where the animals would appear. Later the printmaker, J. T. Bowen, reconciled the two in the finished lithograph (*Quadrupeds*, plate 11).

For the plate of the *Soft-Haired Squirrel* (*Quadrupeds*, plate 19), John James Audubon sketched each of the two squirrels on separate sheets. His son Victor again provided a sketch of the background, tree branches.

In other works for the beginning plates of the *Quadrupeds*, the elder Audubon composed the picture as well as drew individual parts. In the *Cat Squirrel*, dated December 9, 1841, which became plate 17, he positioned three squirrels on a V-shaped tree branch. He presented three variations in coloring for this squirrel, from a reddish brown to soft gray to gray-black. He also adroitly posed the animals to show different postures and characteristics. The branch unites the three and provides a strong diagonal, which crosses from lower left to upper right. At the top of the left side of the branch, the uppermost squirrel is twined around the branch, exposing its underside and its delicate reddish-tinged coloring, as well as creating a graceful countercurve with its tail. The pose of the uppermost squirrel describes behavior that is explained in the text of the *Quadrupeds*: "After ascending, it does not immediately mount to the top, as is the case with other species, but clings to the body of the tree, on the side opposite to you, or tries to conceal itself behind the first convenient branch."[7] In the print, the squirrels are closer together than in the original watercolor. Some of the grace of Audubon's original placement is thus lost, but the effect makes the animals more like the text, for they appear even shier.

In 1841, Audubon purchased a tract in New York City along the Hudson River and had a house built there. The following year the Audubons moved to this new home, which was called "Minnie's Land" in honor of his wife, Lucy, "Minnie" being an affectionate diminutive for "Mother." The site where Audubon built his home is now at 155th Street in Upper Manhattan, but when he lived there it was an idyllic country setting with abundant wildlife. The nearby Hudson River provided the lushness that supported many varieties of animals and plants. This was the setting in which Audubon drew some of his best works for the *Quadrupeds*, surrounded by family and possessing a studio where he could draw from specimens obtained nearby.

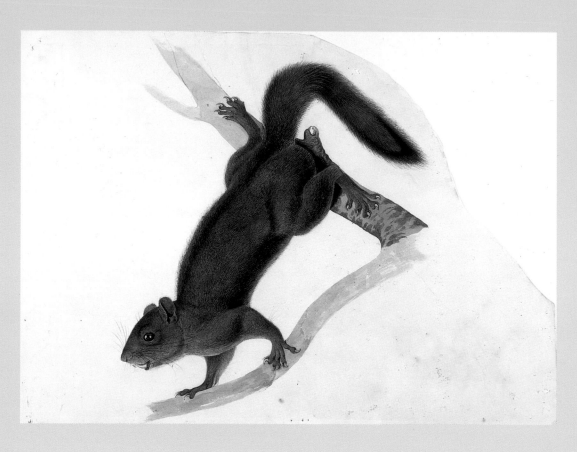

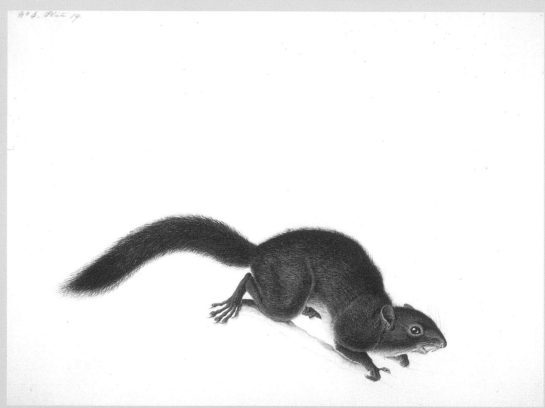

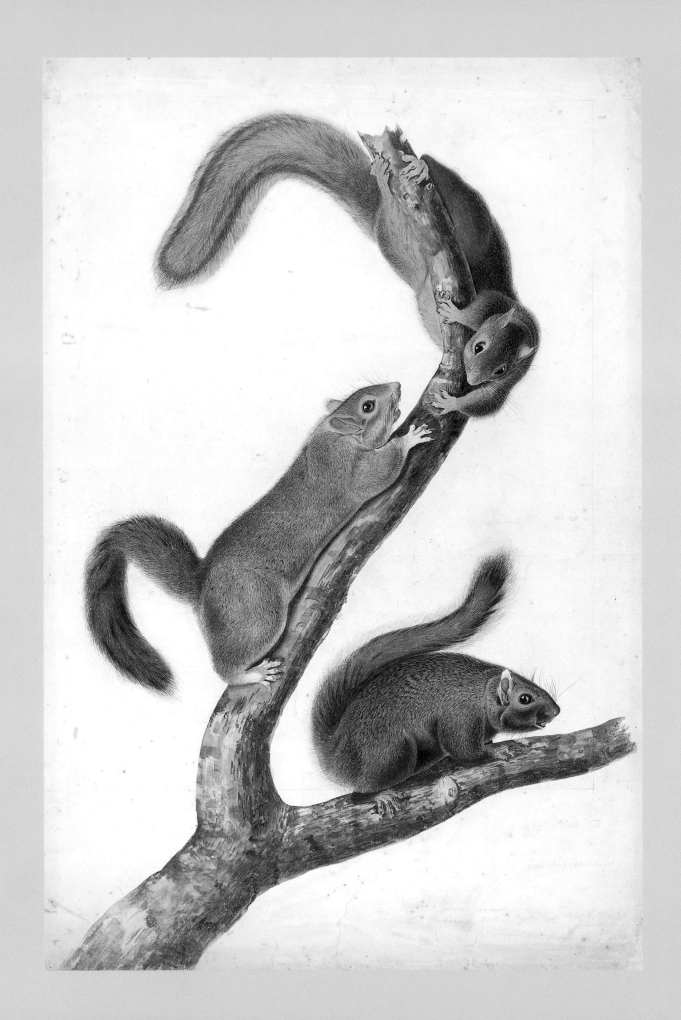

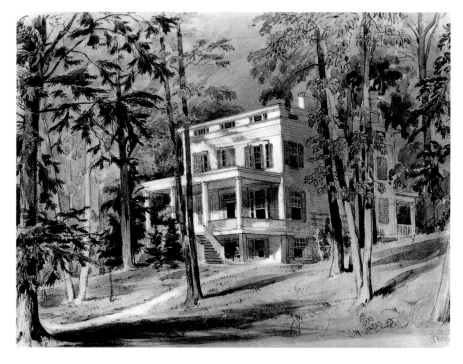

*William
Rickarby Miller*
**House of John
James Audubon**
*1852. Watercolor
on paper,
15 3/16 x 10 1/8".
Museum of the City
of New York*

*Miller sketched
the Audubon house,
Minnie's Land, the
year after John James
Audubon died.*

OPPOSITE:

John James Audubon
Cat Squirrel
*1841. Watercolor
and pencil on paper,
36 3/4 x 24 1/4".
The Pierpont Morgan
Library, New York,
1976.12:2*

*Audubon prepared
this work as the model
for plate 17 in*
The Viviparous
Quadrupeds of North
America. *The text
accompanying the
print noted the great
varieties in color
of this squirrel, and
Audubon chose to
present a representative
selection.*

OVERLEAF, LEFT:
John James Audubon
**Common
American Skunk**
*1842. Watercolor
and pencil on paper,
33 x 24 1/2".
The Pierpont Morgan
Library, New York,
1976.12:3*

For plate 42

OVERLEAF, RIGHT:
*John James Audubon
Lithographed,
printed, and colored
by J.T. Bowen.*
**Canada
Pouched Rat,**
*plate 44
Hand-colored
lithograph,
6 3/4 x 10 1/8".
Buffalo Bill
Historical Center,
Cody, Wyoming.
Gift of Deborah B.
Chastain*

*In the text of
Quadrupeds,
Audubon told of his
observations of this
animal: "During a
visit which we made
to the Upper Missouri
in the spring and
summer of 1843, we
had many opportuni-
ties of studying the
habits of this species.
In the neighbourhood
of St.Louis, at the
hospitable residence
of Pierre Chouteau,
Esq., we procured
several of them alive.
In that section of the
country they are
called 'Muloes.'"
(Quadrupeds, I:334)*

*Omega: John James
Audubon's Final
Artistic Journey*

Author Parke Godwin visited Audubon at Minnie's Land the year before the artist departed for the West and stressed the seclusion of the site by describing his wandering walk through the countryside to the house. Godwin relates that the house was simple in its architecture and beautifully sited amid sheltering elm and oak trees. Fawns and a "noble" elk roamed on the grounds, along with turkeys, geese, and other domestic animals. Godwin was ushered into Audubon's workroom, which he surveyed before the Audubons joined him:

In one corner stood a painter's easel, with a half-finished sketch of a beaver on the paper; in the other lay a skin of an American panther. The antlers of elks hung upon the walls; stuffed birds of every description of gay plumage ornamented the mantle-piece; and exquisite drawings of field-mice, orioles, and wood-peckers, were scattered promiscuously in other parts of the room, across one end of which a long rude table was stretched to hold artist materials, scraps of drawing-paper, and immense folio volumes, filled with delicious paintings of birds taken in their native haunts.[8]

For the plate of the *Common American Skunk,* Audubon combined two drawings and gave instructions for the setting. He drew the young male and female at Minnie's Land on June 9, 1842, then drew the adult female on January 22, 1843. On the sheet, he gave the directions that the adult was "to be placed on the rock, and the young beneath it, so as to render them almost unperceptible in the shadows." The young animals were posed to show their coloring. One, shown in profile, is described as having no white stripes but a white tip on its tail, which is depicted curled toward the front. The other young skunk is shown so the viewer sees the animal's back, which has white stripes. Its tail is lifted up, providing a contrast with its counterpart because most of the tail is dark. The adult skunk has a fierce character, unlike the

47

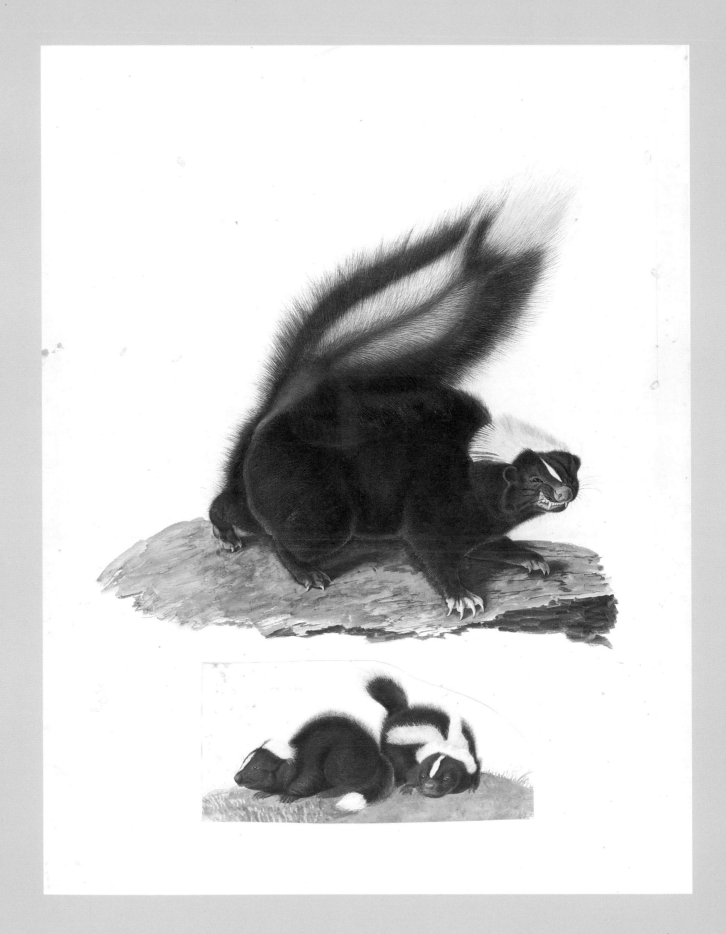

Plate XLIV.

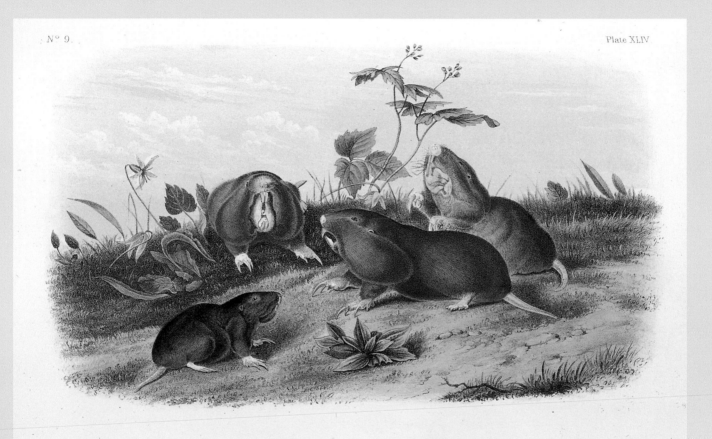

Canada Pouched Rat.

Drawn from Nature by J.J.Audubon F.R.S. F.L.S.

Lith. Printed & Col.ᵈ by J.T. Bowen, Phila.ᵈ

benign presentation of the young; the claws are outstretched and the teeth are bared, showing sharp incisors. The adult's tail is upturned to reveal the area where the glands that emit the animal's noxious odor are located. Audubon conceived of the presentation as a family in which the adult protects the vulnerable young. The sheet also contains Audubon's pencil outline of an ear and a forefront paw, each labeled as being the size of that part in nature. On the reverse, Audubon carefully recorded the measurements of the large animal.

At about this time, Audubon prepared for his western trip by obtaining letters of introduction and by engaging a party that would support his work. He set out on March 11, 1843, and traveled to Philadelphia, where Audubon's longtime supporter Edward Harris joined him for the journey. A prosperous landowner and amateur ornithologist from Moorestown, New Jersey, Harris first met Audubon in 1824, when the artist came to Philadelphia seeking a printer for his bird pictures.[9] Harris's admiration for Audubon's work led to a lifelong friendship. As early as 1838, the two friends were planning to travel to the West together. The three other members of the party joined as staff for Audubon. Isaac Sprague was engaged as an artist to paint backgrounds.[10] The position of taxidermist was filled by John G. Bell.[11] Lewis M. Squires was selected to serve as secretary.[12]

The party assembled in Philadelphia, then went to Baltimore, Cincinnati, and Louisville, reaching St. Louis on March 28. St. Louis was then the launching place for westward journeys, the city of commerce that linked the East with the West. Here the party was forced to wait until the ice had melted on the Missouri River before they could begin their journey. Audubon used his time to visit people, prepare for the trip, and write letters.

He called on Pierre Chouteau Sr., whose son Pierre Chouteau Jr. was now a major figure in the American Fur Company. From the elder Chouteau, Audubon heard stories about the Indians and the country he would see. One of his visits to Chouteau's plantation was for the purpose of acquiring specimens of pouched rats. He wrote to his family that he had drawn and finished four figures of these pouched rats, which he described as creatures that were curious beyond description.[13] His drawing is unfortunately unlocated, but the plate for the *Canada Pouched Rat* shows his careful observation of anatomy and his concern for depicting the appearance of the animal's teeth (*Quadrupeds,* plate 44). Audubon recorded additional observations on behavior in his journal and in a lengthy letter to John Bachman, and these became the basis for the text in the *Quadrupeds.*[14]

While in St. Louis, he also created the carefully rendered drawing of the *Say's Squirrel,* (see page 34) which he identified as the most abundant squirrel in the region. He wrote to Bachman: "I have figured 2 of them. Their descriptions as given in Godman, are very poor and admit of discrepancies, but this I have remedied in great measure as you will see when I return."[15] Dated April 9, 1843, this drawing shows his characteristic attention to the texture of the fur in delicate delineations of the hairs and to the modeling of

Blackfoot Shirt
Antelope skin with dyed porcupine quillwork. Alabama Department of Archives and History, Montgomery, Alabama. Collected by Edward Harris

BOTTOM, LEFT
AND RIGHT:
Leather Coat
Buckskin with quillwork and beads. Alabama Department of Archives and History, Montgomery, Alabama. Collected by Edward Harris

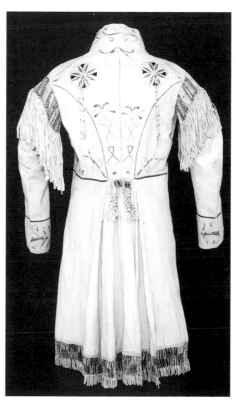

Omega: John James Audubon's Final Artistic Journey

51

the figures. He depicted one squirrel with its body making an oval shape as it curls around, biting its tail. The second squirrel, shown in profile with its tail extended upward, is placed behind the first. Audubon's composition unites the two figures in a design of curves leading into the oval. In this instance the print (*Quadrupeds,* plate 89) appears less successful than Audubon's original drawing. The squirrels are separated by an intervening tree root, which breaks the unity of the pattern.

Finally, on April 25, the party boarded the steamboat *Omega,* leaving St. Louis at 11:30 A.M. with Captain Joseph Sire at the helm. The *Omega* carried supplies and trappers upriver to fur company outposts.[16] The launch must have been a raucous experience. Audubon wrote that there were "a hundred and one trappers of all descriptions and nearly a dozen nationalities, though the greater number were French Canadians, or Creoles of this State. Some were drunk, and many in that stupid mood which follows a state of nervousness produced by drinking and over-excitement."[17] Edward Harris was less forgiving, stating that nearly all were drunk and calling them "the very offscouring of the earth."[18] Some Indians also were on board, of whom Audubon merely mentioned that they "had already seated or squatted themselves on the highest parts of the steamer and were tranquil lookers-on."[19] In a letter home on this first day, Audubon complained that the fur traders were not observant or knowledgeable about animals, other than what was necessary for business. He also reported showing his plates of the finished *Quadrupeds* to the Indians, and they, in contrast, knew all the animals except one and told him stories about new animals.[20]

The trip up to Fort Union would take forty-eight days and seven hours—the fastest steamboat journey up the Missouri River to that time. Nevertheless, even with frequent stops for gathering firewood, it was a long journey for the aging Audubon, who was just then turning fifty-eight years old. Early on, Audubon reported that the boat had less motion than any he had been on, and he thought he would be able to draw during the day.[21] The *Omega* passed Jefferson City, the capital of Missouri, three days after departure, then reached Boonville the following day, where Audubon bought some additional equipment.

The river was overflowing its banks, and the travelers commented on the sight of the submerged land. During these early days of the trip, Audubon reported seeing mainly small mammals such as squirrels, groundhogs, and rabbits. Although the expedition's purpose was to gather information for the *Quadrupeds,* Audubon's personal love for birds is evidenced in his many references to bird sightings as they traveled. Audubon recorded observations of mammals as well: "It appears to me that Sciurus macrourus of Say relishes the bottom lands in preference to the hilly or rocky portions which alternately present themselves along these shores."[22] The journey also left time for some philosophical reflection. As he gazed at the riverbanks being washed away by the flooding, Audubon read it as a lesson of Nature's intention that all should live and die.

OPPOSITE, TOP:
Cloth Pouch
Dyed quillwork.
Alabama Department
of Archives and History,
Montgomery, Alabama.
Collected by
Edward Harris

OPPOSITE,
BOTTOM:
Pad Saddle
Alabama Department
of Archives and History,
Montgomery, Alabama.
Collected by
Edward Harris

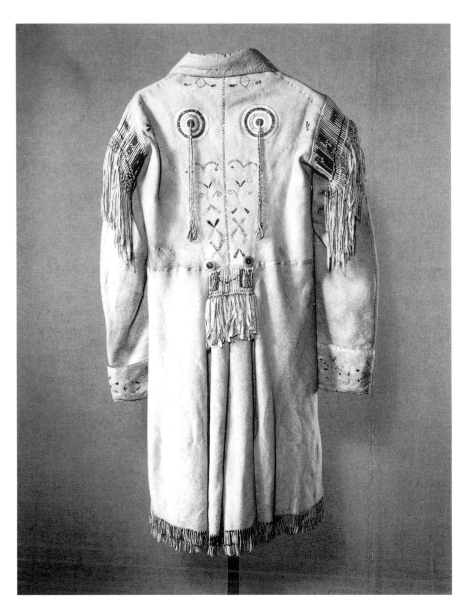

Audubon's Coat

Skin coat belonging to John James Audubon. Courtesy, Department of Library Services, American Museum of Natural History, New York

Stops were welcome for exercise and hunting. Audubon's room on the boat contained his collection of skins and specimens, which he proudly showed to visitors when stops permitted. On May 1, the travelers had contact with the steamboat *John Auld,* and several U.S. Army officers as well as Father Pierre-Jean De Smet, the noted Jesuit missionary, came on board for a visit. The *Omega* reached Independence, Missouri, the last town of any size, on May 2. The following day the expedition came to Fort Leavenworth, an army outpost in what is now the state of Kansas. Sprague described it as a "frontier fort beautifully situated on a high bluff. 431 miles above St. Louis. From this fort there is a fine view of the country for many miles around consisting of immense forests and boundless prairies as far as the eye can reach."[23] Upon leaving Fort Leavenworth, Audubon noted that the travelers "entered Indian country on the west side of the river."[24] The river also changed, becoming "narrower, the current stronger, and a hundred for one more snags, sawyers and planters than we had below."[25]

On May 4, Audubon makes a reference in his journal to a new finch, and

by the next day he concluded that it was a new species. He recorded dimensions in his journal and named it after his companion, Edward Harris. He included the *Harris' Finch* in the octavo edition (as plate 484), the smaller-sized version, of *The Birds of America,* which was being published by J. T. Bowen.[26] Soon Audubon added another bird. The day after they stopped at the Black Snake Hills, Audubon reported that Bell shot a small vireo, which he also believed was a new species. Audubon gave the honor of the bird's name to Bell, and it, too, was destined for the octavo edition. The drawing of the *Bell's Vireo* survives, providing an example of collaboration between Audubon and Sprague. The beautiful watercolor shows the bird perched on a rattlesnake root plant that Sprague drew in July, documented both by the inscription and by a reference in Audubon's journal. Audubon later added his drawing of the vireo and completed the work on January 22, 1844, after he returned to New York.

When the boat stopped on May 6 to discharge the Iowa Indians, the Indian agent, a Major Richardson, told the travelers that hares were abundant; indeed, Harris saw one later. This was the Rocky Mountain hare, which Audubon had already illustrated for plate 3 of the *Quadrupeds,* from specimens. Sprague commented on the Iowa Indians, writing that there were upwards of a hundred: "Some of them were fine looking fellows others looked like the Devil. many of them having their faces painted with red, black or yellow, which did not add much to their beauty as I could see."[27]

On May 8, Bell killed a black squirrel, which the travelers believed was also a new species, and Harris planned to name it in honor of Audubon's son John. Despite its potentially glorious place in the *Quadrupeds,* the squirrel was drawn by young Sprague, not Audubon. The next day the boat reached Bellevue, in what is now Nebraska. Audubon's earlier hopes of drawing while on board had been dashed: "Sprague is at this moment outlining the black Squirrel and it will be late before he has finished 2 figures of it. This is absolutely our only chance to draw as whilst we are running no one can either write or draw with any comfort."[28] When mentioning outline drawings, Audubon most likely meant drawings that were obtained by using a camera lucida, an optical device relying on a prism to project the shape of a subject onto paper. The travelers later decided the squirrel was not a new species; the location of Sprague's outline is unknown.

A military party inspected the *Omega* for illegal liquor on May 10. The ship's pilot, Joseph La Barge, later accused Audubon of being a shield to divert attention during the inspection while the cargo was rearranged.[29] In his journal, Audubon recounts his visit with the commanding officer but does not mention the liquor at all.[30] Although the *Omega* could have been carrying contraband, La Barge's account seems inspired by his dislike for the artist. Audubon, who had charmed his way across two continents, had not made a friend in the ship's pilot. La Barge described him as haughty: "The impression which the celebrated scientist made upon the crew and those who were entertaining him was quite unfavorable. He was very reserved and

OVERLEAF, LEFT:
John James Audubon
Bell's Vireo
*1844. Watercolor
on paper,
17 5/8 x 11 13/16".*
*The John Work Garrett
Library, Johns Hopkins
University, Baltimore,
Maryland*

*Audubon found this
vireo in 1843, named
it after John Bell, and
added it to the octavo
edition of*
The Birds of America.
*Isaac Sprague
drew the plant.*

*Omega: John James
Audubon's Final
Artistic Journey*

55

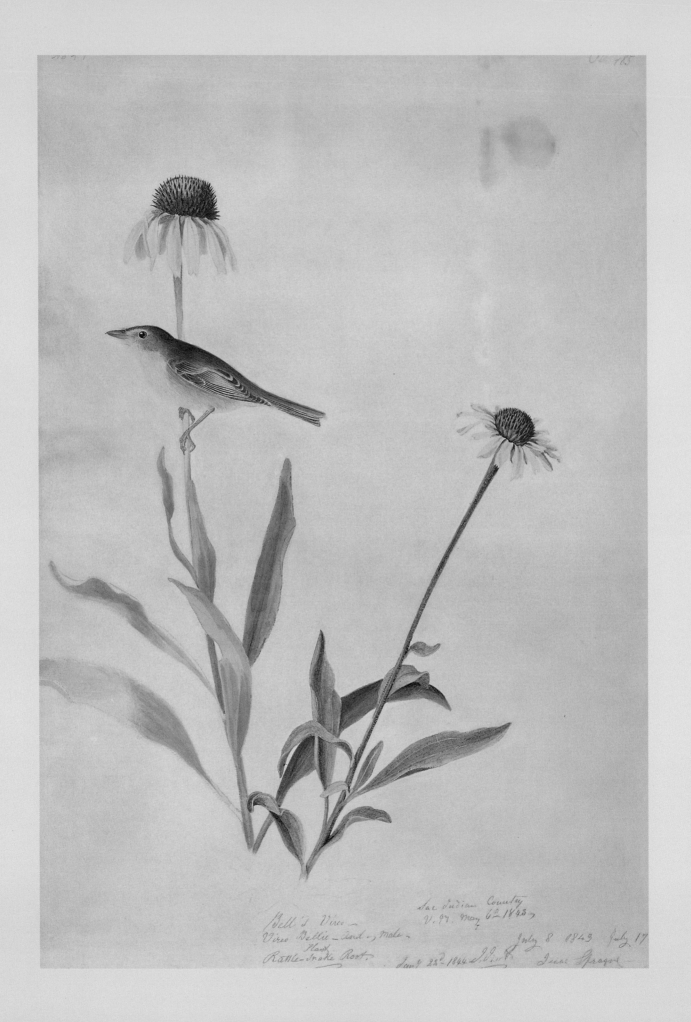

Bell's Vireo
Vireo Bellii — and., Male.
Plant
Rattle-snake Root.

Sac Indian County
V. 94 May 6th 1843

July 8 1843 July 17
Sent 25th 1844
Isaac Sprague

Harris' Finch.
Adult Male & Young Female.

Drawn from Nature by J.J.Audubon.F.R.S.F.L.S. Lithᵈ Printed & Colᵈ by J.T.Bowen Philᵃ

Bell's Vireo.
Male.
Rattle-snake Root.

Drawn from Nature by J.J.Audubon.F.R.S.F.L.S. Lithᵈ Printed & Colᵈ by J.T.Bowen Philᵃ

ABOVE, LEFT:
John James Audubon
J. T. Bowen,
lithographer
Harris' Finch
After 1843.
Hand-colored
lithograph, 8 ⅞ x 5".
Buffalo Bill Historical
Center, Cody,
Wyoming. Gift of
Dean and Mary Swift
and Mary Williams
Fine Arts of Boulder,
Colorado

Added to the Birds
after the Missouri
River trip.

when he did hold intercourse with members of the crew it was generally in an overbearing manner which alienated their good will."31

Later that day the boat passed Council Bluffs, in Iowa Territory, a site named by Lewis and Clark about forty years earlier. Audubon noted that the river had dug a new channel so it no longer was as close to the site as it had been. He soon observed that at this point the Missouri became more crooked and the shores lower on both sides, opening onto prairie land. Other sites that Lewis and Clark identified provided mileposts. On May 12 the travelers saw Blackbird Hill, the burial site of a famous Omaha Indian leader; the following day they passed the burial site of Sergeant Floyd, a member of Lewis and Clark's party. Audubon also reported much commotion over the sight of a black bear swimming in the river. Fierce winds prevented travel on May 15, so the party trooped out into the muddy bottomland. Then further delays were caused by a burned-out boiler. Audubon commented on seeing a dead buffalo and its calf floating down the river, then eight more; he described in his journal how the buffalo died of exhaustion trying to climb the high bluffs there.

The delay gave Audubon an opportunity for reflection, and in his journal he contrasted his impressions of the land and of the Indians with those

ABOVE, RIGHT:
John James Audubon
J. T. Bowen,
lithographer
Bell's Vireo. *After*
1843. Handcolored
lithograph,
9 ⅛ x 5 1/16".
Buffalo Bill
Historical Center,
Cody, Wyoming.
Gift of Dean
and Mary Swift
and Mary Williams
Fine Arts of
Boulder, Colorado

Added to the Birds
after the Missouri
River trip.

Omega: John James
Audubon's Final
Artistic Journey

of artist George Catlin, who had traveled up the Missouri in the 1830s and whose accounts had been published in 1841.[32] Audubon objected to Catlin's noble characterization of the Indians he had met such as *In-ne-ó-cose, The Buffalo Child, Blackfeet,* 1836; Audubon considered them not only "poor" but "stupid and superstitious."[33] Similarly, Audubon mocked Catlin's gentle descriptions of the prairies as "carpeted" and "velvety," as in the later *Grassy Bluffs on the Upper Missouri,* 1852. It was not uncharacteristic of Audubon to criticize the work of any artist with whom he felt in competition. His barbed comments about Catlin also stemmed from Audubon's identification with the fur traders and others engaged in commerce who approached the region with a pragmatic agenda, not a romanticized concept of nature or of the Indian as "noble savage."

The travelers were able to resume the voyage on May 19, and Audubon reported that the land changed again, becoming more barren. Now they began to see large herds of buffalo. By June 1 the boat had reached Fort Pierre, in what is now South Dakota. Audubon described the landscape as desolate, "dreary Hills covered with scant grass growing in tufts at the distance of a few feet together and as yet very short." How very different this landscape was from the ones in Kentucky, Louisiana, and the Hudson River valley that had nurtured Audubon and provided rich settings for abundant wildlife. In his letters he yearned for Minnie's Land, not only his loved ones but also "a good Garden, Potatoes planted, a young orchard. . . ."[34]

They reached Fort Clark, adjacent to a village of Mandan Indians, on June 7. Here the travelers saw the rounded earthen lodges of the Mandan, but the sight did not inspire Audubon, who again denigrated Catlin's representations, similar to those on page 60: "The Mandan mud huts are very far from looking poetical, although Mr. Catlin has tried to render them so by placing them in regular rows and all of the same size and form, which is by no means the case. . . . It is possible that there are a hundred huts, made of mud, all looking like so many potato winter-houses in the Eastern States."[35]

A swift fox was captured at Fort Clark as they traveled up the Missouri, then held for their return. Audubon described his delight in observing this animal. He would later take it back to New York, where he had a cage constructed that was sunk below the ground so the fox could have a burrow. (He also took a badger back to New York.) Audubon's watercolor of the *Swift Fox,* 1844, is one of his loveliest compositions. Perched on its hind legs, the fox points its nose in the air with an elegant grace that is counterbalanced by the curve of its full, bushy tail. The text of the *Quadrupeds* provides narrative about the speed of this animal but also notes, "There is nothing in the conformation of this species, anatomically viewed, indicating extraordinary speed. On the contrary, when we compare it with the red fox or even the gray, we find its body and legs shorter in proportion than in those species, and its large head and bushy tail give it rather a more heavy appearance than either of the foxes just named."[36]

George Catlin
**In-ne-ó-cose,
The Buffalo's
Child, Blackfeet**
*1836. Watercolor
on paper,
10 ⅛ x 8 ⅛ ".
Gilcrease Museum,
Tulsa, Oklahoma*

*Catlin painted this
portrait at Fort Union
when he visited there
in 1836. He felt that
the tribes in that
region were among the
finest-looking and
best-equipped peoples.
When Audubon visited
the same fort in 1843,
his view of the Indians
was more negative and
he disparaged Catlin.*

George Catlin
**Grassy Bluffs on the
Upper Missouri**
*1852. Oil on canvas,
11 ⅛ x 14 ⅝ ".
Gilcrease Museum,
Tulsa, Oklahoma*

*Catlin portrayed the
region around the
Missouri as a green
Edenic site, but
Audubon was
disappointed by
the scenery.*

*Omega: John James
Audubon's Final
Artistic Journey*

59

Fort Union, near the confluence of the Missouri and Yellowstone Rivers, came into sight at last, and the travelers reached their destination on June 12 at seven o'clock in the evening. Audubon's party would stay at the fur-trading post nearly two months, occupying their time with drawing and gathering observations for the *Quadrupeds,* but primarily with hunting, which was a sport as well as part of their method. Fort Union had entertained other notable artists: both Catlin and Karl Bodmer had stopped at the site on their trips up the Missouri River. Audubon was initially disappointed with the small, dark room he was assigned, even though it was the same one previously occupied by Maximilian, Prince of Wied, and was relieved to move to an upstairs room.

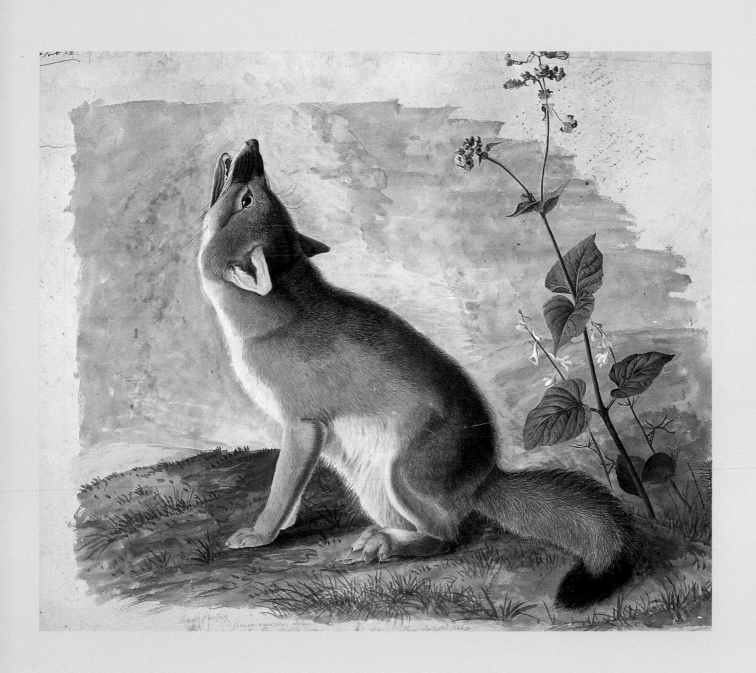

At the fort, Audubon had conditions more amenable to drawing, and he recorded, "I drew the young Gray Wolf and Sprague made an outline of it."[37] He also noted, "The young fawn was hung up, and I drew it. By dinner-time Sprague had well prepared the Gray Wolf and I put him to work at the fawn."[38] Wolves are mentioned repeatedly in Audubon's journal, especially while he was at Fort Union. Wolves would come around the fort to scavenge for food, and the men would climb up into the towers to shoot at them for sport. Yet even though Audubon had ample opportunity for observation and reports having made a drawing of a wolf, he did not provide a drawing of a wolf for the *Quadrupeds.*

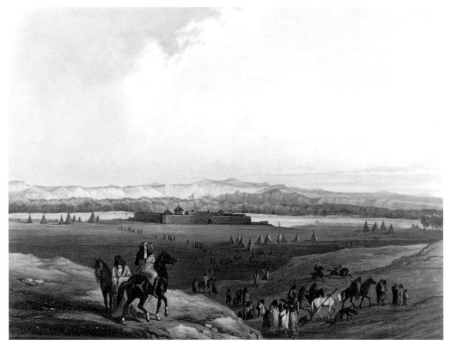

Plate 72 in the *Quadrupeds,* the *White American Wolf,* is identified as being by John Woodhouse Audubon, and the oil painting in the collection of the American Museum of Natural History confirms the attribution to the younger artist. John lacked the sure touch of his father. His modeling of the figure renders the anatomy slightly less convincing in general, and in the instance of this wolf, the head seems wooden and not well connected to the body. Yet the general pose with the body forming a triangle, the teeth bared in a menacing position, and the inclusion of a bone for gnawing are all touches reminiscent of the portrayals that John James Audubon created of other predator animals. In the text on this wolf accompanying the *Quadrupeds,* the section on habits clearly comes from the elder Audubon's experiences at Fort Union and on the Missouri River. One sentence in the text even seems to be the inspiration for this representation of the wolf: "Whilst prowling over the prairies (and we had many opportunities of seeing them at such times) they travel slowly, look around them cautiously and will not disdain even a chance bone that may fall in their way. . . ."[39]

The burden of completing the animals for the *Quadrupeds* fell on John

Woodhouse Audubon. Quite probably he used materials brought back by his father, such as drawings, to inspire his composition, but because the final work was his, he so claimed it. The *White American Wolf*, as plate 72 in the publication, fell somewhat late in the line of production, when John James Audubon was not capable of being much help.

The attribution of the painting of the *American Bison* is more complicated. Of all the animals encountered on the journey, the bison would seem to have presented Audubon with the best opportunity for a masterwork. The bison was observed with admiration as the group traveled on the river, was the object of numerous hunts, and had been the subject for many other artists. Culbertson arranged opportunities for the travelers to participate in hunts. In mid-July they set out on a "grand hunt," with Audubon, Harris, and Bell in a cart driven by Culbertson, and others in carts and leading the hunting horses. According to Bell's account, the party saw four bulls and allotted one each to Bell, Culbertson, Harris, and Squires. The bulls ran in different directions, and the hunters set off in pursuit. Squires was thrown from his horse and injured; then Harris was also thrown, but not hurt. Bell noted that "Mr Audubon was seated on a hill where he had a full view of all our movements and two of the Bulls were killed within a few hundred yards of him and no doubt he will give a glowing description of the whole scene."[40] During the hunts, the inevitable tensions of the party surfaced; Bell, the taxidermist, disparaged the efforts of Squires and reported that the secretary repeatedly missed in his efforts to shoot a bison.[41]

The text of the *Quadrupeds* heralded the significance of the animal: "Whether we consider this noble animal as an object of the chase, or as an article of food for man, it is decidedly the most important of all our contemporary American quadrupeds. . . ."[42] The *Quadrupeds* publication included two 1845 prints devoted to the bison. *Quadrupeds* plate 56 is a large standing bull bison, shown in profile. An oil painting of this image also survives. The next plate features a bison family, with a bull standing forward, a female reclining, and a small calf standing and grazing. The original source for this image is unlocated.

In the first plate, the standing male is a typical illustration of a specimen in profile, showing the characteristic anatomy of the animal. The modeling of the form seems authoritative in the print; the drawing on which this is based must have conveyed the animal well to the printmaker. Audubon was working primarily in watercolors during this period and painted in oil only under special circumstances. Most likely he prepared a now-lost drawing of the bison as the model for the print; the modeling of the bull's anatomy is assured. The oil painting is a second version, but one that should properly be attributed to John Woodhouse Audubon.

In the second print, one of the intentions seems to be to compare the male and the female, particularly the shapes of their heads. Yet the modeling of the figures is not as full and three-dimensional as the earlier version, and the head of the female bison is awkward and unnatural. Although credited

OVERLEAF:
John James Audubon
**Four-Striped
Ground Squirrel**
*1841. Watercolor
on paper,
14 1/2 x 21".
Princeton University
Library, Princeton,
New Jersey*

*This work contains
two of the chipmunks
depicted in plate 24
of the* Quadrupeds.
*Although Audubon
reported collecting
the animal on the
western journey, he
made this drawing
based on specimens.*

*Omega: John James
Audubon's Final
Artistic Journey*

to John James Audubon, the figures were more likely done by John Woodhouse Audubon.

On August 12, Audubon and his party went on their last buffalo hunt with the traders from Fort Union and made their preparations for leaving. They departed from the fort on August 16 on the *Union*, a flat-bottomed boat called a mackinaw. Impatient to be home with his family, Audubon made briefer entries in his journal on the return trip, although he continued to look for animals, to hunt, and even to sketch.

On the journey back, Audubon reported observing the four-striped ground squirrel. The text of the *Quadrupeds* gives his account: "We met with this species as we were descending the Upper Missouri River in 1843; we saw it first on a tree; afterwards we procured both old and young, among the sandy gulleys and clay cliffs, on the sides of the ravines near one of our encampments." The drawing of two of the ground squirrels for the published plate 24 was done by Audubon before the journey, from specimens, yet it demonstrates his lively use of watercolor in approaching the small quadrupeds. The party reached St. Louis on October 19, and Audubon returned to his family on November 6, 1843.

The trip up the Missouri River was John James Audubon's last major expedition. He would continue to draw specimens after the journey, but his personal contribution to the publication was really in the early stages and in the vision of the whole project. After the effort of the trip up the Missouri, Audubon's direct participation in the artistic work lessened. Both his physical and mental health deteriorated, until he was no longer able to contribute. Granddaughter Maria R. Audubon, editor of his published journals, commented that "of course the journals kept by Grandfather ended in 1847 when he lost his mind. . . ."[43]

The plates that are based on Audubon's drawings have graceful compositions and lively representations. Those plates that are not by the elder Audubon have representations that are stiffer, less lifelike, and less original in composition. The task of completion fell to John Woodhouse Audubon, who as an artist was not as talented as his father. Yet the younger artist did produce handsome work, such as *Red Texan Wolf*, approaching the quality of his father's work. Nevertheless, *The Viviparous Quadrupeds of North America* was a collaborative project. The final product resulted from the combined work of Audubon, his sons, and his printmakers. In the end, the beauty of the work is greater than the sum of its parts.

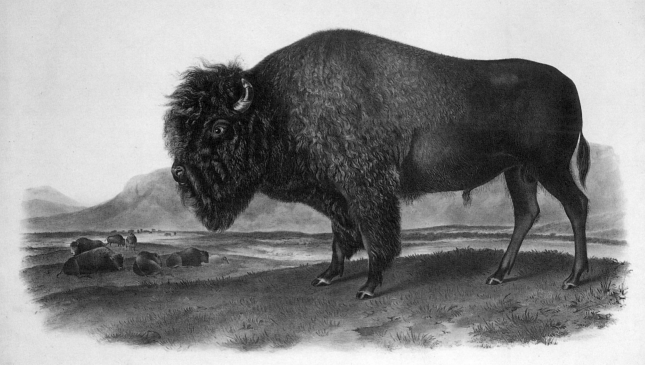

BOS AMERICANUS, GMEL.
AMERICAN BISON OR BUFFALO.
Natural Size.
MALE.

Drawn from Nature by J.J. Audubon F.R.S.L.S.

Lith. Printed & Col.d by J.T. Bowen. Phil.a 1845.

PLATE LVII.

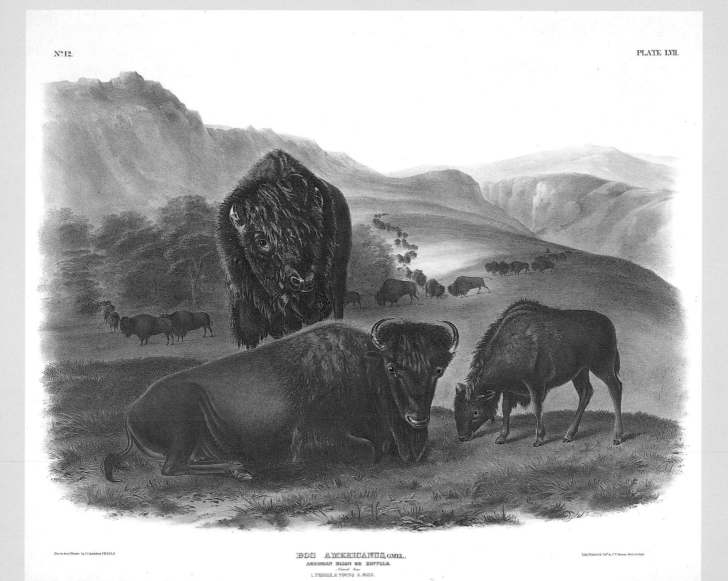

Drawn from Nature by J.J.Audubon.F.R.S.F.L.S.

Lith.Printed & Col.d by J.T.Bowen.Philad.a 1845

BOS AMERICANUS, GMEL.
AMERICAN BISON OR BUFFALO.
Natural Size.
1. FEMALE, 2. YOUNG 3. MALE.

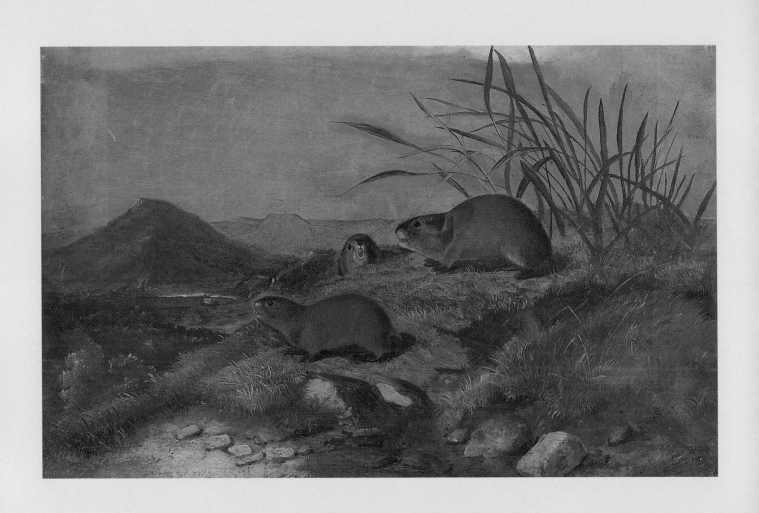

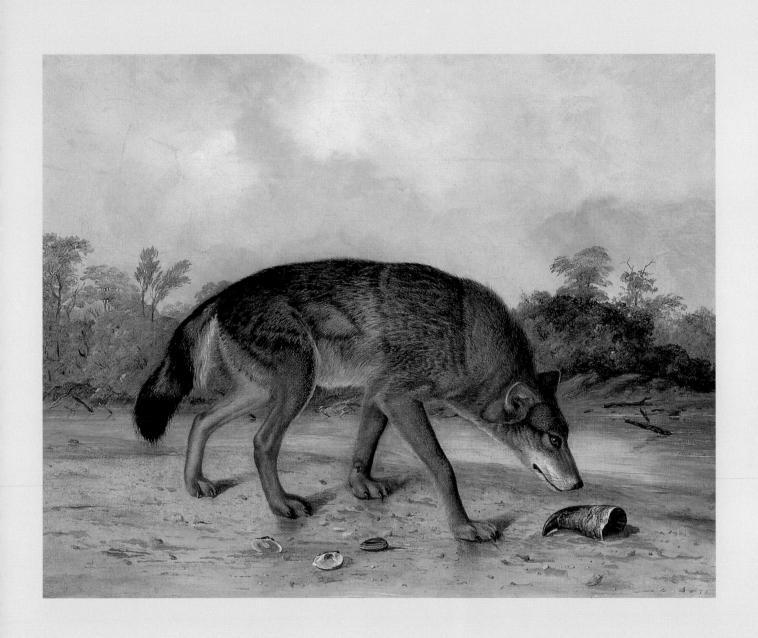

Audubon and Bachman:
A Collaboration in Science

ROBERT McCRACKEN PECK

When John James Audubon and the rest of his party of five left the St. Louis docks on the morning of April 25, 1843, for a six-month trip up the Missouri River, the self-proclaimed "American Woodsman" was fulfilling a dream that had long possessed him. Since 1831, when he first openly declared his desire to explore the American West, Audubon had imagined reexperiencing the excitement of his youthful travels in the American Southeast by visiting the fabled Yellowstone River, the Rocky Mountains, or even "that almost unknown country, California."[1]

During the long and difficult decade in which he struggled to publish his ornithological findings, he watched with envy while other, younger naturalists crossed the continent and sent back species of birds not previously known to science. Unable to collect them himself, Audubon purchased and illustrated some of the new discoveries in his still evolving book, *The Birds of America,* then criticized the collectors for their lack of diligence in bringing back more. "That he saw many new birds which he has not procured I am now certain," Audubon complained to the Reverend John Bachman about John Kirk Townsend, who had traveled cross-country to the Pacific Coast in 1834 and 1835. "I cannot understand how he spent his whole days and years at Fort Vancouver. . . . Good God, what a Pity that you or I or [Edward] Harris had not been there, oh what might we have done that he has left undone."[2] But the relentless painting and subscription-gathering schedule that Audubon imposed on himself in support of *The Birds of America* (1827–38), *Ornithological Biography* (1831–39), and *A Synopsis of the Birds of North America* (1839) precluded collecting trips of the sort Audubon had so enjoyed in his youth.[3] The consuming demands of self-publication had made him a slave to his own success and taken the American

Woodsman away from the woods and into the salons and drawing rooms of Europe.

Finally, in 1843, five years after the last giant plates of his double elephant folio had been engraved, printed, colored, and distributed to subscribers, and three years after the smaller, octavo edition of *The Birds of America* had been successfully launched, Audubon could justify a return to the wild from which he had drawn so much inspiration in the past. By then, both Audubon and his adopted country had changed significantly, and so had the purpose of his time in the field. According to his published journal, Audubon made his long-awaited expedition to the Yellowstone River not for the love of birds, as on so many of his earlier trips, but "'solely for the sake of our work on the *Quadrupeds of North America*,'" a book on mammals that he had begun five years before.[4]

Inspired by the success of his ornithological publications and driven by a need to create "something new rather than tread in old shoes upon people's heels,"[5] Audubon had launched his ambitious plan to publish a definitive book on what he called "the Viviparous Quadrupeds [literally, four-footed animals bearing living offspring] of North America." Initially, he envisioned it as a single-volume work "rather less than half the size of the *Birds of America* in about one hundred plates giving all that can be given in such fauna of the size of life accompanied by one vol[ume] of letter press, the whole to be finished (God granting me life and health) in two years!"[6] It would eventually grow to a three-volume work, with an additional three volumes of text, and take fifteen years to complete.

Although always more passionate about birds than mammals, Audubon showed a serious interest in mammals from the time of his first arrival in America from France in 1803. During his early twenties he made stiff but affectionate paintings of the wildlife found at Mill Grove, the Pennsylvania estate his father had sent him to manage while avoiding conscription in

Napoleon's armies. Later he incorporated mammals in some of the bird-of-prey compositions for *The Birds of America,* often making separate studies of the animals, then instructing his engraver, Robert Havell Jr., to insert them in the final prints. As his earlier projects drew to a close, Audubon decided to create "in a masterly manner" one final book, a definitive publication on mammals of America.[7] He hoped it would replicate the critical and popular success of *The Birds of America.*

"I know a good deal about our Quadrupeds," he wrote a friend in 1839, "and have many valuable notes about them in my various journals of the woods and swamps."[8] And so he did, but he soon recognized that a collection of behavioral anecdotes, no matter how original and interesting, was not enough to create a book of significance on so large and complex a topic. For assistance, he turned to his longtime friend John Bachman, inviting him to serve as scientific adviser and coauthor of the proposed book. He retained for himself the role of principal author, illustrator, and publisher. In a letter of 1840, Audubon voiced his fears, aspirations, and enthusiasm for the *Quadrupeds* to his new collaborator:

I believe that such a publication will be fraught with difficulties innumerable, but I trust not insurmountable, provided we join our names together, and you push your able and broad shoulders to the wheel, I promise to you that I will give the very best figures of all our quadrupeds that ever have been thought of or expected, and that you and I can relate the greatest amount of truths that to this time has appeared connected with their dark and hitherto misunderstood histories!—My hair[s] are grey, and I am growing old, but what of this? My spirits are as enthusiastical as ever, my legs fully able to carry my body for some ten years to come, and in about two of these I expect to see the *Illustrations* out, and ere the following twelve months have elapsed, their histories studied, their descriptions carefully prepared and the book printed! Only think of the quadrupeds of America being presented to the world of science, by Audubon and Bachman; the latter one of the very best of D.D.'s and the former the only American living F.R.S.L.![9]

Bachman, the much-loved pastor of St. John's Lutheran Church in Charleston, South Carolina, was a highly respected amateur naturalist who had assisted Audubon in gathering specimens and information for—and subscriptions to—his ornithological books. Hardworking, meticulous, and steeped in the scientific literature of the day, he was in many ways the ideal partner for Audubon: a temporizing influence on his friend's more flamboyant, ambitious, and sometimes arrogantly reckless personality. While offering his full support and cooperation, he was also realistic in what could be accomplished. "Don't flatter yourself that this book is child's play," Bachman cautioned his older friend.[10] In an earlier letter he had written, "The animals are not numerous but they have never been carefully described, & you will find difficulty at every step. The books cannot aid you much. Long journeys will have to be undertaken—several species remain to be added—their habits ascertained."[11]

Bachman knew whereof he spoke, for he was one of a handful of American naturalists who had studied mammals in a serious way. One contemporary writer called him "the most learned and accurate student of Mammalogy our country has yet produced,"[12] while another described him as "the most distinguished student of Mammalogy in this country."[13] He was also one of the very few people who could speak frankly—even critically—to Audubon without alienating the egocentric artist. Years of friendship and the marriages of their four children (Audubon's sons, Victor Gifford and John Woodhouse, to two of Bachman's daughters, Mary Eliza and Maria Rebecca, respectively) had given Bachman the license to chide Audubon for his haste in publicly launching the *Quadrupeds* without sufficient preparation[14] and, later, to chastise him for sloppiness and careless mistakes. While Audubon did not always accept Bachman's criticisms gracefully, he appreciated the spirit of cooperation in which they were given, for the two men had become professional colleagues in an ambitious attempt to make what Bachman called an "original and creditable publication" on a subject to which no previous naturalists had done justice.[15] "Nothing worth looking at exists at present," Audubon noted, accurately, when describing his plans for the *Quadrupeds* to a friend.[16]

Fiercely proud of his own achievements and reluctant to share the limelight (or financial reward) in ornithological matters, Audubon had never

before sought assistance with a scientific publication. He did so reluctantly, but with the confidence that if collaboration was necessary, Bachman would be the best possible partner. Bachman was flattered by the invitation to participate and understood the critical role he could play as Audubon's collaborator. "I have studied the subject more than you have," he wrote Audubon with characteristic candor in 1839,[17] and a few months later commented that "you cannot do without me in this business."[18] Declining any remuneration from Audubon for his participation in the project, Bachman agreed to become coauthor of the book as his way of making a lasting contribution to American science. He was also eager to contribute to the financial security of his daughters by helping his sons-in-law. "I am . . . anxious to do something for the benefit of John and Victor," he wrote Audubon in 1840: "The expense and profit [of the *Quadrupeds*] will be yours, or theirs which is the same thing. In due time it will sell as well as the birds & if the boys with their good points and industry cannot be independent after all this—they deserve to starve."[19] Bachman boldly predicted at one point that the book

might become "the most profitable speculation into which you have ever entered," adding, "It will amuse & occupy you in your old days & keep you from snuff and grog."[20]

In every respect the book would become a team effort, with Bachman providing much of the scientific content for the text and Audubon's sons, Victor and John, providing most of the financial management and roughly half of the illustrations for the publication.

The collaboration was at times a difficult one. Audubon, already insecure about his relative lack of knowledge in the field of mammalogy, was not used to having others tell him what needed to be done. Throughout the production of *The Birds of America,* it was Audubon who had set the agenda, driving his friends and associates to distraction with his demands for specimens, information, and timely production of engraved and colored plates. With the *Quadrupeds,* it was often Bachman who had to prod Audubon or his sons to provide information to ensure the accuracy and completeness of the text.

The geographic distance and different working methods of the two collaborators meant that there were frequent miscommunications between them. On at least fifteen separate occasions, Audubon or his sons published scientific names with the mammals they were illustrating that Bachman had to change in the accompanying text. "I perceive you are clamorous for names to furnish your drawings," wrote a frustrated Bachman. "Let me advise you to do a little more in obtaining specimens, books and information & issue your numbers less frequently."[21]

Bachman's scientific rigor and systematic approach to the topic, while sometimes exasperating to the Audubons, transformed a randomly organized aesthetic exercise and collection of anecdotal species accounts into a meaningful contribution to the collective knowledge of American natural history.

As Audubon embarked for what his friend considered "the inhospitable wilds of the center of the continent"[22] to gather information for the *Quadrupeds* in the spring of 1843, he carried a virtual shopping list from Bachman, reminders from his homebound friend of what should be sought out and collected. Accompanying him, with a desiderata list of his own, was Edward Harris, forty-three, a longtime friend, supporter, and traveling companion of Audubon who was making the journey at his own expense and filling the role of financial manager for the expedition.[23] The three other members of Audubon's party were John Bell, thirty, a professional taxidermist from New York City;[24] Isaac Sprague, thirty-one, an artist from Hingham, Massachusetts, whom Audubon had employed as a "draftsman";[25] and Lewis M. Squires, an English "gentleman"[26] and New York neighbor of Audubon's, whom Audubon asked to serve as secretary for the expedition. Although "no naturalist," Squires was described by his employer as "a tough, active and very willing person."[27]

Audubon and his family saw Harris as the only member of the party "qualified by education and habits" to be both a "confidential advisor" and

Edward Harris
*Photograph.
Alabama
Department
of Archives
and History,
Montgomery,
Alabama*

friend (in other words, social equal) to the expedition's leader.[28] Squires, Bell, and Sprague were clearly subordinates, participating at Audubon's invitation and traveling at Audubon's expense. Each had a specific role to play: Squires was to keep records; Bell, to collect, measure, and preserve specimens for future reference; and Sprague, to capture, in watercolor and pencil, bits of the western landscape for use in the final plates.

Although Sprague was the first artist invited to accompany Audubon on an extended field trip for the purpose of making paintings, his role was not without precedent. In preparing the illustrations for *The Birds of America*, Audubon frequently had relied on the skills of other artists, most notably George Lehman, Joseph Mason, and Maria Martin (Bachman's sister-in-law and, later, his second wife), to provide the backgrounds and botanical details. The surviving examples of Sprague's western work suggest that he was expected to serve a similar role, though in the end his contribution to the *Quadrupeds* would be virtually invisible.[29] Audubon himself appears not to have done much landscape painting on his western trip, focusing instead

on observing—and in a few cases drawing—the animals he had traveled so
far to see.

When originally planning his Missouri River party, Audubon had hoped
that his son Victor would join him,[30] but as Victor had just married his sec-
ond wife, Georgianna Mallory, in February, he preferred to give up partici-
pation, taking consolation from the knowledge that Harris would offer his
father the companionship he himself might otherwise have provided.[31]

In addition to Victor, two other participants declined Audubon's invita-
tion to ascend the Missouri River: the first was his brother-in-law, William
Bakewell of Louisville, Kentucky, whom Audubon described as "the very
Nimrod of the West"[32] (meaning a great woodsman and hunter); the second
was the future secretary of the Smithsonian Institution, Spencer Fullerton
Baird, then a twenty-year-old collector-naturalist with whom Audubon had
developed a friendship by correspondence. Audubon had hoped Baird would
serve as a recording secretary and describer of quadrupeds for the expedition.
His participation might have made a tremendous difference in the scientific
productivity of the trip, but a troubling heart condition and his family's fear
of exposing their son to the dangers of "Indians, Rattlesnakes, and such
Vermin" as he might encounter in the "Great Wilderness" caused Baird to

decline the tempting offer.[33] Ironically, it was Baird's subsequent publication, *Mammals of North America* (1853–56), that eventually supplanted Audubon's *Viviparous Quadrupeds of North America* as the most widely accepted work in the field.

Nº 100. Pl. 500

Baird's Bunting.

Drawn from Nature by J.J.Audubon.FRSFLS. *Male.* Lith⁴ Printed & Col⁴ by J. T. Bowen. Philad⁴

By assembling a group of specialists to assist him on his western expedition, Audubon was creating the kind of team approach that he had seen work so effectively in the studios of his London engraver, Robert Havell Jr., and his Philadelphia lithographer, J. T. Bowen. Having achieved a degree of financial stability unknown in his earlier life, Audubon was now able and willing to hire assistants to perform such disagreeable or time-consuming tasks as hunting, killing, measuring, skinning, and preserving large mammals, just as he had hired engravers, lithographers, and colorists in Edinburgh, London, and Philadelphia to help him with his ornithological publications. He considered the roughly $2,000 it cost him to pay Bell's salary and cover the other expenses of the expedition (four-fifths of the total cost) an investment in a publishing venture that he hoped would confirm his preeminence in American natural history and, at the same time, secure his family's financial independence.[34]

So enthusiastic was he about the western trip that the very prospect of "this grand and Last Journey I intend to make as a Naturalist" seemed to rejuvenate him.[35] A reporter from the *Daily People's Organ* in St. Louis was one of several journalists who remarked on the aging naturalist's deceptively youthful energy in the days just prior to his departure: "Although an old man with silver locks and the weight of years upon him, [Audubon] retains all the freshness, elasticity, and energy of youth, and is as ready to endure the toils and deprivations of long and tedious journies [*sic*] through savage wilds and

uninhabited territories, for the purpose of pursuing his favorite study, as he ever was in his juvenil [*sic*] days."[36]

"Mr Audubon is quite an aged man," echoed the *Missouri Republican,* "but his active and hardy life has given a vigor and strength to his constitution which renders him far more active than the generality of men of his years."[37] But at fifty-eight (his birthday was the day after the trip began), Audubon was not quite as vigorous as he pretended to be, nor was he as independent as he wished the world to believe.

When writing the text for his *Ornithological Biography* from the urban isolation and comfort of his London town house several years before, Audubon had ridiculed what he called "galloping parties" that had preceded him into the West. These were commercial or military expeditions in which scientists had been included, but which Audubon believed were unable or unwilling to provide adequate time for collecting or observing wildlife. "For my part," he wrote, "nothing in the world could ever induce me to join a caravan of fur traders moving with all possible expedition from St. Louis— near the mouth of the Missouri bound for the Rocky Mountains at the rate of a fast traveling vessel. . . . No, Reader, give me youth and strength enough to ramble on foot over the Rocky Mountains, and thus be enabled to tarry when I choose, to diverge from the tract far and wide and to watch for weeks if necessary the habits of a single bird!"[38]

Isaac Sprague
View of Fort Union on Upper Missouri
1843. Watercolor on paper. Collection of The New-York Historical Society

Sprague recorded the appearance of Fort Union, the fur-trading post where Audubon's party stayed during the summer of 1843.

And yet, when Audubon finally made his trip west, he traveled under exactly the conditions he had decried. Accepting the invitation of Pierre Chouteau, head of the American Fur Company, one of America's great fur-trading dynasties, Audubon joined a fur-trading party of one hundred men traveling up the Missouri River from St. Louis to the mouth of the Yellowstone. So great was the speed of the traders' "fast traveling vessel," the *Omega,* that it arrived at Fort Union (a U.S. Army base and trading center built at the junction of the two rivers) on June 12, in the record time of forty-eight days. "[We] arrived here earlier in the season by one day than has ever before been done," wrote Harris in his diary, "and made a quicker passage than any other boat by about 15 days."[39]

On his way up the river, Audubon and his companions observed and collected examples of wildlife. Their time and route of travel may well have biased their observations in favor of birds, because they were following a major migratory route (known today as North America's "central flyway") during the peak of the spring migration. A typical entry in Audubon's journal records that in the few hours they were ashore on May 4,

Bell shot a Gray Squirrel which I believe to be the same as our *Sciurus carolinensis*. Friend Harris shot one or two birds which we have not yet fully established, and Bell shot one Lincoln's Finch—strange place for it, when it breeds so very far north as Labrador. Caught a woodpecker, and killed a Catbird, Water-thrush, seventeen Parakeets, a Yellow Chat, a new Finch, and very curious, two White-throated Finches, one White-crown, a Yellow-rump Warbler, a Gray Squirrel, a Loon, and two Rough-winged Swallows. We saw Cerulean Warblers, Hooded Flycatchers, Kentucky Warblers, Nashville ditto, Blue-winged ditto, Red-eyed and White-eyed Flycatchers, Great-crested and Common Pewees, Redstarts, Towhee Buntings, Ferruginous Thrushes, Wood Thrush, Golden-crowned Thrush, Blue-gray Flycatcher, Blue-eyed Warbler, Blue Yellow-back, Chestnutsided, Black and White Creepers, Nuthatch, Kingbirds, Red Tanagers, Cardinal Grosbeaks, common House Wren, Blue-winged Teals, Swans, large Blue Herons, Crows, Turkey-buzzards, and a Peregrine Falcon, Red-tailed Hawks, Red-headed, Red-bellied, and Golden-winged Woodpeckers, and Partridges. Also innumerable "Gopher" hills, one Ground-hog, one Rabbit, two Wild Turkeys, one Whippoorwill, one Maryland Yellow-throat, and Swifts.[40]

Such sightings notwithstanding, the speed of the *Omega's* river journey precluded the sort of open-ended observations of wildlife that Audubon had grown accustomed to when traveling on his own. Only in St. Louis before his departure and when he reached Fort Union was he free to indulge in the detailed studies of mammal behavior that Bachman had requested. His accounts of the pocket gophers and fox squirrels he observed in St. Louis and of the prairie dogs, bison, and several other animals he encountered near Fort Union are among the most comprehensive and engaging of the species accounts that appear in the text of the *Quadrupeds*.[41] Curiously, his thrilling diary description of one of several buffalo hunts near Fort Union appears to have been drawn from Harris's diary rather than his own experience.[42] Citing old age, fatigue, and stiffness from riding, Audubon preferred to remain an observer of such rigorous activities. Despite his lifelong love of blood sports, Audubon seems finally to have felt some revulsion at hunting animals for fun. In his Missouri River diary, as in his Labrador journals, he occasionally expressed his regret over killing birds and mammals "uselessly."[43] He was particularly—if inconsistently—distressed by the wanton slaughter of bison:

It happened, by hook or by crook, that these two [hunters] managed to kill four Buffaloes; but one of them was drowned, as it took to the river after being shot. Only a few pieces from a young bull, and its tongue, were brought on board [the

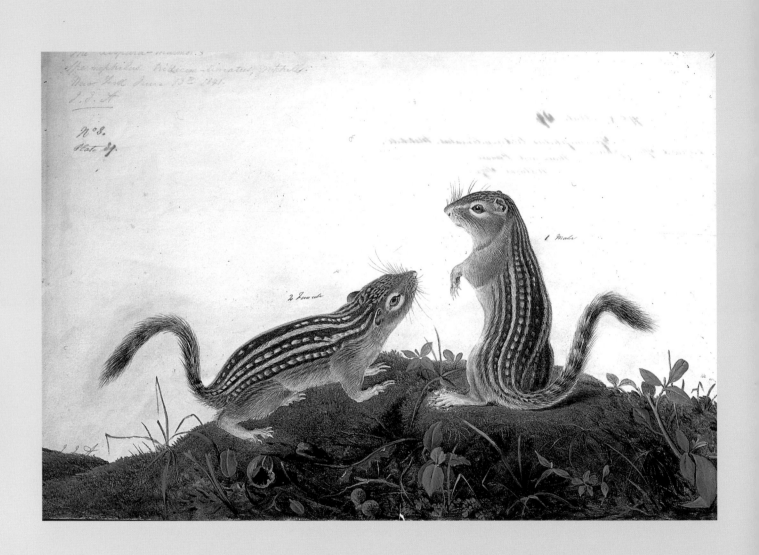

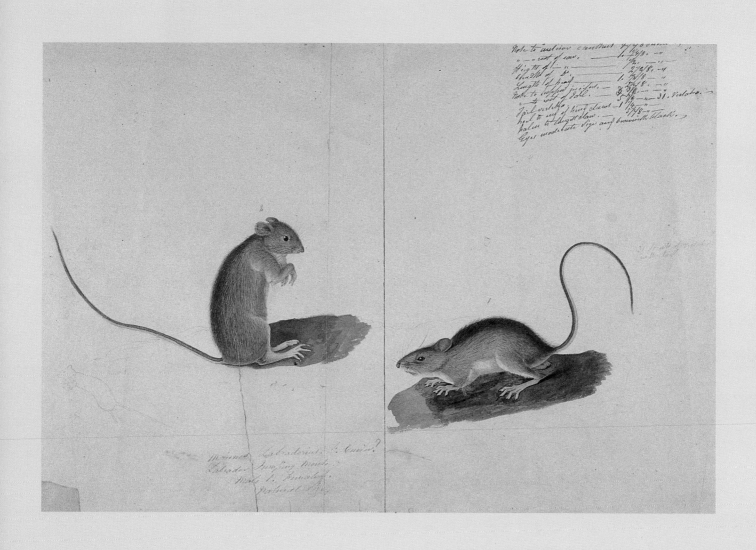

Omega], most of the men being too lazy, or too far off, to cut out even the tongues of the others; and thus it is that thousands multiplied by thousands of Buffaloes are murdered in senseless play, and their enormous carcasses are suffered to be the prey of the Wolf, the Raven, and the Buzzard.[44]

When writing the long descriptive entry for the *Bison* in the *Quadrupeds,* Bachman reflected Audubon's concern for the species' survival by calling it "a link (perhaps sooner to be forever lost than is generally supposed), which to a slight degree yet connects us with larger American animals belonging to extinct creations."[45]

Audubon spent June and July 1843 in what he called "the very midst of the game country,"[46] collecting what specimens and scientific information he could with the help of Bell, Harris, Sprague, Squires, and several commercial hunters he employed at Fort Union. He and his party began their return trip down the Missouri on August 16, arriving back in St. Louis sixty-four days later.

Soon after his return to New York in November 1843, Audubon wrote Bachman to report the results of the expedition. With characteristic bravura, he proclaimed his trip a success. "I have the best accounts of the habits of the Buffalo, Beaver, Antelope, Big Horns &c. that were ever written," he boasted, "and a great deal of information of diverse nature."[47] He had made similar claims about his earlier trips to Labrador, the Gulf Coast, and everywhere else he had been.[48] He had, in fact, decreed his western trip a success even before leaving St. Louis. "When I see you again," he wrote his family, "I will tell you many a strange fact differing *in toto* from what has been printed in great books."[49] His ambitious promises and the triumphant tone of his letter to Bachman notwithstanding, Audubon could not conceal that the Missouri River trip had failed to live up to their expectations. While he

Plate LXXIII

On Stone by Wᵐ E. Hitchcock

Drawn from Nature by J. W. Audubon.

Lith. Print'd & Col'ᵈ by J.T. Bowen, Phil

Rocky Mountain Sheep.

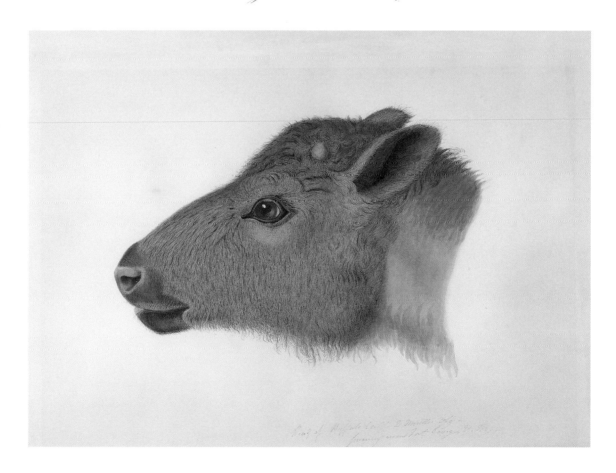

exaggerated his legitimate ornithological successes ("I have no less than 14 New Species of birds, perhaps a few more"), he acknowledged that his mammal discoveries had been surprisingly few. "The variety of quadrupeds is small in the country we visited," he explained defensively.[50] But there are other possible explanations for the disappointing return on his considerable investment of time and money.

Despite the energetic impression he had made on the newspaper reporters in St. Louis, at age fifty-eight Audubon was no longer the indefatigable physical specimen he had been when researching his books on North American birds. Years of celebrity and comfortable living in Europe and the United States had curbed his appetite for rigorous travel. Although he liked to stress the difficulties of the expedition when describing it to others, it was, in fact, quite easy by comparison to those that had gone before. "We [were] never out of sight of the Coffee Pot, feather beds or white faces," he acknowledged to Bachman when recounting his trip.[51]

Unfortunately, his reluctance to push beyond the comfort and relative safety of Fort Union meant that he and his party were seeking new species in a part of the West that had been thoroughly explored and regularly hunted for more than two decades. "The ground within walking distance of the Fort is pretty well used up for new or rare birds or quadrupeds," observed Harris, "and the walking distance is very much circumscribed by the excessive heat of the weather."[52] Even though Audubon desperately wished that the area he visited had never "been trodden by White man previously" and tried to convince others of its virginal state, his frequent references to George Catlin's books and his familiarity with other travel literature of the period makes it clear that he never really believed this to be the case.[53]

When Bachman saw the results of Audubon's efforts, he was dismayed at the paucity of new discoveries. "You did not go far enough [into the wild]," Bachman chided after reading Audubon's notes of the journey. "There are in your journal some Buffalo hunts that were first rate—But after all, your expenses were greater than the knowledge was worth."[54] Audubon replied defensively to Bachman's criticism, but no amount of rhetorical self-promotion could successfully refute the charge or provide the specimens and scientific information that the expedition had failed to collect.

On one level, when judged against his previous achievements, ambitious goals, and inflated claims of success, Audubon's Missouri River expedition was a disappointing failure. Several new birds were discovered (Bell's vireo, Sprague's pipit, and Harris' sparrow still bear the names of Audubon's companions, while Nuttall's whip-poor-will, LeConte's bunting, and Baird's sparrow commemorate his friendship with three other naturalists who helped with the *Quadrupeds* by providing specimens), but of the eighty-five mammal skins Bell prepared at Fort Union and elsewhere during the expedition (twenty-seven species in all), none proved new to science.[55] In Bachman's view there had been too much sport hunting and not enough hard-nosed research. "I am afraid the broad shadows of the Elk, Buffalo, and

Le Contis Sharp-tailed Bunting.

Male.

Drawn from Nature by J.J.Audubon,FRSFLS.　　　　　　Lith.Printed & Col.by J.T.Bowen,Philad.

Smith's Lark Bunting?

Drawn from Nature by J.J.Audubon,F.R.S.F.L.S *Adult Male.* Lith.ᵈPrinted & Colᵈby J.T.Bowen,Philadᵃ

Western Shore Lark.

Drawn from Nature by J.J.Audubon,F.R.S.F.L.S *Male.* Lith.ᵈPrinted & Colᵈby J.T.Bowen,Philadᵃ

OPPOSITE, TOP:

John James Audubon
J. T. Bowen,
lithographer
Smith's Lark
Bunting
After 1843.
Hand-colored
lithograph,
5 ⅝ x 7 ¼ ".
Buffalo Bill
Historical Center,
Cody, Wyoming.
Gift of Dean
and Mary Swift
and Mary Williams
Fine Arts of
Boulder, Colorado

Added to the Birds
after the Missouri
River trip.

OPPOSITE,
BOTTOM:

John James Audubon
J. T. Bowen,
lithographer
Western Shore Lark
After 1843.
Hand-colored
lithograph,
5 ⅝ x 7 ¼ ".
Buffalo Bill
Historical Center,
Cody, Wyoming.
Gift of Dean
and Mary Swift
and Mary Williams
Fine Arts of Boulder,
Colorado

Added to the Birds
after the Missouri
River trip.

Nuttall's Whip-poor-will

Sprague's Missouri Lark

John James Audubon
J. T. Bowen,
lithographer
Nuttall's
Whip-poor-will
After 1843.
Hand-colored
lithograph, 5 ¾ x 7".
Buffalo Bill
Historical Center,
Cody, Wyoming.
Gift of Dean and Mary
Swift and Mary
Williams Fine Arts of
Boulder, Colorado

Added to the Birds
after the Missouri
River trip.

John James Audubon
J. T. Bowen,
lithographer
Sprague's
Missouri Lark
1844. Hand-colored
lithograph,
6 ¾ x 10 ⅜ ".
Buffalo Bill
Historical Center,
Cody, Wyoming.
Gift of Mr. & Mrs.
Dean W. Swift

big-horn [sheep] hid all the little marmots, squirrels, jumping mice, rats and shrews," he lamented.[56]

Judged by a different standard, however, the expedition was a reasonable success. No matter how disappointing, the trip had fulfilled Audubon's dream of traveling west of the Mississippi. It enabled him to add first-person anecdotes to the text and thus claim authority over most of the subjects depicted and described in the first two volumes of the *Quadrupeds*.

During the years of obtaining subscriptions for *The Birds of America* (both elephant folio and octavo editions), Audubon had learned that his colorful personality and tales of adventure were his most effective marketing tools to a public enamored of such fictional and real-life heroes as Natty Bumppo, Daniel Boone, and Davy Crockett.[57] By traveling to the western frontier at a time when such trips were still unusual, Audubon was able to

Audubon and
Bachman:
A Collaboration
in Science

renew his credentials as an explorer-naturalist. A series of entertaining letters from the field, strategically placed by friends and family in local newspapers looking for interesting news, enabled Audubon to keep himself in the public eye and promote his newest publishing venture at the same time.[58] "I hope that on the receipt of each of my letters, Victor sends some extracts to several of the News Paper Editors," he wrote to his family from Fort Pierre. "It cannot do any harm and may be a chance to do some good."[59]

That his trip to Fort Union did relatively little to advance the cause of science was almost irrelevant to Audubon. By this time in his career he was more concerned with the financial viability of his publications than with winning the acceptance of the ever-critical academics. Having been elected a member of the Royal Society, Great Britain's most prestigious scientific institution, in 1830, Audubon had already realized as much academic success abroad as he could ever hope to attain. Similar acceptance in his adopted country had proved more difficult.

As early as 1824, when Audubon first encountered America's nascent scientific community in Philadelphia, the self-trained naturalist had found himself outside the rapidly closing circle of academic science within the United States. The broadbrush, anecdotal approach to natural history that had been practiced through most of the preceding century was being supplanted by the specialization of a new generation of scientists more interested in comparative anatomy and systematic taxonomy than in tales of derring-do on the frontier. As the schism between "field" naturalists and "closet" naturalists widened in the nineteenth century, Audubon found himself increasingly isolated from the new mainstream of professional science, even as he was making the once esoteric discipline of ornithology accessible (and even popular) to the public at large.

In an uncharacteristic moment of modesty, Audubon admitted to the respected French naturalist Charles-Lucien Bonaparte, "I am not a Learned Naturalist—I am only . . . a *practical* one. . . . I am no Scholar of any kind."[60] It was an opinion shared—and occasionally expressed—by many of his scientific contemporaries on both sides of the Atlantic. While acknowledging Audubon's enormous public reputation, such influential naturalists as John Cassin, William Cooper, Frédéric Cuvier, William Jardine, and William Swainson each made similar comments about the popular author of *The Birds of America*.

"Mr. Audubon is confessedly only a field naturalist, not a scientific one," wrote Swainson in his *Bibliography of Zoology with Biographical Sketches* (1840), making the important distinction between those inside and outside the newly institutionalized profession of ornithology. "He can shoot a bird, preserve it, and make it live again, as it were, upon canvass; but he cannot describe it in scientific, and therefore in perfectly intelligible terms."[61]

On receiving praise for his plan to explore the West, Audubon confessed, "I have no very particular desire to embark as deep in the Cause of Science as the great [Alexander von] Humboldt has done . . . simply because

Although the stated purpose of the expedition was to study and collect mammals for the Quadrupeds, *Audubon's continuing interest in birds is evidenced by the number he collected and described in his journal. Several of the species shown here were described for the first time by Audubon. These include the Western Meadowlark (dubbed "neglecta" by Audubon because it had been overlooked by previous visitors to the area), Sprague's Pipit, and Bell's Vireo. The red tag on the last of these indicates that it is a "type" specimen, the very one on which Audubon based the first scientific description of the species.*

I am both too poor . . . and too incompetent."[62] Time and again, when feeling challenged by the scientific establishment for his lack of technical knowledge, Audubon countered by pointing to his unmatched observations of wildlife behavior and criticizing the theoretical naturalists who worked only from specimens and secondhand information.

Ironically, in producing *The Viviparous Quadrupeds of North America,* it was Audubon and his collaborators who were frequently forced to rely on the work of others. Many of the illustrations and much of the accompanying text for the *Quadrupeds* were based not on firsthand observations in the wild but on zoo animals and preserved specimens borrowed from museums in Europe and the United States. In the end, it was this lack of primary source material that made the *Quadrupeds* less compelling than *The Birds of America.*

Early in the process of preparing the *Quadrupeds,* Bachman had recognized the challenges that mammal observation might hold for Audubon. "These creatures, the majority of them nocturnal and living in concealment [are] not so easily obtained as birds,"[63] he warned Audubon at the end of 1839. "I am not sure but you might more conveniently make a drawing of the Buffaloe in England than here," he had written in July, adding,

It will do no harm to take a figure or two of such Indian Dogs obtained far N[orth] & West as you may see in the Zool.[ological] Gard.[en] & we will talk the matter over afterwards. The porcupine and wolverine too may be figured in England & if you can find a real skin from America of the sable, do [not] let it pass—also the Fisher/Pennant's martin/the German martin & the rascally grizzly bear. . . . There are some Hares & squirrels in the British & zool.[ogical] Museums, particularly the latter, that you ought to figure—ask Waterhouse. . . . There is in the Zool.[ological] Gard.[en] a Canada marmot that you ought to figure & the moose at Earl Derby's &, if I mistake not, also at the Zool.[ogical] Gard.[en] that you ought to figure & measure. The prong-horned antelope, mountain sheep (of which it is conjectured there may be 2 species), musk ox, a white bear & several of Richardson's Deer are not to be obtained here.[64]

Audubon accepted Bachman's advice and acted on it, creating a good number of North American mammal studies before ever leaving England. At the same time, he launched an aggressive letter-writing campaign to obtain information and specimens that he knew would be essential for the success of the book. He employed his considerable charm and influence to obtain specimens from other naturalists and explorers, pleading, cajoling, or badgering anyone he could in order to get hold of the specimens he was otherwise unable to secure. "Anything and everything is wanted," he wrote one friend.[65] "I should like . . . to have 2 specimens of the same animal," he wrote another, "one saved in rum, the other in the skins, after the measurements and the colour of the eyes are noted as well as the date, part of the country, etc., etc. . . . Send me *extra heads* of everything you can in rum, even that of a moose, and elk, and rein-deer."[66]

OPPOSITE, ABOVE:
Northern Flying Squirrel (Glaucomys sabrinus, *labeled* **Scinropterus volucella var. Hudsonius)** *The Academy of Natural Sciences of Philadelphia, Department of Mammalogy*

This is one of several specimens collected for the Academy of Natural Sciences by John Kirk Townsend, then sold to Audubon by the Academy. Audubon evidently returned it to the institution after gleaning what information he needed for his plate. The skin was subsequently turned into an exhibition specimen for the Academy's museum.

As with his earlier books, he tried to convince reluctant collaborators that whatever they might do to help him was "for the sake of the advancement of Science in our country!"[67] For overseas sources, he appealed to the higher goal of science without borders. Friend or enemy, ally or rival, everyone whose collections were thought to be useful was contacted by Audubon, Bachman, or one of their surrogates. Before the project was over, specimens were obtained from dozens of different contributors, including a lifelong adversary of Audubon, the English naturalist-explorer Charles Waterton.[68] Twenty-seven suppliers of specimens were mentioned by name in the book's acknowledgments, and many others were cited as sources of information in the text.

RIGHT, BELOW:
Chipmunk,
labeled **Tamias
quadrivittatus Say**
*Collected in the
Rocky Mountains by
John Kirk Townsend.
The Academy of
Natural Sciences
of Philadelphia,
Department of
Mammalogy
(collection no. 247)*

*Although Audubon
was unable to
procure from the
Academy of Natural
Sciences all of the
western specimens
collected by John
Kirk Townsend, he
based many of his
illustrations on
them. Although this
chipmunk shows
signs of wear today,
it was considered so
unusual and interesting at the time of
its collection in the
nineteenth century
that it was mounted
for display in the
academy's museum.*

OVERLEAF, LEFT:
*John Woodhouse
Audubon*
**Caribou or
American
Rein Deer**
*1847. Oil
on canvas,
21⅝ x 21¹⁵⁄₁₆".
Courtesy,
Department of
Library Sciences,
American Museum
of Natural History,
New York*

For plate 126.

OVERLEAF,
RIGHT:
*John Woodhouse
Audubon*
*J. T. Bowen,
lithographer*
**Prong-Horned
Antelope,**
*plate 77
1845.
Hand-colored
lithograph,
22 x 28".
Courtesy,
Department of
Library Sciences,
American Museum
of Natural History,
New York*

*In the distance are
the Three Buttes, or
Three Mamelles,
which John James
Audubon sketched
in a journal during
one of the buffalo
hunts from
Fort Union.*

One of the most important sources of new western species during the period in which the book was being produced was the United States Exploring Expedition (1838–42), which, under the command of Lieutenant Charles Wilkes, had charted (and made scientific collections in) the Columbia River valley and Oregon Territory, then traveled on to San Francisco Bay as part of its five-year exploratory journey around the world.

*Audubon and
Bachman:
A Collaboration
in Science*

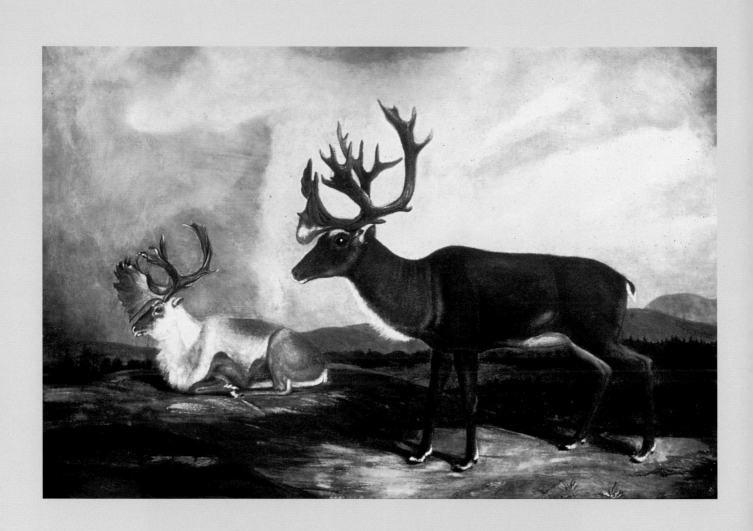

PLATE LXXVII.

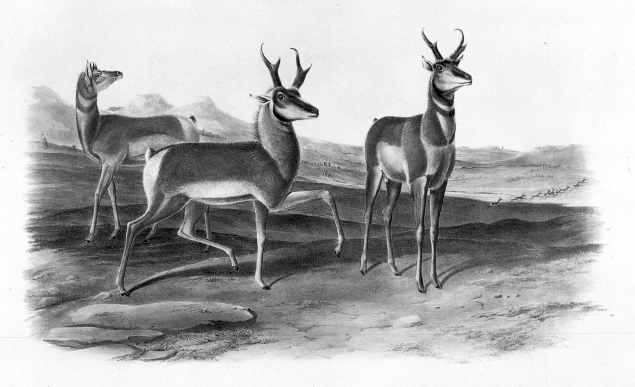

Drawn from Nature by J.J.Audubon F.R.S.F.L.S.

Lith. Printed & Col.d by J.T.Bowen, Phila.d 1847

ANTILOPE AMERICANA, ORD.

PRONG-HORNED ANTELOPE.

MALES & FEMALE.

Audubon did everything he could to gain access to the scientific collections of the federally funded expedition. Over a five-year period, he approached the expedition's temperamental commander,[69] several of the scientists who participated in the expedition,[70] and even the secretary of state, Daniel Webster,[71] with requests to examine specimens. In the end, it was Bachman who got to see the desired material when he visited one of the expedition's principal scientists, the man initially charged with writing up its zoological results: Audubon's onetime scientific and artistic rival Titian Ramsay Peale.[72]

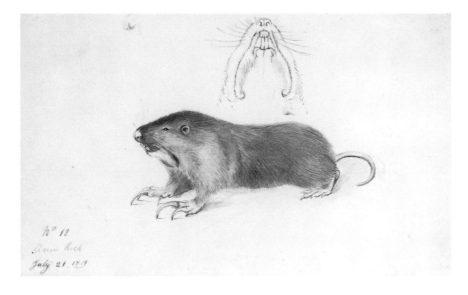

"At Washington we worked like a horse with Peale among the Quadrupeds," Bachman wrote Audubon. "Poor fellow, he is too timid to do anything. He seems indeed to be ignorant of every thing connected with our present branch [Mammalogy]. They had undoubtedly a number of new species—which they all lost by accident."[73]

Peale's ignorance, possibly exaggerated by Bachman to confirm Audubon's low opinion of his former competitor, was not unusual.[74] The more Audubon and Bachman probed, the more they discovered deficiencies or voids in the knowledge of American mammalogy among their contemporaries. They found the ornithologist Thomas M. Brewer friendly, encouraging, and helpful, but uninformed in matters mammalogical.[75] Bachman knew William Cooper to be knowledgeable but considered him "cold, cautious and lazy."[76] To his great disappointment, even the great Swiss naturalist Louis Agassiz of Harvard, whose opinion on scientific subjects Bachman valued "more than [any] in America,"[77] was of no help in mammalogy: "He knows scarcely one of our animals & not those of his own country—he knows nothing of Quadrupeds."[78]

The naturalists who were supposed to know America's mammals were, in Bachman's opinion, more often than not in error. He derided Richard Harlan of Philadelphia as a "blunderer"[79] and dismissed his zoological monograph, *Fauna Americana* (1825), one of the few books then available on North American mammals, as "poor trash" filled with serious errors of

nomenclature.[80] Though he gave lip service to the value of Harlan's publication in the introduction to the *Quadrupeds,* in private he conceded that it was almost worthless: "All of Harlan's names but one, perhaps, will have to go by the board," Bachman wrote Audubon in 1839.[81]

With no network of living experts to call upon, Bachman and the Audubon family crafted their magnum opus from the spotty information that was available to them. For the illustrations, Victor Audubon provided generic backgrounds (some possibly based on Isaac Sprague's sketches from the West or on commercially available illustrations of the day), while the senior Audubon painted mammals from study skins and a few live specimens, including, after the fall of 1843, a badger and a swift fox that he had brought back alive from his trip to the West. "My swift fox is now quite beautiful, and so is my badger," he wrote Bachman a month after his return to New York. "I will have at them after a while."[82]

Though Audubon clearly had less detailed familiarity with the anatomy of mammals than with that of birds, the paintings he made from live specimens are far and away the best in the *Quadrupeds.* Those based on animals he knew personally—like the swift fox—compare favorably with the best of his ornithological plates. The ones based on dried study skins or painted late in his life fall far short of the high standards he had set in *The Birds of America.*

Audubon had already made a significant start on the *Quadrupeds* before he embarked on his western journey. "I have drawn 61 Species comprising 115 figures," he wrote Harris in December 1841. "I have now on hand Specimens enough to enable me God willing to have drawings of 100 Species by the 1st of May next."[83] This was the time in which he produced some of his finest mammal paintings. But Audubon was already growing impatient to complete the work, trying to achieve in two years with mammals what had taken him the better part of a lifetime to accomplish with birds. "As to myself," he wrote Bachman in August 1841, "I am as anxious now to finish the quadrupeds as I ever was to finish the Birds."[84] Sadly, his own physical and mental ability, so confidently celebrated in his letter of 1840, would deteriorate beyond recovery before the book was complete. In the years following the western expedition, his pace slowed and the quality of his paintings gradually declined.[85] When Bachman wrote Audubon in 1846 to suggest that he redraw a LeConte's mouse, Victor Audubon replied with a sad admission of his father's diminishing powers: "My father will not perhaps do better than the last [painting] although he has now gotten better brushes."[86] The man whose work Bachman once considered "the very best in the world" had begun to drift into another world.[87] Loyally concealing their father's decline to anyone outside the immediate family, John and Victor were already well on their way to assuming full responsibility for the visual and marketing side of the enterprise.

Even before his father went west, Victor Audubon had been charged with creating the backgrounds for many of the *Quadrupeds* paintings. He

Plate XLVII

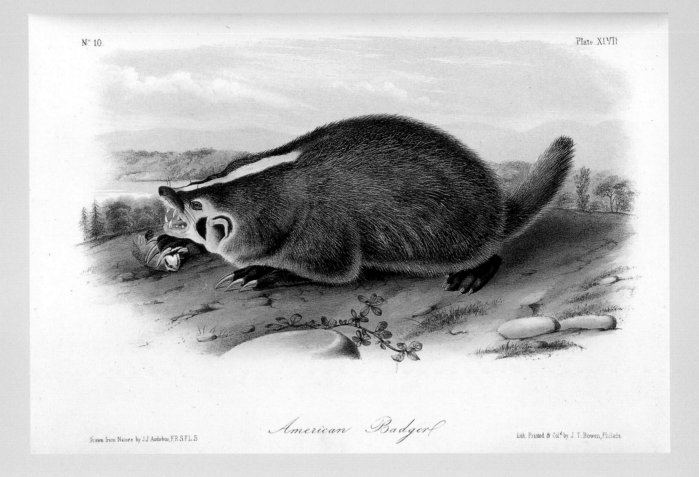

Drawn from Nature by J.J.Audubon,F.R.S.F.L.S

American Badger.

Lith. Printed & Col.ᵈ by J. T. Bowen, Philada

 Plate LXXX

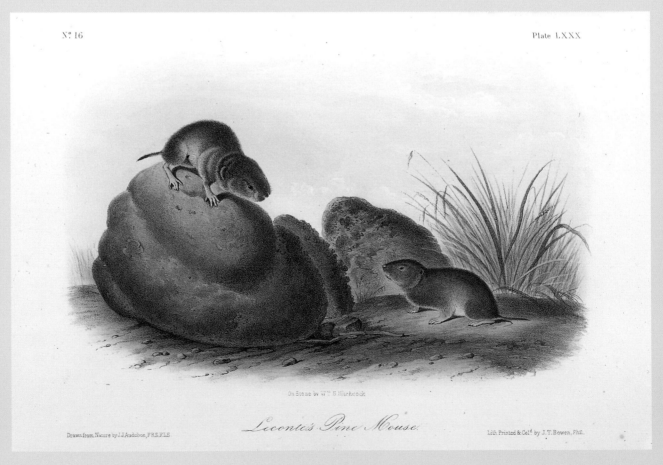

On Stone by Wᵐ E Hitchcock

Drawn from Nature by J.J.Audubon,F.R.S.F.L.S

Leconte's Pine Mouse.

Lith. Printed & Col.ᵈ by J. T. Bowen, Phil.

Plate LII

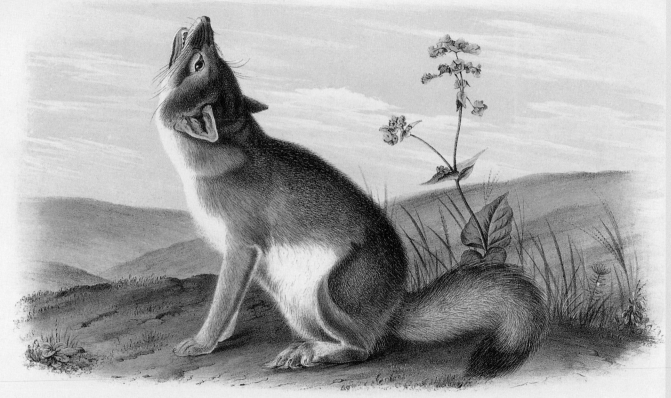

Drawn on Stone by Wm E. Hitchcock.

Swift Fox.

Drawn from Nature by J.J. Audubon, F.R.S. F.L.S.

Lith. Printed & Col'd by J.T. Bowen, Philada.

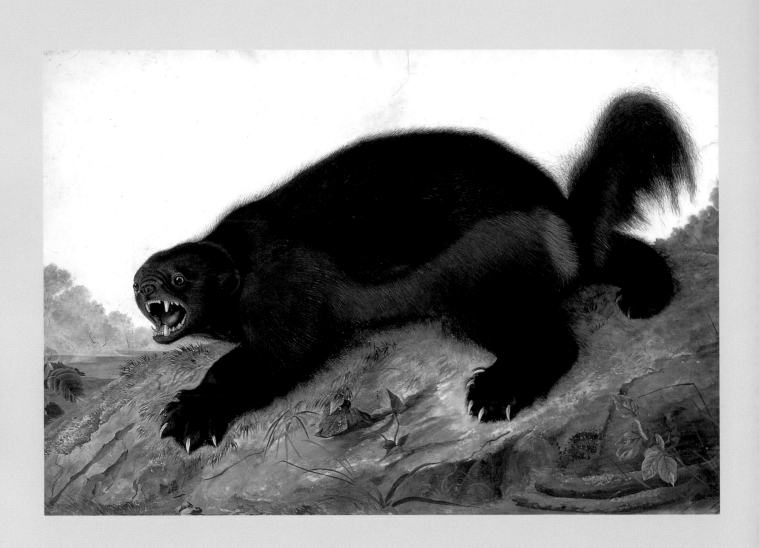

appears also to have been the person most consistently responsible for over-seeing the lithographers and coordinating the financial logistics of the publication. "I trust that Victor will be able to manage the cash business," Audubon wrote from Fort Pierre on the Missouri River, "and have a famous set of backgrounds most highly finished when I return."[88] In 1846 he wrote Bachman, "We have now on hand about 15 plates ready for Victor to put backgrounds to."[89] As the person most responsible for the physical production of the *Quadrupeds*, it was Victor's name that appeared as publisher in volumes 2 and 3 of the text (1851 and 1854).

Victor's younger brother, John Woodhouse Audubon, began his involvement with the *Quadrupeds* by serving as an assistant artist and secretary to his father as early as 1839. He collected specimens in Texas (1845–46), then traveled to England on behalf of the project to gather information and make drawings (from museum and zoo specimens) of species of North American mammals that his father had been unable to obtain in the United States. He took over his father's role as principal painter of mammals sometime in 1846, thus fulfilling by default a lifelong ambition to "become a second Audubon." "My wish," he told his brother in 1833, when he was just twenty-one, "is that I may some day publish some birds or quadrupeds and that my name may stand as does my father's."[90] At least 72 of the 150 paintings for the large imperial folio series and five additional plates in the octavo edition of the *Quadrupeds* are by John Woodhouse Audubon.

His best paintings, the *American Black or Silver Fox, Ocelot, Ring-Tailed Cat*, and *House Mouse* (or *Common Mouse*), show flashes of his father's genius. By contrast, his *Cougar*, whose ineptly foreshortened right front paw is as large as its head, and the *Texas Jackrabbit* (or *Texian Hare*), whose front and rear legs are oddly out of scale with one another, reveal his unfamiliarity with mammalian anatomy. Others, like the *Black Fox Squirrel* or *Douglass' Ground Squirrel*, show the difficulties of working from stuffed specimens. These appear stiff and lifeless when compared to his father's more successful depictions of related species. Nevertheless, had it not been for John Woodhouse Audubon's willingness to step into the project when his father's health failed, the plates for the *Quadrupeds* might have ended partway through the second volume.

Even though Bachman made conspicuous use of John W. Audubon's travel diaries and conscientious research abroad, the role of naturalist was one the younger Audubon never felt comfortable assuming. "Until I went to Texas, I never thought I should have to become in any degree [a] naturalist as well as an artist," he admitted to Bachman in 1848. "You suppose me to have far more knowledge of the smaller animals than I can boast of myself."[91]

While the Audubon family—father and sons—were seeking to paint every North American mammal they could lay their hands on, Bachman was ransacking the scientific literature for any and all information on mammalian anatomy and taxonomic classification. "Charleston is a poor place for

OPPOSITE:
John James Audubon
Victor Gifford
Audubon
Wolverine
1841. Watercolor
and oil on paper,
35 ¼ x 25".
Courtesy, Department
of Library Sciences,
American Museum
of Natural History,
New York

Done for plate 26
of the Quadrupeds,
the painting of the
wolverine, or glutton,
combined the
animal's depiction
by the elder Audubon
with a background
by his son Victor
Gifford Audubon.

OVERLEAF, LEFT:
Fox Squirrel (Sciurus niger, *labeled* **Sciurus vulpinus).** *Female, collected by John James Audubon in Florida. The Academy of Natural Sciences of Philadelphia, Department of Mammalogy (collection no. 257)*

This fox squirrel skin and two related skulls were collected by Audubon in Florida, perhaps to serve as models for plate 68 in The Quadrupeds of North America. *When his subscribers complained that there were too many squirrels in his book, Audubon patiently explained that he had little choice in depicting them as the family was particularly diverse in North America. The white in the eye sockets is cotton used to fill the study skin at the time it was preserved.*

OVERLEAF, RIGHT:
John Woodhouse Audubon
Long-Tailed Red Fox, or Jackal Fox
c. 1848–54.
Oil on canvas,
22 ⅛ x 27 ¼".
National Gallery of Art, Washington, D.C. Gift of E.J.L. Hallstrom

J. W. Audubon added this image to the octavo edition of the Quadrupeds *as plate 151.*

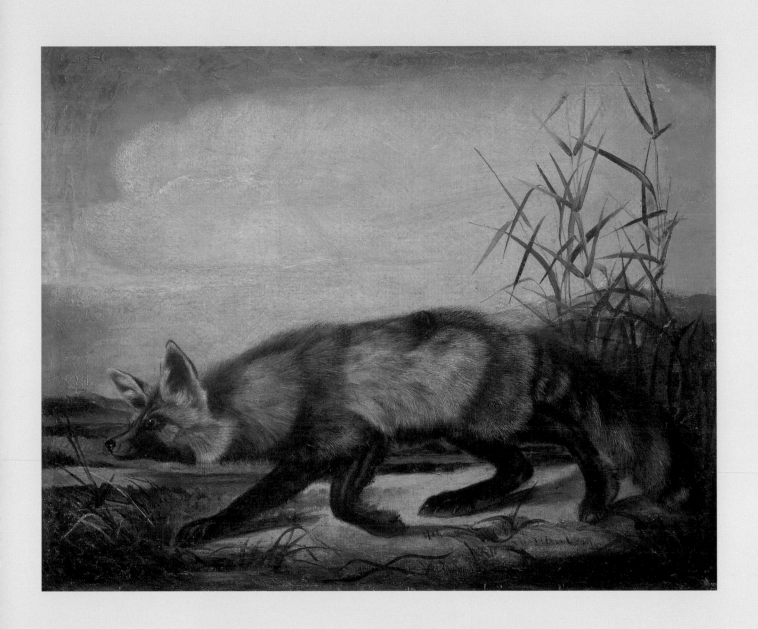

*John Woodhouse
Audubon
Drawn on stone by
William E. Hitchcock.
Lithographed,
printed, and colored
by J. T. Bowen.*
**American Black
or Silver Fox,**
*plate 116
Hand-colored
lithograph,
6 ¾ x 10 ⅛ ".
Buffalo Bill
Historical Center,
Cody, Wyoming.
Gift of Deborah B.
Chastain*

*John Woodhouse
Audubon
Drawn on stone by
William E. Hitchcock.
Lithographed,
printed, and colored
by J. T. Bowen.*
Common Mouse,
*plate 90
Hand-colored
lithograph,
6 ¾ x 10 ⅛ ".
Buffalo Bill
Historical Center,
Cody, Wyoming.
Gift of Deborah B.
Chastain*

*John Woodhouse
Audubon
Drawn on stone by
William E. Hitchcock.
Lithographed,
printed, and colored
by J. T. Bowen.*
The Cougar: Male,
*plate 96
Hand-colored lithograph,
6 ¾ x 10 ⅛ ".
Buffalo Bill Historical
Center, Cody, Wyoming.
Gift of Deborah B.
Chastain*

Texian Hare

John Woodhouse Audubon Drawn on stone by William E. Hitchcock. Lithographed, printed, and colored by J. T. Bowen. **Texian Hare,** *plate 133 Hand-colored lithograph, 6 ¾ x 10 ⅛".* *Buffalo Bill Historical Center, Cody, Wyoming. Gift of Deborah B. Chastain*

BELOW. John Woodhouse Audubon **Northern Meadow Mouse** *1842–45. Oil on canvas, 14 ¼ x 22". Joslyn Art Museum, Omaha, Nebraska. Gift of Michael Zinman*

For plate 129.

Audubon and Bachman: A Collaboration in Science

105

scientific books," he complained in a letter to Victor Audubon, "and I am often sadly put to for books that I am anxious to consult."[92] Nevertheless, before the project was through, he was able to secure most, if not all, of the existing zoological literature relating to mammalogy. His working library, bought, copied, or borrowed from friends far and wide, included books by Buffon, Catesby, Cuvier, D'Azara DeKay, Desmarest, Ehrenbach, Godman, Griffith, Harlan, Hernandez, Lewis and Clark, Lichtenstein, Linnaeus, Long, Pennant, Richardson, Say, Temminck, and a wide range of other authors, as well as most of the literature of exploration of the day.[93] "The task of procuring and reading all the zoological papers scattered through the pages of hundreds of periodicals, in many different languages, is beyond our power," Bachman wrote modestly in the introduction to the *Quadrupeds,* yet his careful referencing and listing of synonymous descriptions of each mam-

mal species in the book indicates that he was remarkably successful at tracking down the "numberless papers published in different cities of Europe and America" that contained relevant information.[94]

From the outset, Bachman was determined to make the *Quadrupeds* as comprehensive as time, knowledge, and resources would permit. He was therefore disappointed when Victor and John decided to omit entire families of animals from the final work. Although they had reported having "a good number of the bats drawn" as of February 1848,[95] by June of that year the Audubons' desire to finish the project was beginning to override their coauthor's desire for comprehensiveness: "We do not wish to make more than thirty or thirty-one numbers," wrote Victor, "and I think by putting more than one species on a plate we can easily finish the work in thirty-one no's. We do not include in this the seals or the bats and both John and myself think we had better omit them, for we have no opportunity of getting good figures of the seals, those John brought with him from London being drawn from very old specimens, and the bats being few of them done and we not knowing where to get the specimens. What do you say to this?"[96]

Bachman, who had originally proposed including whales, porpoises, and even "antediluvian animals" in the book,[97] lobbied hard to include at least the flying and marine mammals, but he was not successful.[98] The Audubons were convinced that even if the artistic shortcomings and incompleteness of their bat and seal paintings could be overcome, the additional time and expense required to include them would make little difference in the financial or critical success of the book. They were probably right. No reviewer of the *Quadrupeds* ever noted the absence of these major groups, perhaps believing that they had never been considered for a book whose title seemed to preclude them.[99]

With no organized system of professional peer review for scientific literature in place in the nineteenth century, published reactions to the *Quadrupeds* are unreliable as accurate reflections of its acceptance by the academic community. Bachman himself acknowledged salting the local press with favorable reviews of Audubon's earlier books and urged Audubon to do the same: "I wish you would get the different editors to notice your work. . . . This is a puffing world from the porpoise up to the steam-boat."[100] The press, for its part, was a more than willing participant in the promotion game. One reviewer brazenly asked Victor Audubon for a deferred payment schedule for his personal copies of *The Birds of America* (octavo edition) in exchange for his writing favorable reviews of the *Quadrupeds* in the *National Intelligencer* and the *Cincinnati Gazette*.[101] Another received a free copy of *The Birds of America*, then went on to editorialize enthusiastically about the *Quadrupeds* in a Boston newspaper.[102]

Despite the favorable press attention it received, *The Viviparous Quadrupeds of North America* (its unwieldy title was shortened to *The Quadrupeds of North America* when it was published in its octavo edition, 1851–54) was never as popular as *The Birds of America*. The public's natur-

OVERLEAF, LEFT:
John James Audubon
Hoary Bat
1841. Watercolor on paper, 7 ¹¹⁄₁₆ x 10 ³⁄₁₆".
Collection of The New-York Historical Society

OVERLEAF, RIGHT:
John James Audubon
Free-Tailed Bat
1841. Watercolor on paper, 19 x 11 ⅝".
Collection of The New-York Historical Society

Audubon made numerous studies of bats, but at the end they were not included in the publication.

Audubon and Bachman: A Collaboration in Science

107

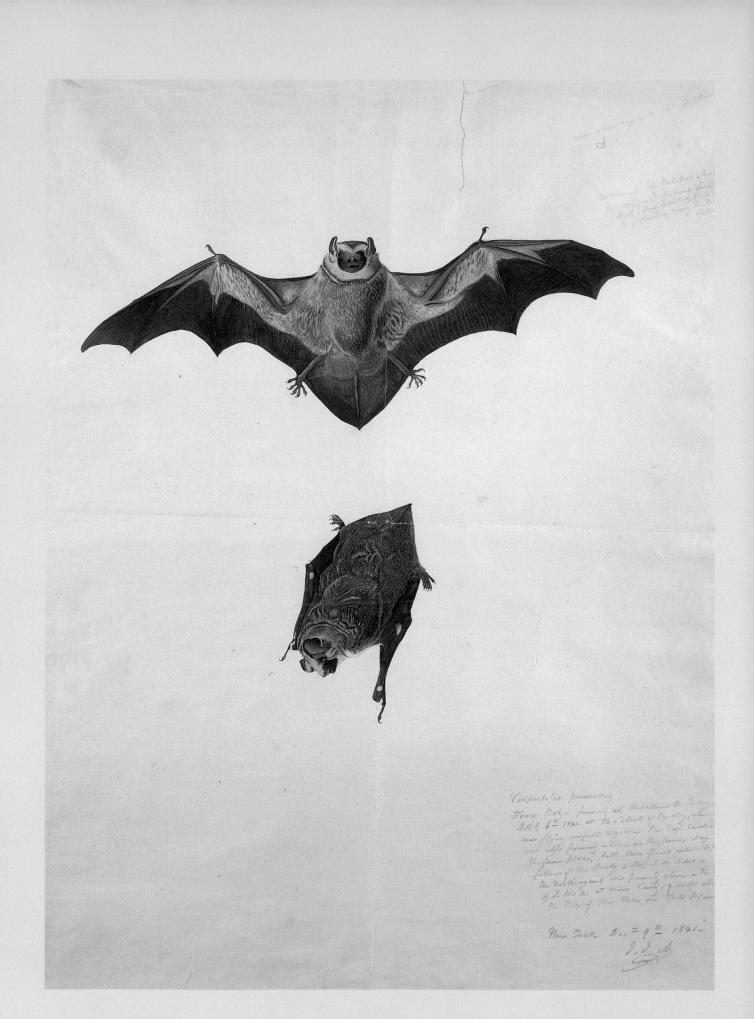

Vespertilio pruinosus
Hoary Bat — procuring at Hoboken N. Jersey
Dec. 6th 1841 at 1/2 o'clock of the day, when
was flying in full vigor — The Vesp. caroline
was also procuring alive on the same day
N. James Place, both three flying relation to
father of Mr Rocky & Nathaniel & dare —
The Noctivagans was procuring alive in the
E. J. W. R. at mino Land, 9 miles above
the City of New York on Fall Island

New York Dec. 9th 1841 —
J. J. A.

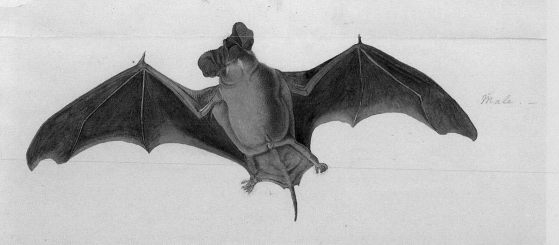

Male. —

head nearly profile —

al preference for birds over mammals may help to explain this disparity. "Birds are the type of aspiration," wrote a reviewer of the *Quadrupeds* in 1847. "They address the imagination. They appeal to what is exultingly and exaltingly in us. . . . Animals, or quadrupeds, on the other hand, are types of the sensuous life. They appeal to our material, lower and purely animal instincts. . . . The beast . . . in its highest moods is [a] crawler with its belly in the dust. . . . It is 'of the earth, earthy' and is associated with the viciousness, the baseness of filth and dirt."[103]

Although most reviewers proclaimed the illustrations in the *Quadrupeds* to be "magnificent"[104] or "truly superb,"[105] at least one, writing "in a severely critical spirit," noted that "there appears something more of a stiffness" in the illustrations in the *Quadrupeds* when compared to Audubon's *Birds of America.*[106]

Comparisons between the text of the two books were also inevitable: "In the letter press [of the *Quadrupeds*], for which Dr. Bachman is mainly responsible, we find a greater precision of style than characterizes the 'Biographies of Birds' [*Ornithological Biography*], though it has not the same spirit and vivacity."[107]

Bachman wrote the text for the *Quadrupeds* in first-person plural, "for the sake of convenience and uniformity,"[108] but surviving manuscripts and internal evidence make it possible to determine which author was responsible for which descriptions. In the first few years of production of the *Quadrupeds,* Audubon wrote long, evocative accounts of his firsthand experiences with mammals, much as he had done with birds for his *Ornithological Biography.*[109] Bachman incorporated as many of these as he could into the letterpress. As *The American Review* observed, his own writing tended toward either straight scientific description or its opposite, the kind of anthropomorphic moralizing that was common in the period but might have been more appropriate for his pulpit in Charleston than as a piece of scientific literature. Extolling the Creator's handiwork throughout the book, Bachman used accounts of individual species to comment on divergent human character traits, and vice versa. He described the black rat as "a thieving cosmopolite" with a "notoriously bad" character[110] and the mink as a "cunning [and] destructive rogue" with "mischievous propensities."[111] The more personal or anecdotal he made the book's text, the less seriously it was taken by the scientific establishment, while the more dry and "scientific" he made it, the less successful it was as a popular book. Bachman thus found himself in the difficult position of serving several masters. Trying whenever possible to follow his guiding principle, "nature—truth & no humbug,"[112] he worked exhaustively for more than fifteen years to balance these conflicting demands.

Audubon faced similar challenges in making the visual aspects of the *Quadrupeds* "not only scientifically correct, but interesting to all."[113] As with *The Birds of America,* in order to keep subscribers interested he made sure that at the beginning of every "number" (each package of five plates

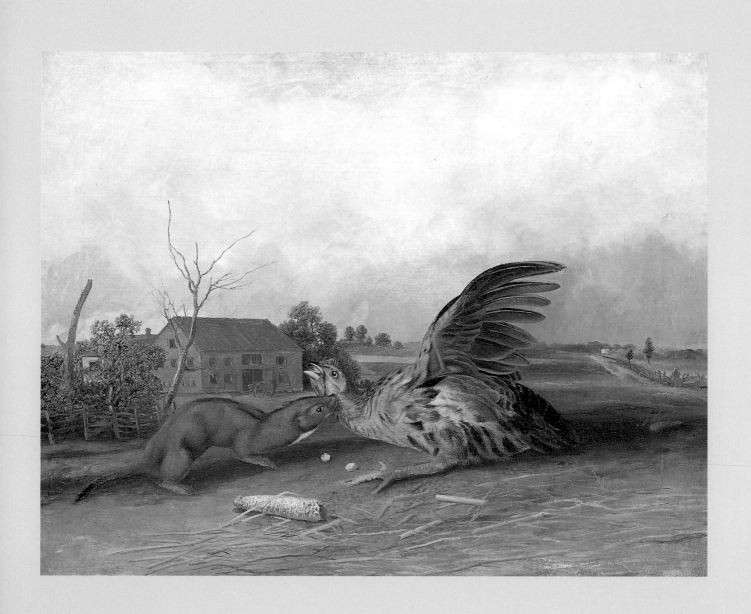

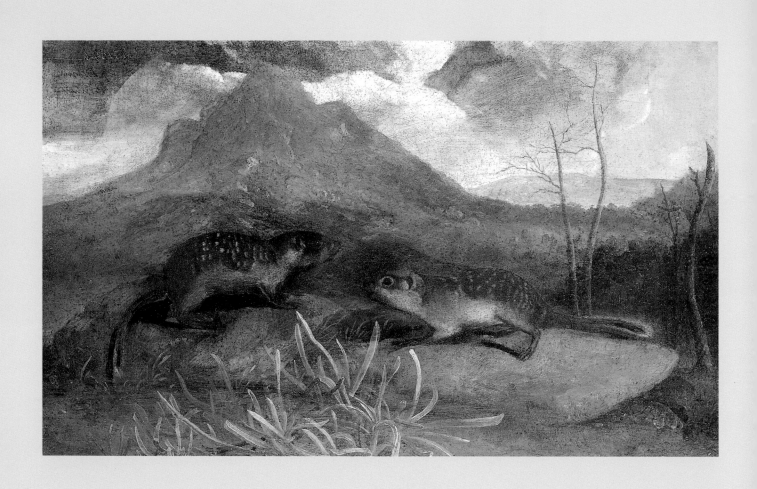

issued) there was an impressive, eye-catching figure of a charismatic species (bobcat, fox, snowshoe hare, fisher, otter, ocelot, polar bear, mountain lion, jaguar, and so on). Still, with so many small and seemingly repetitious mammals to include, he and his sons were often hard-pressed to keep subscribers happy. When one English patron complained of the seeming excess of rodents in the book, Audubon patiently explained the reality of biological diversity and distribution: "In talking of squirrels, you say, like some of our subscribers in this country, that there are rather too many, and yet what can be done? This is the Land of Squirrels and Woodpeckers and you must not be surprised to see a dozen more species of the former."[114] It was what made selling the *Quadrupeds* to the public such a challenge.

American reviewers often touted the book's nationalistic significance ahead of its scientific value. "We are proud to claim this noble work as a native in every sense," enthused the *Literary World* in 1847: "We are extremely grateful to perceive that all the labor has been accomplished at home, and that Mr. Audubon has not been compelled to seek foreign patronage, or to depend upon foreign artists for the engraving and typographical execution of his work. Its mechanical execution is such as would be eminently creditable to any country or period of civilization."[115]

The *American Review,* a Whig journal, also heralded the national origins of the *Quadrupeds.* "We have at last a Great National Work, originated and completed among us—the authors, artists, and artisans of which are our own citizens,"[116] crowed the journal's anonymous critic, who then added a religious dimension to his favorable opinion of the book: "We have no truer mission here than that of commentators upon the illustrators of God's first revelation to us—'the Bible of Nature!' and it would be very difficult to find a Family whose deeds and history more entirely illustrate their recognition of such an Apostleship. They may be called the Levites of a new order of priesthood in the Temple of Nature!"[117]

In folio form, *The Viviparous Quadrupeds of North America* was grand and impressive—with McKenney and Hall's *History of the Indian Tribes of North America* (1829–44), the most important colorplate book published in

Sciurus rubricaudatus. Aud & Bach.

Red-tailed Squirrel.

Male.
Natural Size.

N.Y.—
Jan'y 8 1841

America in the nineteenth century. In octavo (with text inserted and its awkward first name removed), it was a modest commercial success as a useful—and far more affordable—assemblage of information on the most common mammals of the continent. Samuel G. Morton, a longtime friend of Audubon and an influential member of the Academy of Natural Sciences, considered the *Quadrupeds* to be "one of the most delightful of its class,"[118] but few, if any, of his colleagues in the scientific community considered it the watershed contribution Audubon and Bachman had hoped it would be. The uneven quality of its plates and the spotty, incomplete nature of its contents (despite its authors' best efforts) made it something less than a definitive treatise.

Aside from its own shortcomings as a visual and literary successor to *The Birds of America,* the success of the *Quadrupeds* was compromised by several bits of bad timing. First, John James Audubon's declining mental and physical health, leading to his death in 1851 (three years before the book was finished), took from the project its greatest promotional asset: a name with wide recognition and unmatched public credibility in the field of American natural history. Second, and perhaps more important, a spate of new discoveries, made possible by the western railroad surveys that began shortly after Audubon's own western journey, made the *Quadrupeds* seem outdated and incomplete almost as soon as it was published.

Under the direction of Spencer Fullerton Baird, Audubon's onetime protégé and almost participant on the Missouri River expedition, the newly established Smithsonian Institution was giving support and structure to the sort of investigations and publications that the Audubon family (including John Bachman) had tried to accomplish on their own. In the preface to his *Mammals of North America* of 1859, Baird acknowledged that when *"The Viviparous Quadrupeds of North America* was prepared, the materials at [Audubon's and Bachman's] command were far less extensive than have been at mine."[119] A self-financed family enterprise led by a failing veteran of another age had been supplanted by the investigatory machine of a nation fueled by the excitement and energy of Manifest Destiny. Nevertheless, these subsequent publications, while often more complete than Audubon's in the numbers of species described and more comprehensive in the biological and behavioral details provided, never approached Audubon's in the aesthetic quality of their illustrations.

As American science continued to expand and professionalize in the decades following the Civil War, the first and last great American colorplate book on mammals quietly took its place beside (and often in the shadow of) Audubon's *The Birds of America* as one of the most remarkable technical and artistic achievements of its age. Although consulted more often by book collectors than by working scientists, *The Viviparous Quadrupeds of North America* would remain a lasting legacy of America's most beloved and influential naturalist.

OPPOSITE:
*John James
Audubon*
**Red-Tailed
Squirrel**
*1843. Watercolor
on paper,
27 ¾ x 21 ¾ ".
Collection of
The New-York
Historical Society*

For plate 55.

OVERLEAF:
*John Woodhouse
Audubon*
**Mountain
Brook Minks**
*c. 1848. Oil
on canvas,
21 ¾ x 26 ¾".
JKM Collection,
Courtesy of
National Museum
of Wildlife Art,
Jackson Hole,
Wyoming*

*The Mountain
Brook Mink did
not appear in the
imperial folio size.
It was one of six
octavo-sized prints
that were included
with the text volume
of* The Viviparous
Quadrupeds of
North America.
*It was inserted as
plate 124 in the
octavo edition to
replace the Mexican
Marmot Squirrel,
which was combined
with two young in
plate 109.*

*Audubon and
Bachman:
A Collaboration
in Science*

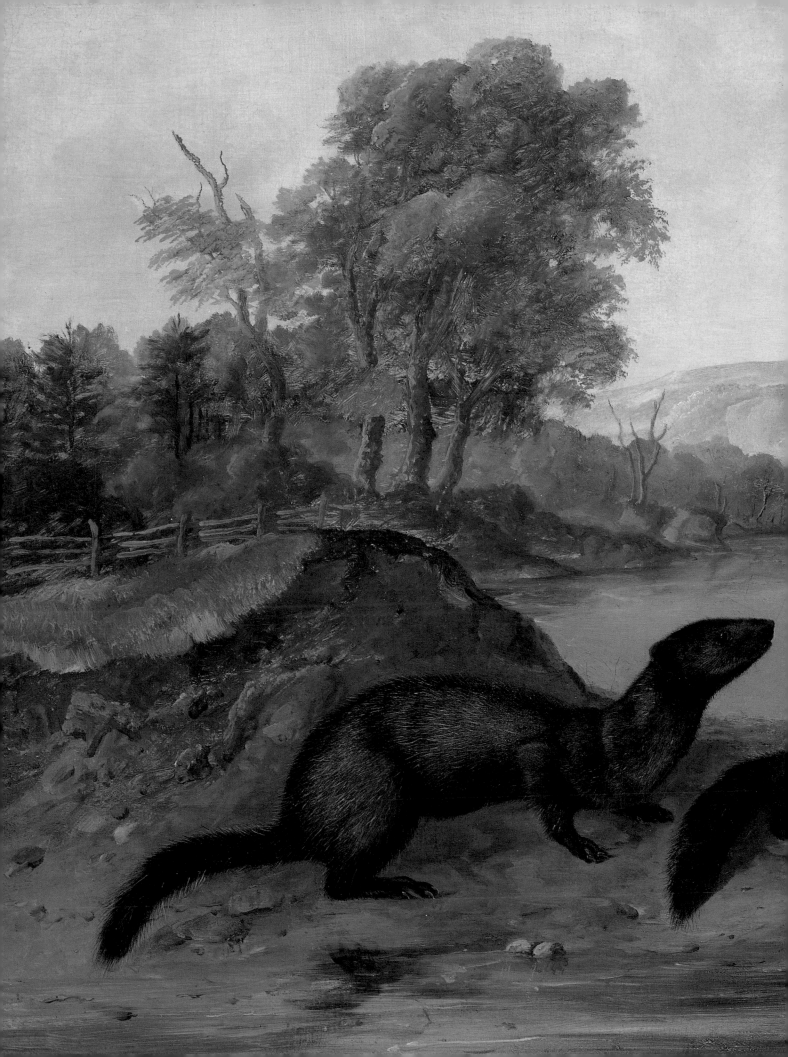

The Publication of
The Viviparous Quadrupeds of North America

RON TYLER

In 1839, following the successful completion of *The Birds of America* in London, John James Audubon returned to the United States and immediately embarked upon two huge and expensive projects: a new edition of the magnificent *Birds* in a smaller, octavo format and *The Viviparous Quadrupeds of North America,* a wholly new work.[1] Publication of the octavo *Birds* would establish his American copyright for the work, while the *Quadrupeds* would complete his long-standing dream of documenting both the birds and animals of his adopted land. The *Quadrupeds* would be Audubon's last book and a spectacular success both for the printing arts in America and for Americans, who recognized this significant artistic and natural-history publication as a "Great National Work."[2]

Audubon was fifty-four years old. He had been painting and collecting animals for decades, had accumulated "very many valuable Journals of the Wood and Swamp," and had been dreaming of such a work at least since 1831. "If I do not live to see [it] finished," he wrote his friend and fellow ornithologist Charles-Lucien Bonaparte, "I hope . . . [it will] be completed by one of my sons." Later that year, he met the person who would help him make that dream come true. The Reverend John Bachman of Charleston, South Carolina, shared Audubon's lifelong interest in quadrupeds. As a child, Bachman had provided bird specimens for Alexander Wilson, whose great work on *American Ornithology* preceded Audubon's, and although Bachman presided over one of the most prestigious congregations in the South—St. John's Lutheran Church—for almost sixty years, he maintained his avocational interest in natural science. The Reverend Bachman continued his field research, read widely, corresponded with his scientific peers in this country and Europe, and wrote reviews and articles for the most learned journals of the day.[3]

119

One can imagine the conversation that ensued after Bachman and Audubon were first introduced to each other and Bachman insisted that the naturalist and his assistants spend the next month or so at his home rather than in a Charleston boardinghouse. Audubon's goal was birds at that point. He was in the midst of his second trip back from England, where the great engraver Robert Havell and his son Robert Jr. were printing *The Birds of America,* to the United States to gather specimens and sell subscriptions. But the talk, no doubt, also included their mutual interest in mammals.[4]

Audubon visited Charleston again during the winter of 1836–37, and it might have been then that he and Bachman first discussed the possibility of collaborating on a book. The talk probably continued during Bachman's subsequent visit to Great Britain in the summer of 1838. He spent three weeks in Edinburgh helping Audubon with the *Ornithological Biography,* the text to accompany *The Birds of America,* then moved on to London, where he spent several long days in the Zoological Department of the British Museum and the Museum of the Zoological Society. George R. Waterhouse, curator of the Zoological Society, permitted him to describe several of the unnamed mammals in the society's collection, and Bachman presented a paper to the society on his last evening in town. The society named a hare after him and published his paper on the squirrel genus *Sciurus.* He also presented a paper on the state of natural history in the United States, at a meeting of the Society of Naturalists and Physicians of Germany, in Freiburg.[5] Audubon and Bachman drew even closer when Audubon's sons, John Woodhouse and Victor Gifford, married two of Bachman's daughters, Maria and Eliza, in 1837 and 1839, respectively.

The decision to undertake a book on quadrupeds was more difficult for

*John James Audubon
in the West*

Bachman because of his full-time job and family responsibilities. He was also concerned about his health. Audubon, however, did not hesitate to begin this new undertaking. Besides his longtime desire to document the quadrupeds of his adopted country, his primary reason was the continuing need to earn a living for his growing family. Audubon still owed Havell several thousand dollars for extra bird prints made before he left England, and the only assets that he brought back with him were fifteen bound copies of the double elephant folio, a few loose sets, and the engraved copperplates. He knew that his chances of finding an American engraver who could print Havell's plates would be remote, and he feared that collecting the $10,610.06 owed to him by American subscribers to the double elephant folio would be difficult in the chaotic economic times following the Panic of 1837.[6] "Bankruptcies daily occur," Dr. Benjamin Waterhouse of the Harvard Medical School had written in his journal, "like the children's play with Bricks, one brick knocking down the next one to it until the whole row is prostrate in one dismal scene of obliquity." "The Birds of America being now positively finished," Audubon confided in June 1839 to Dr. Richard Harlan, a longtime friend in Philadelphia, "I find myself very little the bet-

ter in point of recompense for the vast amount of expedition I have been at to accomplish the task. I find that unless I do labor more—or as Madame G. would say, *'Je me tue pour vivre,'* why, I will in fact die perhaps still poorer than I was when I began, which, God knows, was in all respects poor enough."[7]

Bachman did not learn of Audubon's decision until he visited with Victor Audubon, who had preceded the family to New York. "Are you not a little fast in issuing your prospectus in regard to the *Birds & Quadrupeds,* without having a No. of Works, by which the public could judge of their merits?" Bachman asked Audubon. "My idea in regard to the latter, that you would carefully get up in their best style a volume about the size of Holbrooks reptiles; this would enable you to decide on the terms of the book & be an attraction to subscribers."[8]

Bachman was worried because little had been published on North American quadrupeds, save Harlan's *Fauna Americana* (Philadelphia, 1825), John Godman's *American Natural History* (3 vols.; Philadelphia, 1826–28), and Sir John Richardson's *Fauna Boreali-Americana* (London, 1829–37). Many of the type specimens and books that contained descriptions of North American animals were available only in private collections or in Europe, and North American collections were poorly housed and incomplete by comparison. Having just spent several days in two of the most important mammal collections in England, Bachman knew their significance and suggested that Audubon paint as many of the rare animals as he could there before returning home. "Leave nothing in England that you may be obliged to send for hereafter," he urged.[9]

Audubon was the entrepreneur who envisioned the project and forged ahead. He had already begun writing to his long list of acquaintances and collaborators on *The Birds of America* to request their help on this new project. "Now that I am about to commence the publication [of] The Quadrupeds of North America," he wrote the young ornithologist Thomas M. Brewer of Boston, "I will expect your assistance in the procuring for me of all such subjects as may easily be procured around you. . . . [I] intend to open a pretty general correspondance [*sic*] in different parts of the Union, I trust to be enabled to proceed soundly on this fresh undertaking."[10]

He then set out to convince Bachman to join him. Writing from Boston in December 1839, in the midst of a sales trip for what Audubon was now calling the "royal octavo" *Birds,* he offered Bachman encouragement: "I find every one willing and ready to assist us in the procuring [of] quadrupeds for our Work. . . . Major [John Lawrence] LeConte [of the U.S. Topographical Engineers] has promised to give me his own Collection, among which he says are several undescribed species. . . . Almost all the persons to whom I speak of the publication of the *Quadrupeds* of our country are delighted, and a good number would at once subscribe was I prepared to say how much it will contain and the price of it." He claimed to have sold five subscriptions to the *Quadrupeds* without having any prints to show. On January 2, 1840,

he continued: "I have thought very deeply on this most interesting talk, and Know I believe that such a publication will be fraught with difficulties innumerable, but I trust not insurmountable, provided We Join our Names together." Audubon concluded his letter by saying that he now had fifteen subscribers *"unconditionally"* and that he would soon be in Charleston, where they could discuss their plans while hunting quadrupeds together. It seems apparent that he had the vision for the *Quadrupeds* but no firm plans. He admitted as much to the young Spencer Fullerton Baird, future secretary of the Smithsonian Institution, in December. Yet he had announced the project with the same "holy zeal" that enabled him to complete the magnificent *Birds of America*. And it is probably safe to say he did not realize he was undertaking a project that would be even more difficult than the monumental one he had just completed.[11]

But Bachman knew. As the person who would be responsible for the scientific aspects of this massive undertaking, he tried to warn Audubon on several occasions. "The animals . . . have never been carefully described, & you will find difficulty at every step," he wrote on September 13, 1839. "The books cannot aid you much. Long journeys will have to be undertaken. . . . The western Deer are no joke, and the ever varying squirrels were sent by the old boy himself, to puzzle the naturalists."[12] Again, on January 13, 1840, he wrote: "Just bring along with you Harlan—Peale—Ord & the other Bipeds & Quadrupeds & I will row you all up salt river together—I can show the whole concern of you & Richardson to boot that they have often been barking with cold noses on the back track. . . . Such works as Godmans & Harlans could be got up in a Month, but I would almost as soon stick my name to a forged Bank note as to such a mess of soup-maigre."[13]

Bachman had been trying to make sense of "the confused mess into which our quadrupeds have been thrown" for most of his life, and had concluded that "I know more of our quadrupeds than anyone else." Perhaps 190 American species had been described and given scientific names, many by Bachman himself. Twenty-three more had been described by various authors, but Bachman doubted they were all true species. But he later wrote, "The books we have are really worse than nothing," and because he lacked the scholarly resources in Charleston to complete such a project, he would have to depend upon the Audubons for help.[14]

Bachman also knew that Audubon would have to make a western trip to complete his research. "You think you can do very well by buying specimens in the market, but wait till you have [all] the common species & then the jig will be up. I am afraid you will never find the Western rats & field mice or the Spermophilias either in the N.Y. market. If no one sends you these you will have to trudge after them. What a funny object you will be trudging over the Western provinces like another Leather Stocking turned into a trapper—with a terrier by your side & a load of rat traps on your shoulder—a grey beard as long as a Flanes [?] tail & an old slouched hat enough to scare a Grizzly bear." Earlier that year he had predicted, "The Mountains of Texas

OVERLEAF, LEFT:
John James Audubon
Douglass's Squirrel
*c. 1841– 43.
Pencil, ink, and
watercolor on paper,
22 ½ x 17 ½ ".
The Museum of Fine
Arts, Houston, Texas.
Museum purchase
with funds provided
by* One Great Night
in November, 1994

For plate 48.

OVERLEAF, RIGHT:
John James Audubon
Douglass's Squirrel
*c. 1843. Watercolor,
ink, graphite, and
glaze on paper,
12 ¼ x 9 ¼ ".
The Fine Arts
Museums
of San Francisco,
California. Gift of*
Mr. and Mrs. John D.
Rockefeller III

Study for plate 48.

The Publication of
*The Viviparous
Quadrupeds of
North America*

Columbia River Sept. 26th (no trees) Sciurus Douglasii.—
 John K. Townsend Douglas' Squirrel. Drawn from Nature New York May 28th 1841.

Douglass' Squirrel

& the plains too are to be our grand resort for new species—so will be the plain for a thousand miles this side of the Rocky Mts—Missouri Territory &c."[15]

Bachman did not need to encourage his friend about a western expedition, for Audubon had long dreamed of such a trip. Inspired by the expeditions of Lewis and Clark and Stephen H. Long (whom Audubon had met while working for the Western Museum in Cincinnati in 1820), Audubon believed that some of the most exotic specimens in North America lay west of the Mississippi River. In 1820, as he was preparing for his trip down the Mississippi, he had written to Henry Clay about his desire to explore in "the Territories Southwest of the Mississippi . . . the Red River, Arkansas and the Countries adjacent." Months later, he wrote Governor Miller of Arkansas Territory of his desire "to travel as far at Least as the Osage Nations on the Arkansas as also along the Whole of our Frontiers." Again, in 1831, he had written to his wife, Lucy, about his intent "to ascend the head of the Arkansa River towards the Rocky Mountains some time next Summer." In that same year, and again in 1835, he had shared with Bachman his desire to visit the Sabine River, then "up it into the broad Prairies . . . and then on to the Rocky Mountains." When he learned in 1836 that Thomas Nuttall and John Kirk Townsend had just returned from an expedition to the Pacific Northwest with Nathaniel Wyeth and had deposited their specimens at the Philadelphia Academy of Natural Sciences, Audubon was so excited that he made special trips, first to Philadelphia to see the specimens, then to Boston to get Nuttall's permission to use them.[16]

Audubon had nurtured the idea of a western expedition as he finished *The Birds of America*. "How would you like to trip it over the Rocky Mountains next spring in company with Ed. Harris, Townsend, and about forty others," he had asked Thomas M. Brewer, now editor of the *Boston Atlas*. "Harris tells me that such an expedition is now *on talk*." Other personal friends, such as Napoleon Costé, pilot of a revenue cutter for the Treasury Department, encouraged him by telling him that the breeding places for the scarlet ibis and the flamingo that he had discovered "all laid west of the Mississipi [*sic*]." And, beginning in 1839, a spate of beautiful and exotic materials on the West began to appear. Karl Bodmer's stunning aquatint engravings accompanying Prince Maximilian's 1839 text of his journey up the Missouri River surely whetted Audubon's appetite even further, as did George Catlin's *Letters and Notes on the Manners, Customs, and Condition of the North American Indians* (London, 1841). Audubon had tried to get help from his friend Colonel John James Abert, head of the Corps of Topographical Engineers, on several occasions: for his 1837 trip to Texas and, again, for a western trip in 1841, but he had been disappointed when Abert offered only "the usual letter to our frontier posts and Indian agencies."[17] His research for the *Quadrupeds* would not be complete until he could make that trip.

When Audubon decided to produce beautiful, expensive books about

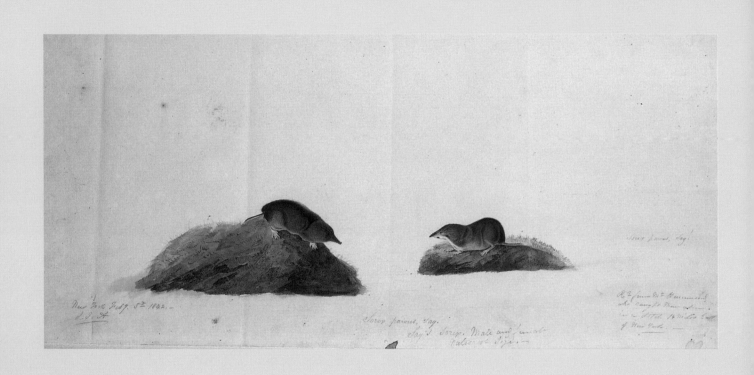

New York, July 5th 1842 —
J. J. A.

Sorex parvus, Say.

Sorex parvus, Say.
Say's Shrew. Male and Female
Natural Size —

Recd from Mr Harris &c
who caught them at home
in a field 18 miles East
of New York —

99

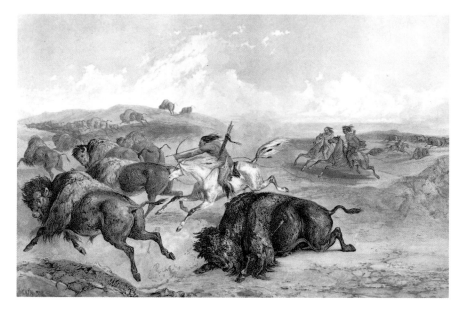

birds and quadrupeds, to be sold by subscription and issued in fascicles, or parts, each containing five illustrations, he was participating in an established and respected method of distributing scientific information. It called for a written description of the creatures, their habits, habitats, appearances, and geographic distribution. It also required good illustrations, because not even the most precise language always clarifies the many distinctions, especially in the case of exotic specimens unknown to the reader. The first such texts—sixteenth-century tomes by Conrad Gesner, Pierre Belon, and Ulisse Aldrovandi—used woodcut illustrations. Copperplate engraving offered a considerable improvement in the seventeenth century, as seen in Mark Catesby's *The History of Carolina, Florida, and the Bahama Islands* (1731–43), and that is the process that Audubon chose for his *Birds of America* (1827–38).[18] By the time he undertook the *Quadrupeds,* however, the relatively new and less expensive process of lithography had all but replaced copperplate engraving in America, so Audubon had the illustrations for both the octavo edition of *The Birds of America* and the *Quadrupeds* printed by lithography.

Lithography offers several advantages over copperplate engraving, the most important of which are speed and cost. Lithography, which had reached America shortly after its invention in Bavaria by Aloys Senefelder in 1798, is a planographic rather than intaglio process, which means that its printing surface is smooth, rather than grooved like an engraving or etching, and it depends upon a chemical reaction for its success. Bass Otis, who is generally credited with the first American lithograph, probably read of Senefelder's discovery in articles reprinted in American journals and produced a print of a small landscape scene using a Kentucky limestone in 1818.[19] Other Americans took up the process, although most of the lithographers during the first half of the nineteenth century seemed to be European immigrants who learned the craft there.

Lithography requires a soft, porous stone, the best of which is still quarried near Solnhofen, Bavaria. Cut into various sizes and thicknesses, depending upon the press and the image to be reproduced, these stones are then ground (one stone against another, with increasingly fine layers of sand mixed with a few drops of water in between) until the desired texture, or grain, is obtained. The great achievement of lithography is that the artist may draw directly on the stone with a special greasy or waxy crayon, and the final image will mirror his or her strokes exactly. There need not be an intermediary, or printer, between the artist and the stone, although lithographic artists were so good at their craft that relatively few artists bothered to learn the process.

When the drawing is complete, the stone is bathed with gum arabic and nitric acid to "fix" the drawing. Then it is wiped with a wet sponge; it absorbs water, except for those parts covered with the greasy ink. A greasy, sticky ink is then applied to the stone with a roller. The ink adheres to the drawing but is repelled by the wet stone. The printer then lays a piece of

John Woodhouse
Audubon
J. T. Bowen,
lithographer
American
White Wolf
Lithographic stone,
22 ½ x 28 ½ x 2 ¾ ".
Cincinnati Museum
Center

Since lithographic
stones can be reused,
specific images do
not often survive.
This stone, which
was possibly sold by
J. T. Bowen, was
found at a
printing company,
H. S. Crocker
Co.–Strobridge
Division in Norwood,
Ohio, in 1966.
The image of the wolf
had been covered by
a piece of slate, which
had been used to back
and strengthen the
stone for its subsequent
printings. Although
the print was originally
credited to John James
Audubon, it should be
assigned to John
Woodhouse Audubon.

John James Audubon
in the West

paper on the stone, applies pressure, and "pulls" the print from the stone. The sticky ink "offsets" from the stone to the paper, producing an image.[20] The resulting reproductions are so accurate that artists have sometimes referred to them as multiple originals, rather than copies or reproductions. Lithographers, of course, have developed many refinements of the process, until literally thousands of prints may be pulled from a single stone, depending upon the quality of the stone, the drawing, and the ability of the printer.[21]

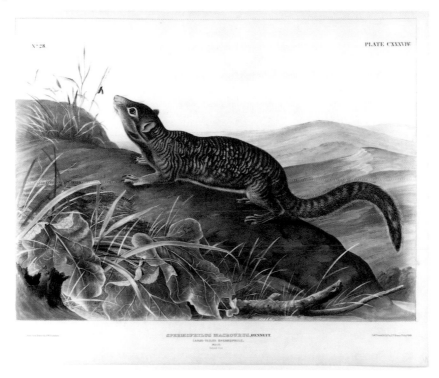

John Woodhouse Audubon J. T. Bowen, lithographer **Large-Tailed Spermophile** *Lithograph, 18 ⅛ x 24 ⅛". Private Collection*

Once the lithographs were printed, they had to be hand-colored by a team of artists. It would be another fifteen to twenty years before chromolithographs (lithographs printed in color) were easily available even in the larger cities. J. T. Bowen, Audubon's printer, lithographed the small birds two to a sheet and the quadrupeds one to a sheet in black ink. Then he turned them over to teams of colorists, usually women, who probably worked in conditions similar to those in the Currier and Ives shop in New York. There they sat at long tables with a model, usually a colored copy of the print that the artist had approved, in the middle of the table for all to see. Each colorist would be assigned a section of the image and would apply only one color. The print would then be passed to the next person, who would apply a different color. Finally, the "finisher" did what was necessary to complete the picture, usually only touch-ups and highlights. If large numbers of prints were needed, as with the small *Birds,* the lithographer would sometimes cut stencils so that the various colors could be washed on by unskilled help outside the shop, then finished by one of the regular employees; however, Bowen considered Audubon's work too detailed and finished for such an approach. Even before the *Quadrupeds* prints, which were even

more exacting, were under way, Audubon complained to one of his distributors that "we have at this moment in this city and at Philadelphia upwards of *Seventy* persons employed upon the present work and that all these . . . are to be paid regularly each Saturday evening, and that *when we are out of temper* it is not without cause."[22]

These colorists were so skilled that there is remarkably little difference between the prints. A close examination of two prints side by side will inevitably reveal minor differences in the details, such as watercolor lopping over a line, but an examination of four complete sets of the *Quadrupeds* failed to turn up any significant differences in the coloring of any of the plates.[23]

As Audubon began to create the illustrations for the *Quadrupeds,* it is clear that, as with the double elephant folio of *The Birds of America,* he again envisioned a book on a scale never before produced in the United States. In order to illustrate the animals that he was painting the size of life, the pages for the folio *Quadrupeds* had to be approximately twenty-two by twenty-eight inches, with the actual images up to nineteen by twenty-five inches. Of course, he had to make compromises here that he had avoided in *The Birds of America,* because he obviously could not paint the buffalo or the elk full size. He would issue the *Quadrupeds* in the same traditional manner that he had the *Birds:* a fascicle, or number, of five plates every two months. This would enable subscribers to purchase his expensive book over a period of years and him to pay the printing bills out of the income flow from subscriptions, rather than have to capitalize the project himself, borrow the money, or take in investors. At this point, he did not know how many plates he would do. Bachman's text would be published later in separate, letterpress volumes.[24]

Works of this size and quality had been produced *on* the United States, but not *in* the United States. Karl Bodmer had his dramatic Indian portraits and landscapes printed and colored in Paris, and Catlin had published his *North American Indian Portfolio* (1844) in London, just as Audubon had done with *The Birds of America.* Although significantly smaller, the only American publications that approach Audubon's vision of the *Quadrupeds* in size and quality are James Otto Lewis's *Aboriginal Port-Folio* (Philadelphia, 1835–36) and Thomas McKenney and James Hall's *History of the Indian Tribes of North America* (Philadelphia, [1833]–44), for which Bowen had printed the plates. It had been this latter book, in fact, that had first attracted Audubon's attention to Bowen, and his subsequent experience with the octavo *Birds* had convinced him that Bowen was capable of the work.[25]

Audubon expected to begin the *Quadrupeds* project soon after his 1839 announcement, but he undertook the octavo *Birds* project first, and it became such a success that it delayed work on the *Quadrupeds* for more than a year.[26] To do both the octavo *Birds* and the *Quadrupeds,* Audubon had in place the same studio system that had successfully completed the double elephant folio of *The Birds of America.* In the same sense that old masters such

OPPOSITE:
John James Audubon
J. T. Bowen,
lithographer
Hare-Indian Dog
1848. Hand-colored
lithograph,
18 ¼ x 25 ⅜ ".
Buffalo Bill
Historical Center,
Cody, Wyoming

PLATE CXXXII.

Drawn from Nature by J.W. Audubon.

CANIS FAMILIARIS, LINN. (VAR LAGOPUS)

HARE-INDIAN DOG.

MALE.

Lith.d Printed & Col.d by J. T. Bowen. Phila.d 1848.

as Raphael or Rubens employed assistants and copyists to reproduce their work, Audubon had used assistants from the beginning of his artistic career. The young Joseph Mason had accompanied him down the Ohio and Mississippi Rivers in 1820 and 1821, painting exotic flowers and shrubs as backgrounds for Audubon's birds. Lithographer and landscape artist George Lehman, whom Audubon had met in Pittsburgh in 1829, provided thirty-nine backgrounds, including the remarkable views of Charleston, Baltimore, and the Florida swamps, among others. Maria Martin of Charleston, sister-in-law and later the second wife of John Bachman, also contributed perhaps twenty backgrounds for *The Birds of America*. In Great Britain, Audubon employed the youthful Joseph B. Kidd to copy almost a hundred of his watercolors in oil, a medium with which Audubon was never comfortable. Ultimately, Audubon hired William Lizars and Robert Havell Sr. and Jr. to reproduce his watercolors as engravings, asking them on several occasions to supply backgrounds for the scenes just as he would a studio assistant. When they got old enough, his two sons, John Woodhouse (1812–1862) and Victor Gifford (1809–1860), worked as his assistants as well; John was more the artist, ultimately producing several of the paintings for the *Birds* and half of the *Quadrupeds* paintings, while Victor, with experience in his uncle's countinghouse, administered the projects, tended to business affairs, and provided a number of backgrounds. All of this work—the backgrounds of Mason, Lehman, Martin, and his sons, the oil paintings of Kidd, and the engravings of Lizars and the Havells—Audubon displayed as his own, according to the standards of the day.[27]

This family team did most of the work on the octavo *Birds* as well as on the *Quadrupeds,* but they depended upon significant contributions from a few key outsiders for both projects. With the aid of a camera lucida, a simple instrument consisting of a glass prism held at eye level by a brass rod over a flat piece of drawing paper, Audubon and John reduced the lifesize watercolors of the birds to the approximately seven-by-five-inch drawings needed for the octavo *Birds,* and they painted all 150 images for the *Quadrupeds.*[28] Victor once again painted backgrounds for the quadrupeds and handled the business affairs and bookkeeping. Audubon initially spent most of his time on the road contracting with agents and selling subscriptions, but he split time between painting quadrupeds and selling trips in 1841, 1842, 1845, and 1846. Much of 1843 was devoted to the trip up the Missouri River.

Before leaving England in 1839, Audubon had asked the younger Havell to engrave and print the *Quadrupeds* pictures, but Havell apparently was not interested in undertaking another large project with Audubon, perhaps because the artist had not yet paid all his bills for the double elephant folio *Birds*. In fact, Havell probably sensed that the era of such huge engraved books was drawing to a close, engraving being replaced by the faster, less expensive medium of lithography, and he had decided to close his shop and immigrate to America. Replacing Havell on the team was the Philadelphia lithographer Bowen, who had lost most of his life savings in the

Arvicola Townsendii. 1.

stock market during the Panic of 1837 and was eager for a big job.[29] At the height of production on the "little work," as he called the octavo edition of the *Birds,* Audubon estimated that Bowen employed seventy people to draw, print, and color the small lithographs.

Audubon also took on John B. Chevalier as an investor and agent to handle his affairs in Philadelphia, although he later bought Chevalier out. Audubon's network of friends and supporters paid off as well. From Dr. George Parkman in Boston, a friend and subscriber who frequently helped him sell subscriptions, he received a memorandum on the quadrupeds in the Boston Museum. The young Spencer Fullerton Baird supplied what he could from Carlisle, Pennsylvania. And Audubon borrowed specimens from John Kirk Townsend, among others.[30]

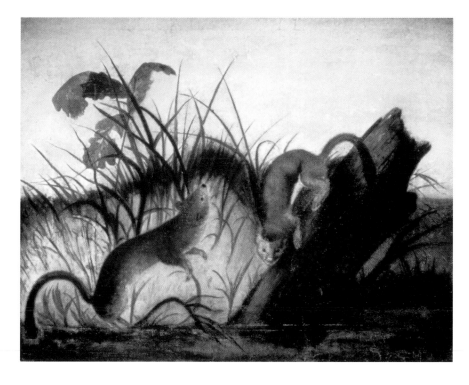

As the critic and Audubon friend Charles Wilkins Webber later wrote about the *Quadrupeds,* everyone involved felt "the infusion of his presence throughout, and . . . all parties concerned have shown themselves worthy to share with him the glory of such a Work." The master provided the genius and guiding hand. Audubon was the person who conceived the projects and had the enthusiasm and determination to see them through. He was the artist, the author, the designer, and, when the time came, the salesman. As the success of the "little work" grew, Audubon's dominant role in the process became more apparent. Having honed his talents on the double elephant folio, he brought a unique mix of skills to the task. And his books were a genuine scientific contribution. He discovered and published literally dozens of new birds and animals at a time when Americans were curious about the continent and its creatures.[31]

Audubon was an undisputed genius in interpreting American birds and

animals and their context, in both pictures and words. According to Webber, Alexander Wilson, author of *American Ornithology*, produced "still life" or "Stuffed Specimen" birds, while Audubon "dared . . . to show them in all the characteristic attitudes, and with every tint illuminated, as with the living hue of passion—vivid in its milder forms—or sparking with the savage joy of fierceness and the comic light of glee." As Bachman put it, "My old friend's brush is a truth teller." Audubon accomplished a similar goal with his writing. An editor with the *Albion* informed his readers that "Mr. Audubon does not write mere barren descriptions, but adorns his book with all the graces of style, improves it with solid and useful reflections, enriches it with anecdote and incident, and in short makes it almost poetical prose, save that it does not indulge in fiction." Audubon drew both the birds and quadrupeds lifesize, where possible, and in an energetic and spirited manner so that the pictures themselves told a story. Just as with the birds, his quadruped illustrations were designed to show specific aspects of the animal as well as to provide dramatic portraits or characteristics. The *Common American Wildcat*, 1842 (plate 1), shows his teeth, for example, a key in his identification. Both young and old cougars are shown in plate 97, and the *Florida Rat* (plate 4) is shown in both summer and winter pelage.[32]

Another key to Audubon's success was his hard work. He began the new year of 1841 by drawing a picture of a beaver, to which he later added a second figure, that became plate 46 in the *Quadrupeds*. He explained his method in his journal: "I am now working on a Fox; I take one neatly killed, put him up with wires and when satisfied with the truth of the position, I take my palette and work as rapidly as possible," he wrote. "If practicable I finish . . . at one sitting—often, it is true, of fourteen hours." In June he told his Boston friend Parkman that he was "deeply engaged on a drawing of Rocky Mountain Flying Squirrels" (plate 143). By August he had drawn thirty-six species, including one hundred figures, and admitted that "I am now as anxious about the publication of the Quadrupeds as I ever was in the procuring of our Birds—indeed my present interest in Zoology is altogether bent toward the completion of this department of natural science." His intent was to produce all the pictures for the *Quadrupeds* within two years. As he had admonished Victor in the midst of the double elephant folio *Birds,* when success was still in doubt: "Depend upon it our *Industry,* our *truth,* and the regular manner in which we publish our Work—this will always prove to the World & to our Subscribers, that nothing more can be done than what we do, nay that I doubt if any other *Family* with our pecuniary means ever will raise for themselves such a *Monument* as 'the Birds of America' is, over their tomb!"[33]

Audubon's extensive collection of drawings over the years enabled him to save some time as he embarked on this huge new task. A number of the hunting pictures that he sold in England contained pictures of quadrupeds, such as the *Entrapped Otter* (plate 51), which was one of his favorites, painted time and again. Mammals were occasionally presented as victims of his

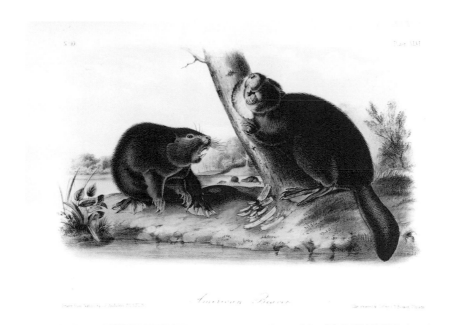

John James Audubon
Lithographed,
printed, and colored
by J. T. Bowen.
American Beaver,
plate 46
Hand-colored
lithograph,
6¾ x 10⅛ ".
Buffalo Bill
Historical Center,
Cody, Wyoming.
Gift of Deborah B.
Chastain

The description of the
beaver's habits begins,
"The sagacity and
instinct of the Beaver
have from time
immemorial been
the subject of
admiration and won-
der. The early writers
on both continents
have represented it as
a rational, intelligent,
and moral being,
requiring but the
faculty of speech to
raise it almost to an
equality, in some
respects, with our
own species." The text
of the Quadrupeds
concludes that the
earlier accounts were
exaggerated and that
"with the exception of
its very peculiar mode
of constructing its
domicile, the Beaver
is in point of
intelligence and
cunning greatly
exceeded by the
fox"
*(*Quadrupeds,
1:349–50).

birds of prey in *The Birds of America.* Havell incorporated Audubon's 1821 portrait of an *Eastern Gray Squirrel* into his image of the *Barred Owl* (plate 46) for *The Birds of America,* and Bowen used it again in what Bachman called the *Carolina Gray Squirrel* (plate 7). The portrait of the squirrel, in fact, is the only one that appears in both the *Birds* and the *Quadrupeds.* Audubon finished up the year with a report to his friend and patron Edward Harris: "Since the 8th of May, I have drawn 61 Species comprising 115 figures. I have now on hand Specimens enough to enable me God willing to have drawings of 100 Species by the 1st of May next." When the writer Parke Godwin called on Audubon at Minnie's Land, his home on the Hudson River, in the spring of 1842, he found evidence of the artist's work on the *Quadrupeds* scattered about the studio. Audubon "worked on an average fourteen hours a day, preparing a work on the Quadrupeds of America, similar to his work on the Birds," Godwin reported. "The drawings, already finished, of the size of life, are master-pieces in their way, surpassing, if that be possible, in fidelity and brilliance, all that he has done before."[34]

Audubon was a largely self-taught artist and writer who emerged at precisely the right time and place for his work to be appreciated and understood by more than just the natural-history community. At a time when the landscapes of Thomas Cole and his followers, Transcendental religious views (which held that natural objects such as might be found in the wilderness were symbolic of higher truths),[35] and an apparently endless supply of open land in the West had focused American attention on the wilderness, Audubon, as the "American Woodsman," seemed to personify all these interests in his bird and mammal paintings. The compositions include "trees, plants, and occasionally views drawn from nature" as backgrounds, and his texts contain narratives of general interest. In the *Ornithological Biography* these stories were called "delineations of American scenery and manners"

The Publication of
The Viviparous
Quadrupeds of
North America

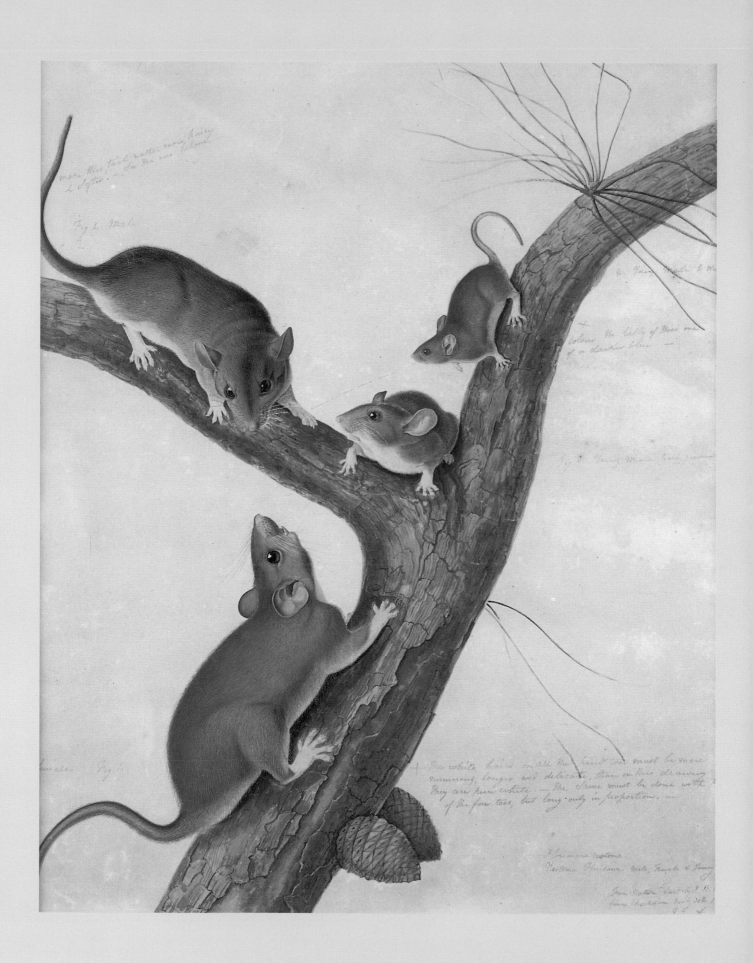

(Audubon called them "food for the Idle" in one of his letters to Bachman).[36]

His and Bachman's eyewitness observations and hunting stories served a similar purpose in the *Quadrupeds,* lending authenticity to the volume as well as giving enjoyment to the readers. Audubon subscribed to the Romantics' moral agenda with his anthropomorphic "mother and child" scenes in the *Quadrupeds,* such as the *Florida Rat* family (plate 4), with the young looking at the parents while the parents look at each other; the *Common American Skunk,* 1842 (plate 42); the cougar with her young (plate 97); and the bison, 1845 (plate 57). And the public responded. One of his subscribers saw "the texture of a leaf, or the tinting of a shell, [as] another inlet into the workmanship with which the mysterious universe teems with such continual demonstration of an ever-present God." And Congressman and future U.S. Senator Robert Barnwell Rhett of South Carolina wrote Audubon that "Mrs. Rhett takes great interest in your labours, and often describes to my little Boys, in glowing terms, taken from your works, on the toils and the pleasures, the labours and the glory of being a great & enthusiastic Naturalist like Mr. Audubon."[37]

Although Audubon often discussed the scientific merits of his books, he was also concerned about their physical appearance—about matters such as design and layout—as is clear from a comment that he made to his wife, Lucy, as the *Birds* began to come off the press: "The little drawings in the center of those beautiful large sheets have a fine effect and an air of richness and wealth that cannot help insure success in this country." Later, as the *Ornithological Biography* was being published, he pointed out, "The type used for my book here are new, clear, and I think very fine—Also the paper," and instructed that the "arrangement of the formulae, Headings &c" be copied in the American editions. Bachman, too, was concerned about the physical appearance of his text for the *Quadrupeds.* "In getting up this volume," he wrote Audubon in 1846, "cant [*sic*] we show John Bull something? Perhaps it may be the beginning of something better for our despised country. The sized type & the paper in Holbrooks Book—or in the Trans. Look &c will satisfy me—The genus & species at the head of the articles must be in capitals."[38]

Finally, Audubon had trained himself to be a superior salesman. When he first arrived in England in 1826, if his journal is to be believed, the forty-one-year-old naturalist was so shy that it pained him to make any kind of public presentation, but by 1839 he had become very good at it. As soon as he had prints to show, Audubon began a trip through New England to sell the octavo *Birds,* get publicity, and collect any funds due to him. Compared to the double elephant folio at about $1,000 (the equivalent of approximately $15,000 today), the octavo edition at $100 (approximately $1,500 in today's money) was hardly an expensive book. But most books sold for under $10 (approximately $150 today), and most of those were priced in the $2 to $4 range ($30 to $60 today). Still, he was able to sell more than 1,200 subscriptions to the "little work."[39]

Using the method that he had developed while selling the double elephant folio, Audubon went first to Boston, a city where he had many friends and subscribers, showing samples of his books and signing up agents who would sell for him on a commission (usually 5 to 10 percent, sometimes as high as 20 percent).[40] His most effective technique involved the use of his memberships in learned societies and letters of introduction from his friends and admirers, but after experiencing extraordinary success in Baltimore—168 subscribers in all—he informed the family of a new twist:

This success and the Means through which it has occurred has . . . taught me a most excellent lesson which I may hereafter Chance to go i.e. to Seek from the very first some of the most influential Men or *Ladies* of the Towns I Visit, and have them to *Accompany* thy poor old husband, from door to Door, and house to house, and to present him and to *preamble* for him, and in his behalf!—I never dreamt of such a thing until I became Acquainted with M*r* Meekle, and M*r* Oldfield.[41]

Audubon incorporated this technique into his repertory, but it probably would not have worked so well had it not been for his charming personality.[42] "Indeed," Bachman noted, "with your influence &c you might induce many to subscribe who would not do so for any one else." "It is true," Audubon admitted to the family, "that my Name, and as Victor is pleased to say my 'Looks' May have some Influence in the Matter. . . ." Audubon probably personally sold more copies of his works than all his agents combined. By the same token, when Audubon was otherwise occupied—during his trip up the Missouri, for example—the books did not sell.[43]

Another reason for Audubon's success was that he usually had more than one arrow in his quiver. He regularly carried with him a copy of the double elephant folio as well as an assortment of other items, such as his and his sons' original paintings, copies of John Gould's various books on birds, bird and animal skins, and, on one trip in 1842, a Salvator Rosa painting.[44] He was also always on the lookout for agents to handle his works and visited with established dealers, such as Little and Brown in Boston, to collect money due him. He gave painting lessons if the occasion permitted and, all the while, maintained his enormous correspondence, regularly sent money home, and provided financial advice and general encouragement, as well as gentle prodding, to the family. He took every opportunity to visit with editors in the hope of a favorable press and continually admonished Victor to be sure that his activities were reported to any newspapers likely to carry a story. From the remote outpost of Fort Pierre on the Missouri, for example, he urged, "I hope that on the receipt of each of my letters, Victor sends some extracts to several of the News Paper Editors. It cannot do any harm and may be a chance to do some good." He promised to send them his journal so that they could extract interesting items for publication, "but I would be nice and circumspect in all such cases as I prefer keeping as much as possible for our Books on Quadrupeds."[45]

Audubon's small team was so overwhelmed by the success of the octavo

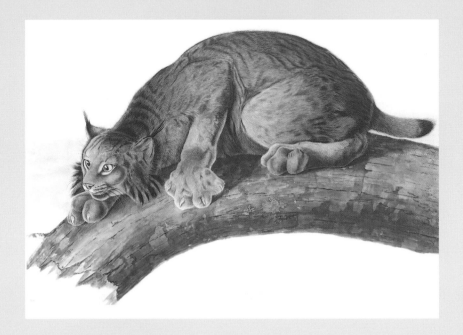

Drawn on Stone by R. Trembly

Canada Lynx
Male

Drawn from Nature by J.J Audubon F.R.S.F.L.S. Printed by Nagel & Weingærtner N.Y.

Birds and by other events during 1840 and 1841 that he postponed any serious work on the *Quadrupeds* until the summer of 1841. When the tuberculosis that plagued the Bachman family struck down his two daughters-in-law in 1840 and 1841, Audubon first took over John's job of producing the small drawings needed for the lithographs, and then Victor's job of managing the business office. With more than 1,200 subscribers to a $100 book, Audubon found himself reprinting early fascicles to supply later subscribers and eventually hiring a second lithographer, George Endicott of New York, to print three new numbers while Bowen caught up with the backlog. The book was so successful that it provided the funds for the family to move out of the populated part of New York City in 1842 and build their dream home along the Hudson River. They called their new home "Minnie's Land" after the term, meaning "Mother," that the family had long applied to Lucy, and they came to refer to the "little work" as their "salvator."[46]

Meanwhile, Bachman tried to bring some order into the collaboration on the *Quadrupeds.* He and Audubon agreed on a division of work: Victor, John, and Maria Martin would help Audubon with the paintings. Bachman would do the text and serve as the scientific editor—piecing together stories and accounts that he received from Audubon, John, and many others who submitted material to them—and they would be billed as coauthors. The Audubons would produce, publish, and sell the book, and would receive all the profits. Bachman had agreed to contribute the text in the hope of helping his daughters' families.[47]

As Audubon began to plan for the *Quadrupeds* book itself, he realized that he again had designed an expensive publication and, worried about the economy, he asked his closest advisers for their "advice on the size & Style of this publication." Perhaps recalling that Bachman had suggested a book that would sell for approximately $100, Harris suggested that the *Quadrupeds* should be available at a "moderate [price], [because] an expensive work in these times will not go down." Bachman, too, warned that for such an expensive book "I doubt whether the first edition can command more than 350 or 400 subscribers."[48]

Victor sent several paintings to Bowen so that he could make some proofs and give them an accurate estimate of how much the book would cost.[49] Part of Bowen's bid had to take into consideration the condition of the pictures the Audubons sent him. Rarely was the composition finished on one sheet of paper, as in the *Black Rats,* about 1842 (plate 23), with Victor painting the background on the same sheet on which his father had figured the animals. More often Bowen's task was to take the two or three paintings that he received for each plate and work them into one finished lithograph.[50] Even when Audubon painted all the animals on one sheet, changes were sometimes made, as with the *Woodchuck* (plate 2), in which the positions of the small animals were reversed. Usually Bowen's job was simple enough, as in the case of the *Northern Hare,* 1841 (plate 11): Audubon painted two life-size figures of the hares, and Victor produced the background, leaving blank

The Cougar

Male & Young

American Black Rat

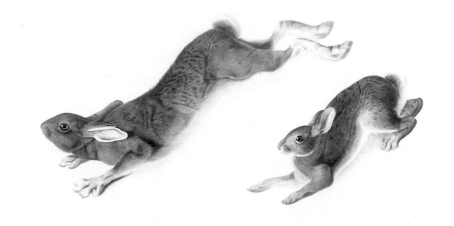

John James Audubon
Northern Hare (Old and Young)
1841. Pencil, watercolor, and ink on paper, 20 ½ x 34 ¾".
Courtesy, Department of Library Sciences, American Museum of Natural History, New York

Audubon drew the two hares for plate 11 and his son Victor Gifford Audubon drew the background.

Victor Gifford Audubon
Background for Northern Hare
1841–42. Watercolor on paper, 20 ½ x 34 ¾".
Courtesy, Department of Library Sciences, American Museum of Natural History, New York

OPPOSITE:

John James Audubon Victor Gifford Audubon
Black Rats, or Black Rat Eating Eggs
1842. Oil and watercolor on paper, 26 x 32".
Courtesy, Department of Library Sciences, American Museum of Natural History, New York

To produce a complete image for the printmaker, the two Audubons collaborated on the depiction of the rats. John James Audubon portrayed the animals, and his son the setting of the wooden henhouse. For plate 23.

outline spaces for Bowen to insert the figures. Victor's composition brought the hares closer together than Audubon had painted them, but he wrote instructions within the outlines so that Bowen would get it right: "This animal *must* be given as here without *the least* reduction of size." Sometimes a third painting was involved, as with the *Soft-Haired Squirrel*, about 1841 (plate 19). Audubon painted two figures on separate pieces of paper, which Bowen assembled according to the spaces left in Victor's background.[51] The same is true of the *Common American Skunk* (plate 42), for which Audubon instructed Victor and Bowen to combine two of his watercolors into a finished composition. One of the drawings was cut out and pasted on the same paper as the other. Audubon's watercolor of the *Northern Gray Squirrel* contains only two figures, but the lithograph (plate 35) contains three, indicating that a third portrait was sent to Bowen for this plate as well.[52]

Bowen showed Audubon the proofs of the first number for his approval in 1842: the *Common American Wildcat* (plate 1), the *Woodchuck* (plate 2), *Townsend's Rocky Mountain Hare* (plate 3), *Florida Rat* (plate 4), and *Richardson's Columbian Squirrel* (plate 5). Both Audubon and Bachman were

The Publication of
*The Viviparous
Quadrupeds of
North America*

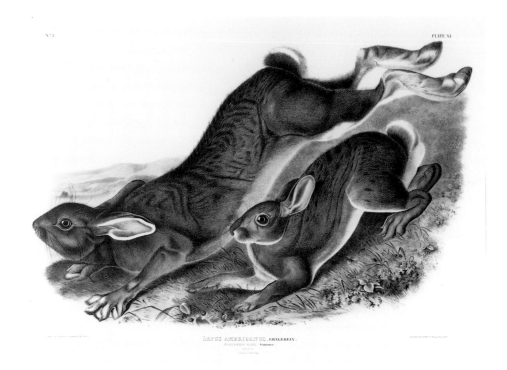

pleased with the initial lithographs.[53] So was their friend Brewer, who probably wrote the review for the *Boston Atlas:*

The new work is already tolerably forward in its progress . . . and from some splendid specimens we are enabled to say to the people of the United States, that a treat is in preparation for them, such as none other than Audubon could have prepared. They are beautiful beyond anything that we have looked upon. It were utterly useless to attempt a description. They must be seen to be appreciated. To those of our readers who may possibly suppose that we are exaggerating—that we are writing what is technically termed a *puff*—we can only say, look for yourselves. You will then see how utterly impossible it is to give any adequate idea of the living and almost *moving* truthfulness of Audubon's portraits of the four footed denizens of the Country *with the pen,* and how entirely impossible it would be to exaggerate.

The plates are colored to the life, and are so thoroughly life itself, that few people would venture to put their fingers near the mouth of one of the squirrels, for fear of an actual bite.[54]

Based on the figures at hand, Audubon described a folio publication that would be approximately twenty-two by twenty-eight inches in size. It would be issued in fascicles of five plates every two months, each number to cost $10, payable on delivery. He projected as many as thirty numbers (more of whales, seals, and bats were included) containing 150 plates in all, with a total selling price of $300 (approximately $4,500 today) plus binding. Bachman's text, which would be printed later, was included in the price.[55]

In the worsening economy, meanwhile, Victor was having difficulty collecting from subscribers and paying Bowen's printing bills. Audubon's partner in the "little work," John B. Chevalier, was so concerned that he had

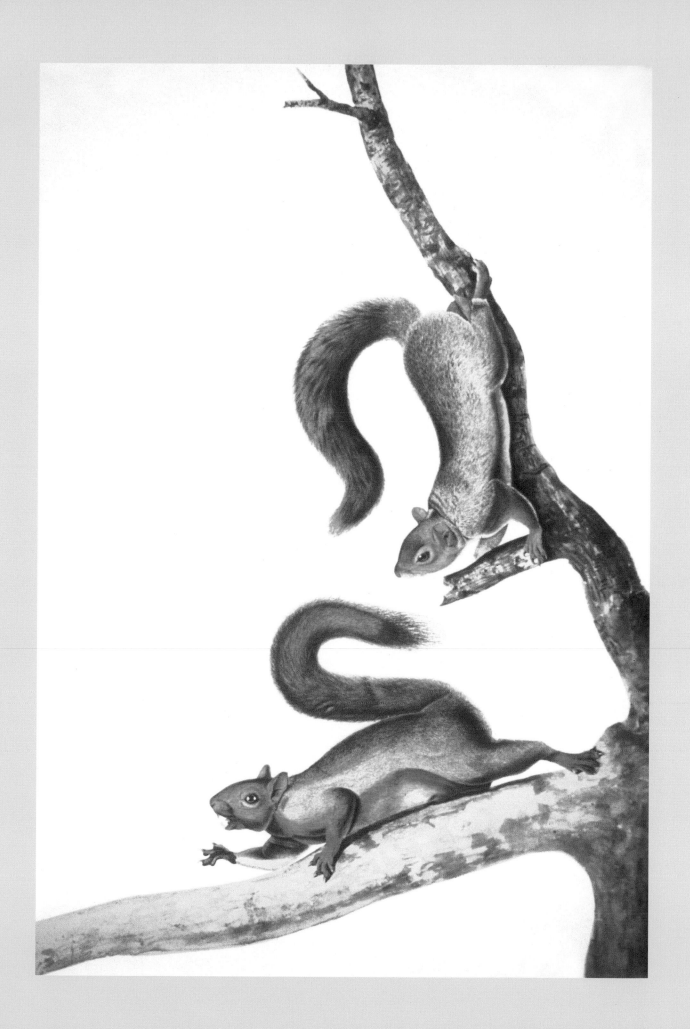

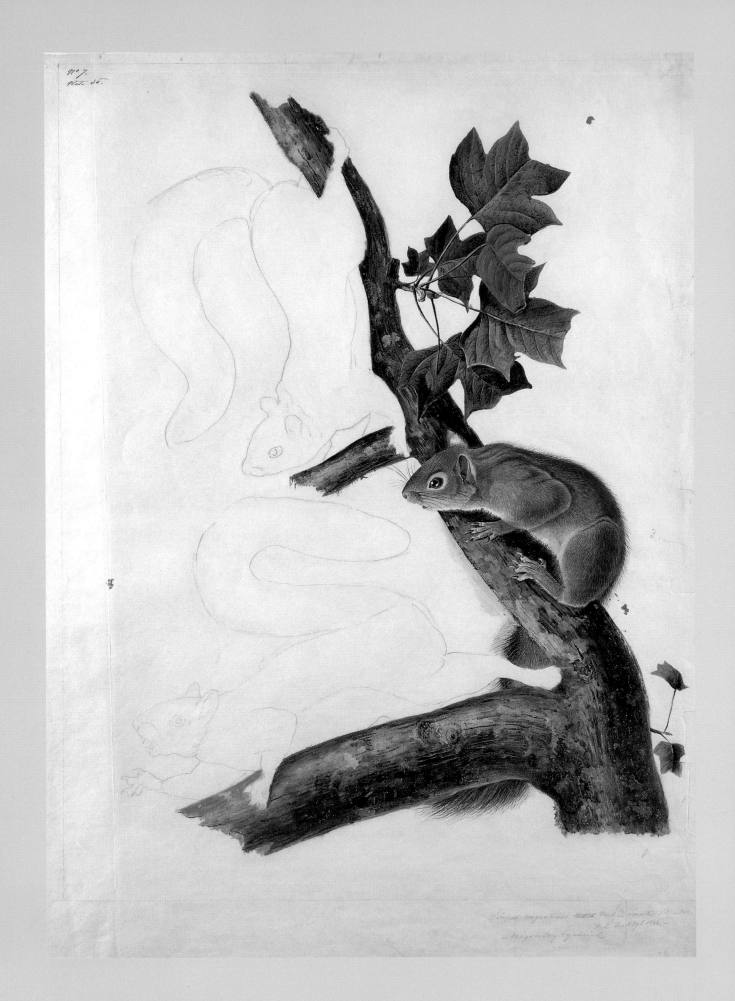

convinced Audubon to stop overprinting the letterpress for it, despite the fact that they had more than 1,100 subscribers at the time. Bachman was even more dramatic in June 1842: "I am sorry you are thinking of publishing the *Quadrupeds* just now. Depend on it you will not obtain one third of the subscribers that better times, & that probably within a year[,] would afford you. If you begin small, you are likely to go on in the same way, for men will not be willing to subscribe full prices for back numbers." By October, he had softened his position a bit, agreeing that "I don't think the work will be extravagantly high & if the times were not so shockingly pinching there would be no difficulty in making up 3 or 400 subscribers—as it is I hope for the best & trimble [*sic*] whilst I hope." Audubon understood. The Philadelphia zoologist Richard Harlan, one of the subscribers to *The Birds of America,* had recently asked Audubon for a $700 loan with *The Birds* as collateral, and Dr. Benjamin D. Greene, an ornithologist, son of one of the wealthiest men in Boston, and subscriber to the octavo *Birds,* had told him that summer that he had lost $70,000 during the previous year and a half.[56] But Audubon's optimism and enthusiasm prevailed, and he did not change his plans.

The poor economy explained the reaction of two of Audubon's Philadelphia friends—Harlan and the craniologist Samuel G. Morton—when Audubon proudly showed them the first four plates of the *Quadrupeds* in the summer of 1842. He characterized their response to Victor as "cold & heartless." But, as Morton later explained to Bachman, it was the expense of the book rather than the quality: "I regret the stupendous consequently expensive plan of work on *Quadrupeds,* for I shall be deprived (in common with many others here) of the satisfaction of possessing so valuable a work." Audubon's longtime nemesis, George Ord of Philadelphia, predicted, "In a pecuniary point of view it will prove a failure. No expensive works of the kind will succeed in this country; and the author of the imprudent project ought, from his experience, to know it. But you can do nothing with an enthusiast, to whom everything appears *couleur de rose.*" Even Harris indicated that he would have to "dispose of the large Birds" before he could acquire the *Quadrupeds.*[57]

Just as with the *Birds,* Audubon had begun the project before he completed his research. Bachman called his attention to the missing western specimens. When he learned of the United States Exploring Expedition's return in 1842, following four years of exploration, including in the Pacific Northwest, Audubon hoped that he might be able to duplicate the feat he had accomplished with the Nuttall material.[58] He hurried to Washington to meet with Lieutenant Charles Wilkes, the expedition's commander, but was denied access. He saw four or five thousand sketches, he told Victor, but no quadrupeds.[59]

It was on this same trip, however, that Audubon met Pierre Chouteau Jr. of St. Louis, who had bought the Western Division of John Jacob Astor's American Fur Company. Chouteau's company sent steamboats up the

OPPOSITE:
John James Audubon
Migratory Squirrel
*1842. Watercolor
on paper,
30 ⅛ x 22 ¼ ".
Collection of
The New-York
Historical Society*

*This drawing
features Audubon's
fully modeled
representation of one
squirrel for plate 35,
with outlines for the
placement of the
other two squirrels,
which were drawn
on a separate sheet
(now at the Pierpont
Morgan Library).*

OVERLEAF, LEFT:
*John James Audubon
J. T. Bowen,
lithographer*
**Townsend's Rocky
Mountain Hare,**
*plate 3
Hand-colored
lithograph, 22 x 28".
Courtesy, Department
of Library Sciences,
American Museum
of Natural History,
New York*

OVERLEAF, RIGHT:
*John James Audubon
J. T. Bowen,
lithographer*
**Common
American Wildcat**
*1843. Hand-colored
lithograph, 18 x 24".
William Reese
Company,
New Haven,
Connecticut*

*When he traveled
up the Missouri,
Audubon carried
proof plates of the
Quadrupeds with
him to show the
project to potential
subscribers. He
presented this plate
to Lieutenant James
Henry Carleton of the
U.S. Dragoons.*

The Publication of
*The Viviparous
Quadrupeds of
North America*

Plate III.

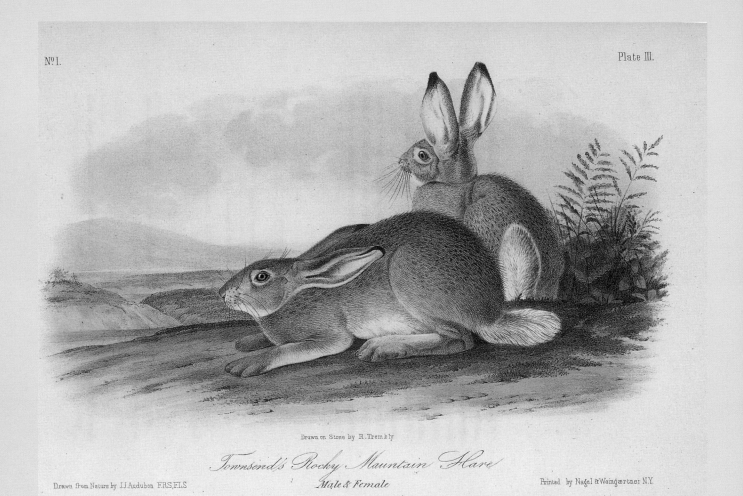

Drawn on Stone by R. Trembly

Townsend's Rocky Mountain Hare

Male & Female

Drawn from Nature by J.J. Audubon F.R.S, F.L.S

Printed by Nagel & Weingærtner N.Y.

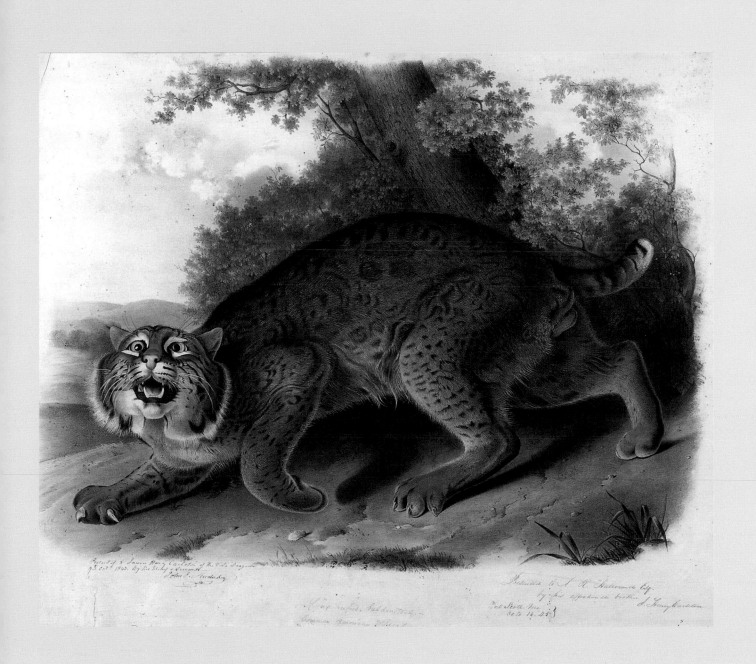

Present of J. Irving Kane. Captain of the U.S. Dragoons,
9th Octr 1845. By his Recty & Servant
John J. Audubon

Cat rufus, red lanx track.
Common American Wild cat

Presented to S. H. Hallowell Esq.
by his affectionate brother J. Tuny Carleton.
Mill Road, Mo.
Octr 16, 45

Missouri River all the way to Fort Union each spring, and Colonel Abert had suggested to his friend Audubon that this might be a way of making his trip. Indeed, Chouteau offered Audubon and his party "passage to the Yellow Stone and . . . back the following year!" as Audubon informed Victor.[60] Audubon invited Bachman, but, of course, his pastoral duties required that he remain in Charleston. Bachman would make the trip vicariously, and just as Audubon departed in March 1843, the pastor penned a long letter of advice.

1. In the first place do not entirely overlook the birds. [Take] My word for it[,] you will see several new species & those too which you have heretofore thought were South-American. Figure them & preserve skins.
2. It will not be much trouble to collect seeds of plants, but this will of course be a secondary consideration.
3. There will not be many snakes or lizzards [sic], but they are so easily preserved that they should not be thrown away.
4. After all you must attend to your business which is looking for quadrupeds & knowing all about their history. I need not say I know nothing of Western animals, but what the books tell me.

Bachman also gave Audubon advice on how to preserve specimens, what he should look for, how he should document them, and the kinds of notes that he should take. "Every thing . . . you write about them will be new," he wrote. "In a word give a true history of every species that inhabits the planes & mountains—the earth, rocks & trees. This is the duty of the Naturalist."[61]

Audubon took his usual complement of letters of recommendation from notable persons and several proof copies of *Quadrupeds* prints with him to show, in hopes of finding a few subscribers on the trip. He arrived in St. Louis on March 28, only to find that the steamboat on which he was to travel—the *Omega*—was still being prepared and that it probably would not be ready for another month. The Chouteaus welcomed him and his party, and he visited with Pierre Chouteau Sr. on several occasions, talking and studying pocket gophers (or *Canada Pouched Rat,* plate 44), which populated his garden. Calling them "Curious beyond description," Audubon drew four of them while in St. Louis.[62]

The citizens of St. Louis treated Audubon as a virtual celebrity. He dined with Major D. D. Mitchell, U.S. superintendent of Indian affairs, who presented him with a historical "gem," a volume of Lewis and Clark's manuscript journal for the year 1805. The Chouteaus dispatched Étienne Provost, the famous hunter who discovered the South Pass, to accompany him. The Academy of Natural Sciences elected Audubon an honorary member. And, despite the fact that Audubon was about to turn fifty-eight years old and clearly slowing down, the newspapers unanimously reported that "his step [is] elastic, and he seems to have all the ardor and vigor of youth." Tellingly, however, one reporter estimated his age to be sixty. Still, the writer for the

Daily People's Organ deemed him "ready to endure the toils and deprivations of long and tedious journies [*sic*] through savage wilds and uninhabited territories, for the purpose of pursuing his favorite study, as he ever was in his juvenil [*sic*] days." It was a bit of an exaggeration, since trappers and traders had long traversed the territory that Audubon would see. Witness the Scottish nobleman and sportsman Sir William Drummond Stewart, who six years before had taken artist Alfred Jacob Miller to the rendezvous of 1837 in the Wind River Mountains. Now he invited Audubon to accompany him on his pilgrimage to the last rendezvous. But to Audubon, Stewart's party looked more like a "gang" than a scientific expedition—and they would be traveling overland instead of in the comfort of a steamboat—so he declined.[63]

Audubon's remarks to his family were somewhat less gracious, concluding that "only 2 Men of Science belong to this City (Natural Science mind you).—Many call to see simply what sort of a looking fellow I am &c &c." The problem was that, although he had shown his prints to a number of people in St. Louis, he had received "No subscriptions, neither do I expect one *here!*"[64]

Audubon departed St. Louis on April 25, arriving at Fort Union on June 12, the fastest trip on record up to then. Alexander Culbertson, bourgeois (superintendent) at Fort Union, led a "cavalcade" down to the boat to welcome the naturalist and his party. After serving them what Audubon deemed to be "first-rate port wine," Owen McKenzie, part-Indian son of the Scottish builder of the post, showed Audubon to the same quarters that Prince Maximilian had occupied during the winter of 1833.[65]

One of the main goals of the Romantic explorers was to find a pristine wilderness and Indian culture untainted by civilization. If that was one of Audubon's goals, he was far too late, for Euro-Americans had been traveling among and trading with the Indians of the upper Missouri for more than a century. As the *Omega* prepared for an even faster return trip, Audubon sent back letters and his journal. "I am going to collect all possible information about Quadrupeds &c during my stay here and from good sources," he wrote in one of those letters. "My head is actually swimming with excitement and I cannot write any more, in a few days after we are settled I will feel better for it, and will send you another and a better Letter." Probably suffering from culture shock, the young Isaac Sprague confided to his diary, "Here far away from civilisation, the traders pass the best of their days—some from a love of adventure, some for gain—and others for crime are driven from civilised society." He asked if he could return immediately on the *Omega,* but then he changed his mind and remained with the party.[66]

Audubon spent a busy two months there, hunting, trapping, observing nature, drawing, and watching his companions in what seemed almost daily buffalo hunts. He felt that at fifty-eight he was too old to engage in this treacherous sport and had promised Lucy that he would take no chances, but his account of the extended buffalo hunt is one of the high points of his jour-

nal.[67] "We are now pretty busy drawing Quadrupeds," he wrote Victor on June 17, "and all possible attentions and accomodations [sic] are granted to us. . . . Sprague and I have been busy drawing all day, and Bell shooting and skinning pretty much as long as we." He noted using the camera lucida to draw the head of an old male buffalo; then he finished it using the system of squares he had developed at Mill Grove.[68]

When Audubon learned that Culbertson had killed two buffalo bulls in a hunt, he went out the next day to get one of the skulls for his collection. "I lost the head of my first bull because I forgot to tell Mrs. Culbertson that I wished to save it," he wrote. Culbertson's wife, the daughter of a Blackfoot chief, "had its skull broken open to enjoy its brains." This was too much for even Audubon: "Handsome, and really courteous and refined in many ways, I cannot reconcile to myself the fact that she partakes of raw animal food with such evident relish."[69]

Audubon and Sprague drew the specimens resulting from several hunts—buffalo, prairie dogs, wolves, hares, antelopes—but dozens of species still evaded him. He offered several of the men money for quadrupeds: $10 for bighorn males, $20 for a grizzly bear, $6 for a male elk, $6 for a black-tailed deer, $3 for a red or a small gray fox, and $2 for a badger or porcupine. He noted in his journal, "I showed the plates of the quadrupeds to many persons, and I hope with success, as they were pleased and promised me much."[70] He also had shown them to a group of Indians on board the *Omega.* "One of the women actually ran off at the sight of the Wood Chuck [plate 2] exclaiming that they were alive &[c].—The chiefs knew all of the animals except the Little Squirrels from the Oregon [plate 15]."[71] As he prepared to return home, Audubon gave four quadruped prints to Lieutenant James Henry Carleton in exchange for a black bear skin and a (promised) set of elk horns.[72]

Audubon began the long return on August 16, 1843. Among his bag-

John Woodhouse Audubon **American Grizzly Bear** *c. 1845. Oil on canvas, 22 x 28". JKM Collection, Courtesy of National Museum of Wildlife Art, Jackson Hole, Wyoming*

John Woodhouse Audubon painted this male grizzly bear for plate 131. The final composition in the print also included a female grizzly.

John James Audubon **Porcupine** *1842. Watercolor and pencil on paper, pasted on canvas, 34 ¼ x 25". Courtesy, Department of Library Sciences, American Museum of Natural History, New York*

The Publication of
*The Viviparous
Quadrupeds of
North America*

gage were animal and bird skins (the new birds would be illustrated for the octavo *Birds*), drawings, Indian trophies, and several live specimens, including a swift fox, a badger, and a Rocky Mountain deer, which he hoped to add to the Minnie's Land menagerie.[73] As he described the uneventful trip back home, he made it seem almost as if the animals themselves came out in a salute to the "great American Woodsman," who was bringing his last great adventure to a close:

Started from Fort Union at 12 M. in the Mackinaw barge 'Union.'. . . Camped at the foot of a high bluff. . . . *Thursday, 17th.* Started early. Saw three Bighorns, some Antelopes, and many Deer, fully twenty; one Wolf, twenty-two Swans, many Ducks. . . . *Friday, 18th.* Fifteen to twenty female Elks drinking, tried to approach them, but they broke and ran off to the willows and disappeared. . . . *Saturday, 19th.* Wolves howling, and bulls roaring, just like the long continued roll of a hundred drums. Saw large gangs of Buffaloes walking along the river. . . . Abundance of Bear tracks. . . . Herds of Buffaloes on the prairies. . . . *Saturday, 20th.* . . . Thousands upon thousands of Buffaloes; the roaring of these animals resembles the grunting of hogs, with a rolling sound from the throat. . . . I made two sketches. . . . *Monday, 21st.* Buffaloes all over the bars and prairies, and many swimming; the roaring can be heard for miles. . . . breakfasted near the tracks of Bears surrounded by hundreds of Buffaloes."[74]

Bachman, of course, was almost wild with anticipation at what Audubon had found and drawn. But, in truth, the trip was something of a disappointment. "The variety of quadrupeds is small in the country we visited," Audubon reported, "and I fear that I have not more than 3 or 4 new ones." The pouched rat (pocket gopher), which Audubon had studied in St. Louis before heading up the river, they knew would be an addition (plate 44). A little mouse from Fort Union also turned out to be a new species, and Bachman requested that Audubon paint it for the book (plate 100, the *Missouri Mouse*). It might have been with tongue only slightly in cheek that

John Woodhouse Audubon Drawn on stone by William E. Hitchcock. Lithographed, printed, and colored by J. T. Bowen. **Missouri Mouse,** *plate 100 Hand-colored lithograph, 6 ¾ x 10 ⅛ ". Buffalo Bill Historical Center, Cody, Wyoming. Gift of Deborah B. Chastain*

In the text of the Quadrupeds, Audubon's voice admits to not paying enough attention to the small animals: "This pretty animal was discovered for us by Mr. Denig, during our sojourn at, and in the neighbourhood of Fort Union in 1843. It was in full summer pelage, having been killed on the 14th of July. At that time being in quest of antelopes and large animals, we did not give it that close attention, which we should have done." (Quadrupeds, 2:328)

John James Audubon in the West

OPPOSITE: *John Woodhouse Audubon* **White American Wolf** *c. 1843. Oil on canvas, 21 ⁷⁄₁₆ x 26 ⅝ ". Courtesy, Department of Library Sciences, American Museum of Natural History, New York*

John James Audubon saw numerous wolves on his Missouri River trip and provided information on the animal for the Quadrupeds text. *He often described them as scavenging in the vicinity of Fort Union, a habit that inspired the presentation of the animal in plate 72 of the* Quadrupeds. *Although based on information from the elder Audubon, the image for the* Quadrupeds *was painted by his son John Woodhouse Audubon.*

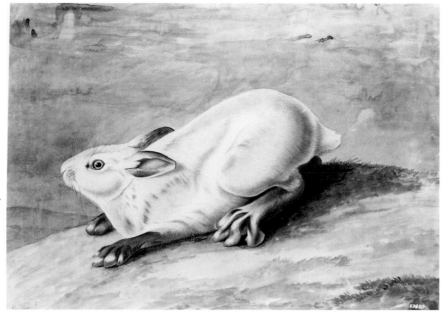

Bachman responded: "I am glad the western prairies have used you so well—that you have grown fat on Bisons humps. . . . You were I fear too stationary for many new quadrupeds." Audubon changed the subject in his sharp retort: "I am now engaged at procuring subscriptions to the Quadrupeds 10 of which I received last Week. How is it that you have not sent us a single name?"[75]

Audubon did not want to show Bachman his journal, probably because he was aware of how little scientific information it contained and he did not want to open himself to Bachman's criticism. He even refused to show it during Bachman's 1845 visit to Minnie's Land. When Bachman, back in Charleston, finally threatened to withdraw from the project, Audubon relented and sent him the journal. Bachman, of course, was disappointed, finding "less. . . of quadrupeds than I had expected." In fact, he said, Lewis

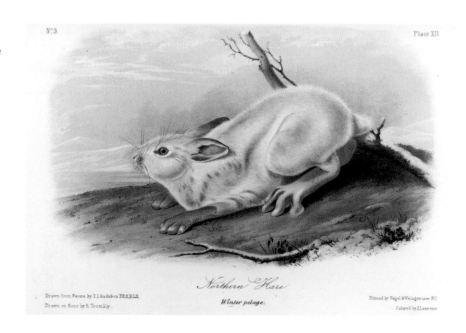

The Publication of
*The Viviparous
Quadrupeds of
North America*

John Woodhouse
Audubon
Drawn on stone by
William E. Hitchcock.
Lithographed, printed,
and colored by
J. T. Bowen.
**American Souslik,
Oregon Meadow
Mouse, Texan
Meadow Mouse,**
plate 147. Hand-
colored lithograph,
6 ¾ x 10 ⅛".
Buffalo Bill
Historical Center,
Cody, Wyoming.
Gift of Deborah B.
Chastain

OPPOSITE:
*John Woodhouse
Audubon*
Black-Footed Ferret
*1846. Oil on canvas,
22 x 27 ⅛".
National Gallery
of Art,
Washington, D.C.
Gift of
E.J.L. Hallstrom*

*Contacts Audubon
made during his
1843 trip continued
to help his project.
The specimen of
the black-footed
ferret, which John
Woodhouse Audubon
used for this painting,
was supplied by
Alexander Culbertson,
the trader at Fort
Union.*

and Clark had written more on the mammals of the Missouri River region than Audubon had. He suggested that Audubon contact Culbertson to obtain information, "not [about] his princess brain-eating, horse straddling squaw" and the other sorts of things he had written about in his journal, but about the skunk, the "hares in winter colors," "the rabbit that led you on so many chases," the large red fox, the mountain goat, the mouse. Bachman found "the narratives . . . are particularly spirited—often amusing & instructive" and was able to use some of the details—on the beaver, for example— but for others, such as the bison measurements, Audubon had not kept very good notes. Nor had he taken the best care of his specimens. "I am exceedingly troubled about . . . the Prairie Dog," Bachman wrote upon receiving a box of specimens. "Sometimes I think that a parcel of legs & a head that came in the box may be that species—there is however as usual nothing labelled."[76]

Still, Audubon's journal contained some good narratives, and some new animals were in the shipments that Bachman received. He thought that Townsend's ground squirrel (plate 147, the *American Souslik*) might be new, but he was certain that "the Missouri fellow" was one of the greatest discoveries from the West: "true blue—a good species no doubt—a species new to the United States."[77] This was the black-footed ferret, which Bachman and Audubon had the pleasure of announcing to the world, and which some doubted because the specimen was lost and no others turned up for years. The largely nocturnal creatures, the only native North American ferrets, are today among the most threatened of the continent's mammals. Because they survive largely on the prairie dog, the dwindling prairie-dog populations contributed to the near extinction of the black-footed ferrets.

If the expedition was a disappointment in terms of new species, it was a huge success in terms of publicity. Audubon was now something of a celebrity, and he attracted a crowd wherever he went. Victor's well-placed feature

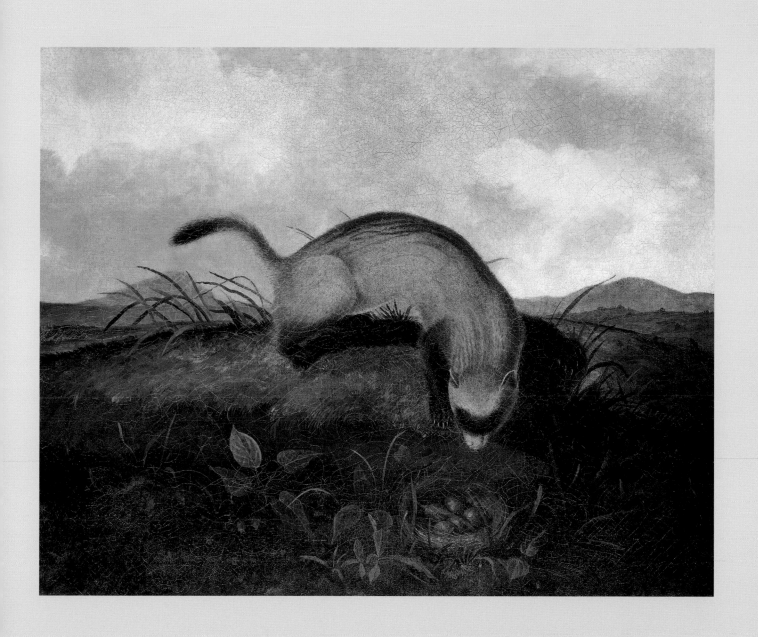

No. 99. Pl. 492.

Brewers Black bird.

Male.

Drawn from Nature by J.J.Audubon.FRSFLS. Lith Printed & Col'd by J.T. Bowen. Philad'

No. 99. Pl. 491.

Least Flycatcher.

Male.

Drawn from Nature by J.J.Audubon.FRSFLS. Lith Printed & Col'd by J.T. Bowen. Philad'

*John James Audubon
J. T. Bowen,
lithographer*
Brewers Black Bird
*After 1843. Hand-
colored lithograph,
8 ¾ x 5 ⅛".
Buffalo Bill
Historical Center,
Cody, Wyoming.
Gift of Dean
and Mary Swift
and Mary Williams
Fine Arts of Boulder,
Colorado*

Added to the Birds *after the Missouri River trip.*

*John James Audubon
in the West*

stories had prepared the eastern audience for his return. When Audubon paused in Philadelphia to see how work on his publications was coming before going on to New York, he encountered a reporter for the *Mercury:*

As we turned into Chestnut street, from 4th on Saturday, coming from our "dinner," . . . we encountered a finely built, muscular looking gentleman, whose appearance attracted general observation. We at once recognized him as Audubon, the celebrated Naturalist. Time has set his finger lightly on him since we saw him last. He was clothed in a white blanket hunting coat, and undressed otter skin cap; his beard was grizzled, and, with his moustache, had been suffered to grow very long. On his shoulder, Natty Bumpo-fashion, he carried his rifle, in a deer-skin cover; and his whole appearance was characteristic of his character for wild enterprise and untiring energy. He went immediately to Sanderson's; and there he was quite the lion of the afternoon. He has brought many rare specimens of natural history and geology with him, accounts of which will doubtless enrich his next publication.

A *Saturday Courier* reporter added, "Nothing could have gratified our feelings more than to have seen the old hero of the forest meet his loving and much loved family; and as we were denied that felicity, we close our hasty

*John James Audubon
J. T. Bowen,
lithographer*
Least Flycatcher
*After 1843.
Hand-colored
lithograph,
9 x 5¹⁄₁₆".
Buffalo Bill
Historical Center,
Cody, Wyoming.
Gift of Dean
and Mary Swift
and Mary Williams
Fine Arts of
Boulder, Colorado*

Added to the Birds *after the Missouri River trip.*

164

Plate LXXI

On Stone by Wᵐ E. Hitchcock

Prairie Wolf

Drawn from Nature by J.W.Audubon

Litʰ. Printed & Colᵈ by J.T.Bowen, Philad

paragraph by wishing him and them all comfort and happiness, as the just rewards of a valued and devoted life, bestowed to the elaboration of the elevating and soul-lifting Science of Natural History."[78] Audubon arrived at Minnie's Land on November 6.

After returning home, Audubon quickly brought the "little work" to a conclusion in the spring of 1844. Then he turned his full attention to painting animals. By May 5 he was on the road on another extended selling trip, leaving Victor in charge of the office and production of the book. He went first to New Bedford, then to Boston, reporting on June 20 that he had received thirty-three new subscriptions. He returned to Minnie's Land for a few days, then set out on a trip that took him through Auburn, Geneva, Rochester, Canandaigua, Buffalo, Utica, and Schenectady, before returning to New England for another brief tour in September. In the meantime, with his subscription list for the *Quadrupeds* approaching 200, Victor was puzzling over how many copies he should print. Now 300 seemed like a more realistic possibility. The imperial folio plates began to appear on a regular basis in 1844, more or less at the pace of five numbers per year until the project was finished early in 1849.[79]

The rush to publication soon forced Audubon into the same kind of compositional problems that he had encountered with the *The Birds of America*. As in the *Goshawk, Stanley Hawk* (plate 141 of the *Birds*), for which he had positioned figures on a white sheet of paper and asked Havell to supply the background, Audubon drew three rabbits and a sketchy background, leaving the final background for probably Victor or Maria Martin. In his painting, the male is located farther to the right than in the lithograph (plate 22), comprising more of a triangular family group. In the finished lithograph, the male is positioned somewhat awkwardly above the female. But for the perspective implied in the image (see the slim grass stalks sticking up behind the female but in front of the male), the male appears to be

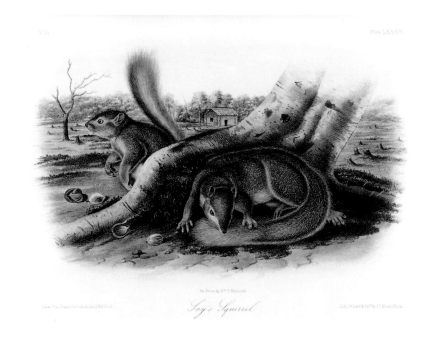

Say's Squirrel

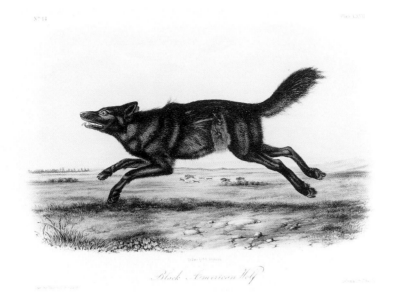

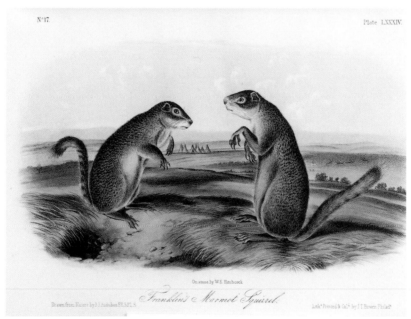

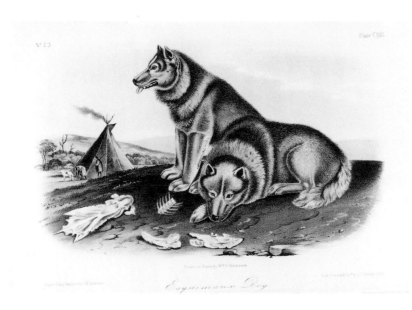

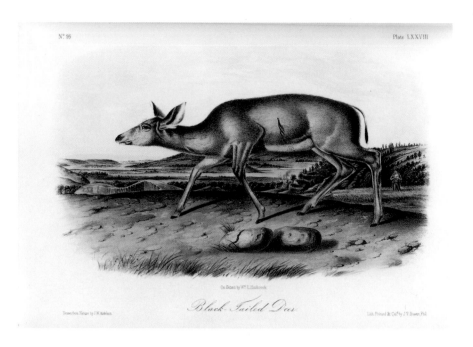

On Stone by Wᵐ E. Hitchcock.

Drawn from Nature by J.W. Audubon. *Black-Tailed Deer* Lith. Printed & Col.ᵈ by J.T. Bowen, Phil.

separated from the composition and to hang in the air above the female. Once the perspective is taken into consideration, the male appears to be much larger, in relation to the female, than he really was. By the time the problem was discovered, Audubon no doubt felt it was not significant enough to redo the plate.[80]

Victor incorporated Audubon's and Sprague's landscapes into backgrounds for a number of the plates, including the *Leopard Spermophile* (plate 39, Fort Union and the Missouri River), *Say's Squirrel* (plate 89, log cabin and tree stumps), coyote (*Prairie Wolf,* plate 71, western landscape), and the gray wolf (*Black American Wolf,* plate 67, wolves chasing bison). Indians are a recurring theme, with teepees and Indian camps appearing in the backgrounds of *Franklin's Marmot Squirrel* (plate 84), the *Esquimaux* [Eskimo] *Dog* (plate 113), and the *Hare-Indian Dog* (plate 132). Victor included Audubon himself in a Missouri River landscape in the plate of the *Black-Tailed Deer* (plate 78).

Back at Minnie's Land on December 23, Audubon continued to write and paint through the spring and completed the introduction to the *Quadrupeds.*[81] He finished an article on "the Habits of the Bison" and in March sent it along with five other articles to Bachman for his reaction. He also wanted Bachman's opinion on the design of the title page of the book. He kept up his correspondence, asking Colonel Abert if there were a zoologist on John Charles Frémont's expedition that had just returned from the West. Admitting that there was none, Abert wrote, "I mean to have the next managed better in these respects."[82]

The first volume of plates for *The Viviparous Quadrupeds of North America,* which Audubon dubbed the "imperial folio," was published in late January 1845. As with "double elephant folio" and "royal octavo," "imperial folio" was a felicitous bit of marketing. Audubon had called *The Birds of America* the double elephant folio, because the paper used for the plates was

PLATE LXXI.

Drawn from Nature by J.J. Audubon. F.R.S.F.L.S.

CANIS LATRANS, SAY.
PRAIRIE WOLF.
MALES.
⅓ Natural Size

Lith. Printed & Col.d by J.T. Bowen, Philad.a 1845.

larger than the elephant folio, the largest sheet routinely available. He probably hoped that the term "royal" would suggest to his would-be subscribers a similar size differential. While the sheets used for the *Quadrupeds* were smaller than double elephant folio, they were nonetheless larger than any such book published in the United States, so Audubon gave it a similarly impressive name. Back on the road that spring with Victor, Audubon sold enough subscriptions in Baltimore and Philadelphia to push the total number of subscribers beyond the 300 mark, which he had indicated as the level necessary for a profitable publication.[83]

Bachman's text was running behind the pictures for a number of reasons, perhaps the most serious of which was Bachman's lack of scholarly resources in Charleston and the Audubons' inability to help him. He ran into difficulty with the first description that he attempted, the *Common American Wildcat* (plate 1). He needed an article by Constantine Rafinesque that had been published in the *American Monthly Magazine.* He wrote to Victor, asking that a copy of the magazine be sent to him, but Victor did not reply. Bachman continually importuned the Audubons for help, and asked Edward Harris to intervene. Finally, he resorted to withholding the scientific names for the plates, something that was crucial to the Audubons, because their cash flow depended upon publishing the numbers on a regular schedule.[84]

In the late summer of 1845, Bachman visited Minnie's Land, and Victor arranged with Samuel Morton of Philadelphia, a member of the Philadelphia Academy of Natural Sciences, to check out books and lend them to Victor, who copied the passages that Bachman needed. Returning that fall, Bachman stopped at the Philadelphia academy and in Washington, where he "worked like a horse with [Titian Ramsay] Peale among the Quadrupeds" from the Wilkes expedition. En route home, he happened to share a train car with *New Orleans Picayune* editor George Wilkins Kendall, who had spent a great deal of time in Texas and Mexico and whose *Narrative of the Texan Santa Fe Expedition* (2 vols.; New York, 1844) had just appeared, with its lengthy descriptions of the prairie dogs on the southern plains. Kendall was "full of information," Bachman wrote, suggesting that John should pay another visit to Texas. And when South Carolina troops prepared to go to war in Mexico, Bachman had prepared a circular offering a bounty for certain animals, complete with "written directions about stuffing—skinning—& transporting."[85]

The visit helped Victor to understand the importance of reference materials to Bachman, and he gradually increased the number of shipments. Despite the effects of an infected dog-bite, Bachman went to work on the text. He sent half of the volume 1 manuscript to Victor for suggestions in February 1846, with the remainder arriving on March 29. Victor edited it and had it set in type, but Bachman was so upset with the changes and typesetting errors in the galleys that he again threatened to abandon the project. Finally, volume 1 of the text was finished and sent to the subscribers in December 1846.[86]

The fact that they did not yet have an armadillo and other Texas and southwestern animals led Audubon to accept Kendall's advice and send John Woodhouse back to Texas in the fall of 1845. John had accompanied his father and Harris there in 1837, but their focus then was birds. John set off in early November, in the company of a neighbor boy and one of the family servants. Bachman indicated his high hopes for the expedition when he wrote that John was "not to come back till he has made a clean sweep of the Southern Quadrupeds from the Atlantic to the Pacific."[87]

John arrived in Texas in December, but his first letters were not encouraging. Expenses were more than he had anticipated, and he was finding few new quadrupeds, especially the smaller ones, because the larger predators raided his traps each night. After John joined Colonel William S. Harney of the U.S. Second Dragoons and Texas Ranger John C. Hays at their camp near San Antonio, a local reporter suggested that they would assist him in his search.[88] John had arrived in Texas at a crucial time. The republic had just become a state—in fact, the official ceremony would not take place until February. War with Mexico loomed, and western settlers feared Comanche raids. So a dragoon or Ranger escort would be necessary if he were going into the country west of San Antonio.

He commissioned Rangers and Indian scouts to bring him specimens to paint, by which he was able to obtain several new species. A Texas Ranger named Powell provided the black-tailed hare that he drew for the book. Colonel Harney provided him with one of his greatest finds, the ocelot. And Colonel Hays told him harrowing stories of the jaguar, which he claimed was the most feared of the Texas quadrupeds. From places "not on the map," such as Castroville, Audubon wrote, John finally began to gather other new species, such as the skunk, the cougar (or mountain lion), the Texan red wolf, deer, a panther, and the bassarisk (or ring-tailed raccoon), as well as some new birds.[89]

He finally reported that he had at least seven new plates and perhaps as many as fifteen, but that he would have to return home shortly because of the expenses. Audubon estimated that at that rate the plates would cost them $200 each. Bachman acknowledged that John did add somewhat to their knowledge as well as to the total number of animals, but he lamented that the younger Audubon had not done a better job collecting the small animals.[90] Still they had no armadillo.

When the second volume of the imperial folio *Quadrupeds* was completed in March, two things were apparent to Victor. He told Bachman that his father was abandoning work because of his failing eyesight and that John would have to go to London and Berlin to paint from specimens in the great collections there in order to finish the book. He did not mention Audubon's increasing mental frailty. John spent almost a year in England and Europe. In June 1847, he wrote that he was homesick and would soon be returning. *"I believe I have left nothing undone that I ought to have done,"* he added in regard to the *Quadrupeds*.[91]

OVERLEAF,
LEFT TOP:
*John Woodhouse
Audubon*
**Ocelot, or Texas
Leopard Cat**
*1846. Oil on canvas,
22 x 28 1/4 ".
Gilcrease Museum,
Tulsa, Oklahoma*

*The specimen for
the ocelot was obtained
by John Woodhouse
Audubon during his
trip to Texas in 1845
and used for plate 86.*

OVERLEAF,
LEFT BOTTOM:
John James Audubon
Black-Tailed Hare
*1841. Pen, brush,
and chalk
on buff paper,
15 5/8 x 22 3/4 ".
The Saint Louis
Art Museum,
Saint Louis,
Missouri*

For plate 63.

OVERLEAF, RIGHT:
*John Woodhouse
Audubon*
**White-Tailed Deer,
or Common
American Deer
(Fawn)**
*Oil on canvas,
21 1/4 x 27 3/4 ".
Audubon Memorial
Museum, Henderson,
Kentucky*

*For plate 81.
The text of the*
Quadrupeds *contains
a commentary on the
coloring of the animal:
"The fawns are at first
bright reddish-brown,
spotted with irregular
longitudinal rows
of white. These spots
become less visible as
the animal grows older,
and in the course
of about four months
the hairs are replaced
by others, and it
assumes the colour
of the old ones."
(*Quadrupeds, *2:221)*

The Publication of
*The Viviparous
Quadrupeds of
North America*

Bachman, meanwhile, was making no more progress on the text. His wife, Harriet, died on July 15, 1846, after a lingering illness, and his daughter Julia followed her in death a year later. Just as he seemed about to get to work on volume 2 that winter, he narrowly escaped blindness when a pot of lard, sulfur, and gunpowder, concocted to treat a mangy dog, exploded in his face. A young slave had mistakenly placed it by the fire. Bachman's glasses saved his sight, but he was badly burned and spent the next two weeks in complete darkness, emerging only to entertain the renowned naturalist Louis Agassiz, who was in Charleston to address the Philosophical Society. Bachman proudly showed him both the lithographs and the text volume and relayed his praise to the Audubons.[92]

Seeking a diversion, Bachman visited the Audubons again in May 1848, hoping as well to move the project along. He was hardly prepared for Audubon's condition. "His is indeed a most sad and melancholy case," he wrote Maria Martin. "The outlines of his countenance & his general robust form are there, but the mind is all in ruins." Bachman returned home in June only to receive a letter from Victor asking when he was going to begin volume 2 of the text. Bachman resolved some of his personal problems when he married Maria Martin, his sister-in-law, and he soon reported to Victor that they were working twelve hours a day on the text.[93]

In New York, meanwhile, Victor focused on bringing the imperial folio edition to a close. He and Bachman agreed that, in order to finish the book in thirty numbers, they would leave out the whales, seals, and bats, but "unless we get the Armadillos," Victor warned, "our last numbers will be rather deficient in interest." Finally, on June 17, 1848, Victor informed Bachman that he had an armadillo skin, which John had painted. He predicted that the folio edition would be finished that fall.[94]

Audubon did not live to see the *Quadrupeds* letterpress finished. He died, probably of heart failure, on January 27, 1851, a little less than three months shy of his sixty-sixth birthday.[95]

In between selling trips, Victor encouraged Bachman to finish the text. Burdened by debt because of a series of bad investments and adventures, Victor offered in February 1852 to go to Charleston to "hold the pen" for Bachman to help him finish volume 3 of the *Quadrupeds* text. Victor reported to his mother on February 26, 1852, that they had "described the armadillo which is in the last number." On March 26, Bachman finished the last essay: "I threw my hat to the ceiling, kicked books, papers, rabbit and

The Publication of
*The Viviparous
Quadrupeds of
North America*

Townsend's Ground Squirrel.

Drawn From Nature by J.J. Audubon F.R.S. F.L.S

Printed by Nagel & Weingaertner N.Y.

Drawn on Stone by R. Trembly

Colored by J Lawrence

Townsend's Chipmunk

drawn by J.J. Audubon

*John Woodhouse
Audubon*
**California
Grey Squirrel.**
*Oil on canvas,
19 x 27".
Owned by Walter
Audubon, and
received as a gift
from his late cousin,
Mrs. Margaret
McCormick*

*One of the squirrels
for plate 153, added
by John Woodhouse
Audubon to the
octavo edition.*

OPPOSITE, TOP:
*John James Audubon
J. T. Bowen,
lithographer*
**Townsend's
Ground Squirrel,**
*plate 20
Hand-colored
lithograph, 6 x 10".
Courtesy of
Mongerson Galleries,
Chicago, Illinois*

OPPOSITE,
BOTTOM:
John James Audubon
**Townsend's
Chipmunk**
*1843. Watercolor on
paper, 7 x 9".
Courtesy of
Mongerson Galleries,
Chicago, Illinois*

*This watercolor
depicts one of
the animals that
appears in plate 20.*

squirrel skins and bats about the room, and felt that the nightmare of some years was off my breast."[96]

The third volume of the *Quadrupeds* text would not be published for two more years. There were so many delays in sending galleys back and forth between Victor and Bachman that, at one point, the printer noted in the margin, "The letter is all used up. We can do no more until we receive back proofs from you."[97] As soon as the galleys were approved, the printer would make a stereotype plate (a metal printing plate cast from the type); then he could break up the type and use it again. The book finally came out in 1854.

By then Victor and John were well on their way to producing an octavo edition of the *Quadrupeds,* which proved as successful as the small *Birds.* Their livelihood now depended upon the sales of the two octavo editions and the remaining copies of the folio *Quadrupeds,* which were to go through many more editions during the nineteenth century.[98]

In many ways, the *Quadrupeds* is a natural-history and artistic triumph. Audubon, Bachman, John, who painted fully one-half of the animals, and Victor and Maria Martin, who supplied many of the backgrounds, had produced truly exceptional work for the *Quadrupeds.* Some of the subscribers saw that Audubon had brought the same liveliness and sense of movement to the animals that characterized his birds. The foxes and squirrels are among his finest paintings; he particularly liked the *Swift Fox* (plate 52), but his *Gray Fox* (plate 21) is also one of his best compositions, demonstrating his ability to paint fur almost hair by hair, using a tiny brush with watercolor and pencil, ink, and scratching, details that Bowen ably mimicked in the lithograph. Others focused on Bachman's text, suggesting that it made the pictures come to life. Still other viewers, like Charles Wilkins Webber, realized that, just as with the *Birds,* the landscapes played a significant role in these compositions: they told something of the animal's habitat and provided visual interest for the viewer. The humble picture of the *White-Footed Mouse* (plate 40), for example, would not be nearly as interesting if it were not for the handsome (probably lower Mississippi River) view in the back-

ground. As for the groups of elks (plate 62) and bison (plate 57), these "unitary fragments from the memory of his long life of wanderings," said Webber, "elevated" Audubon's pictures "into the rank of highest Art!"[99]

The work is also a triumph for Bowen. He had broken new ground for American lithography in terms of the size and quality of the plates. Part of his success may be attributed to his careful attention to detail. When Victor complained about the proof of the *Sea Otter* (plate 137), for example, Bowen replied that "this is the 4th attempt[,] so you see[,] I'm not more or better pleased than yourself." Still, he added, "I think I may Improve on this one." And he attained a remarkable consistency throughout the hand coloring. Audubon's American viewers, not being accustomed to large-format, hand-colored works, must have been stunned by the difference between Audubon's

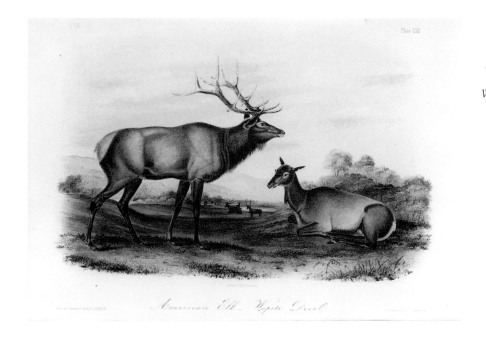

*John James Audubon
Drawn on stone by
William E. Hitchcock.
Lithographed,
printed, and colored
by J. T. Bowen.*
**American
Elk Wapiti Deer,**
*plate 62
Hand-colored
lithograph,
6 ¾ x 10 ⅛ ".
Buffalo Bill
Historical Center,
Cody, Wyoming.
Gift of Deborah B.
Chastain*

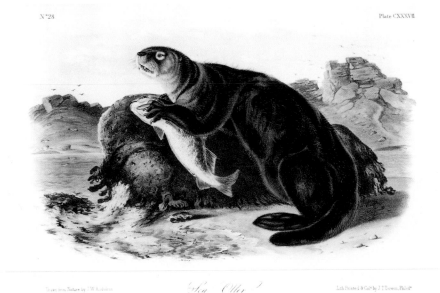

*John Woodhouse
Audubon
Lithographed,
printed, and colored
by J. T. Bowen.*
Sea Otter,
*plate 137
Hand-colored
lithograph,
6 ¾ x 10 ⅛ ".
Buffalo Bill
Historical Center,
Cody, Wyoming.
Gift of Deborah B.
Chastain*

Quadrupeds and the small, cramped, and usually uncolored images in the available encyclopedias or in Wilson's *Ornithology* or Thomas Say's *Entomology.* Critic and author Charles Wilkins Webber, an admirer of Audubon from his youth, concluded that Americans should be "proud that in this instance he has not been compelled, as in that of the 'Birds of America,' to go to the Old World for patronage and skill sufficient to bring out his work. We may justly congratulate ourselves that in the 'Quadrupeds of America,' we have at last a Great National Work, originated and completed among us—the authors, artists, and artisans of which are our own citizens."[100]

Webber, who later became acquainted with the Audubons and visited them at Minnie's Land, may be considered typical of the public response to the naturalist's works. A new social and economic elite emerged in the

The Publication of
*The Viviparous
Quadrupeds of
North America*

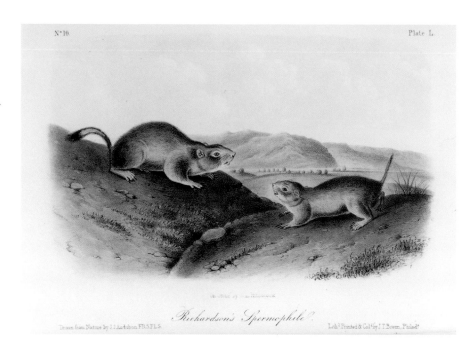

*John James Audubon
Drawn on stone by
William E. Hitchcock.
Lithographed,
printed, and colored
by J. T. Bowen.*
**Richardson's
Spermophile,**
*plate 50
Hand-colored
lithograph,
6 ¾ x 10 ⅛ ".
Buffalo Bill
Historical Center,
Cody, Wyoming.
Gift of Deborah B.
Chastain.*

N° 10.

Plate L.

Richardson's Spermophile?

Drawn from Nature by J.J.Audubon FRSFLS

Lith⁴ Printed & Col⁴ by J.T.Bowen, Philad⁴

decades before the Civil War, one that was attuned to the themes of natural history, susceptible to Audubon's personal charm and persuasive images, and wealthy enough to purchase his books. These people also supported local libraries, art galleries, and natural-history organizations, and collected works by American writers and artists. They subscribed to the journals for which Webber wrote his thoughtful reviews of the *Quadrupeds* and identified with the hardships that Audubon had overcome in producing both the *Birds* and the *Quadrupeds,* the lack of scientific literature on American animals that Bachman had had to deal with, and the fact that Audubon had paid his way with both projects. And they would have rejoiced with Webber in that "The plates in this new work are magnificent." "They are, if possible, even more historical than the plates to the birds. The accessories are indeed more elaborated and detailed."[101]

Bachman was Audubon's greatest fan as well as his severest critic. "The plates are to my eye most beautiful," he wrote Victor in February 1844. "I do not believe as a whole that there is any man living that can equal them." A month later he continued: "The last two numbers of the . . . Quadrupeds . . . are most beautiful & perfect specimens of the Art[.] I doubt whether there is anything in the world of Natural history like them." On the other hand, he pointed out several errors that Audubon had made, probably because he was not as familiar with animals as he was with birds. The image of the *Northern Hare, Summer* (plate 11), for example, contained an obvious error: one of the figures was a common female cottontail (gray rabbit). Audubon argued that the rabbit was small because it was so young and that he would add the word "young" to the legend in the next printing. In addition, the plate of *Richardson's Spermophile* (plate 50) shows the squirrel with a hairless tail because Audubon did not realize that the hair had fallen out of the tail of the poorly preserved specimen that he used. And "that tremendous scrotum" that Audubon had shown on the *Long-Haired Squirrel* of

*John James Audubon
in the West*

California (plate 27) "was not given to it by its creator whose works are natural but was stuffed out of character by Bell." Finally, the plate of the *Texan Skunk* (plate 53) has to be one of Audubon's worst compositions, almost making it appear that there are two animals side by side, one black and the other white, rather than a black animal with a white stripe down its back. Bachman granted that some of the deficiencies resulted from Audubon's poor specimens, and from the artist's never having seen the animals alive. In such cases, he concluded, Audubon failed to show features that distinguish between the species. To all this Audubon defensively responded, "I cannot help copying nature."[102]

John James Audubon Drawn on stone by R. Trembly. Printed and colored by J. T. Bowen.
Long-Haired Squirrel, *plate 27 Hand-colored lithograph, 10 ⅛ x 6 ¾ ". Buffalo Bill Historical Center, Cody, Wyoming. Gift of Deborah B. Chastain*

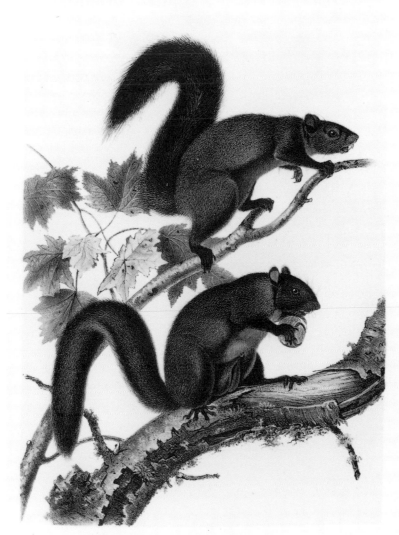

Nº 6 Plate XXVII

Drawn on stone by R. Trembly

Long Haired Squirrel.

Drawn from Nature by J.J. Audubon F.R.S. F.L.S. Printed & Colᵈ by J. T. Bowen, Philad

Plate LIII

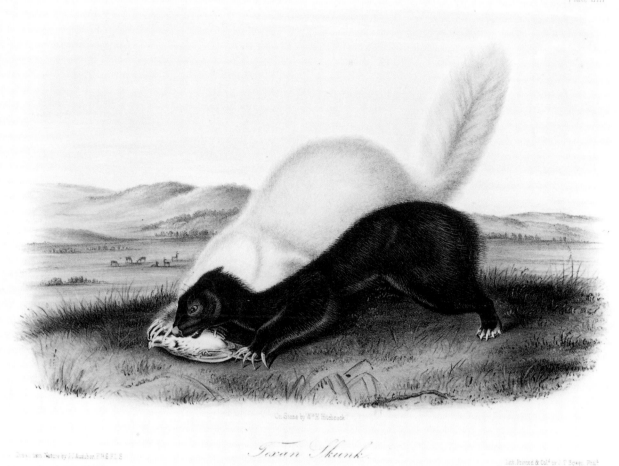

On Stone by Wm H. Hitchcock.

Texan Skunk.

John James Audubon
Drawn on stone
by William H.
Hitchcock.
Lithographed,
printed, and colored
by J. T. Bowen.
Texan Skunk,
plate 53
Hand-colored
lithograph,
6 ¾ x 10 ⅛ ".
Buffalo Bill
Historical Center,
Cody, Wyoming.
Gift of Deborah B.
Chastain.

That is Audubon's ultimate virtue as well. Immediately upon publication, the public accepted the *Quadrupeds* as the philosophical if not the aesthetic equal of the *Birds.* In a later review, Webber placed Audubon's accomplishment on the universal scale: "Audubon saw that art was universal, and that the earth was God's earth and not man's. His genius perceived something purer and more ennobling in the mission of art, than the sole perpetuation of the bloody and perverted passions of humanity. He felt that nothing that God has made is common or unclean to the true artist. HIS truth is every where symmetrical, and though we may turn in disgust from distorted exhibitions of the distorted man, yet are our senses freshened—still is our faith cheered by those chaste revelations of a primeval and most beneficent purpose, which Audubon has bravely snatched from out the 'waste places' of God's earth!"[103]

John James Audubon
in the West

Notes

"My Style of Drawing":
Audubon and His Artistic Milieu

1. Entry for October 12, 1820, in Howard Corning, ed., *Journal of John James Audubon Made During His Trip to New Orleans, 1820–1821* (Boston: Club of Odd Volumes, 1929), 3.
2. As noted in Theodore E. Stebbins Jr., "Audubon's Drawings of American Birds, 1805–38," in Annette Blaugrund and Theodore E. Stebbins Jr., eds., *The Watercolors for the Birds of America* (New York: Villard Books, Random House and The New-York Historical Society, 1993), 3.
3. David was court painter to Louis XVI and Napoleon. Audubon asserted in his journal, "The lessons I had received from the great David now proved all-important to me." Maria R. Audubon, ed., *Audubon and His Journals* (1897; reprint, New York: Dover Publications, 1991), 1:39.
4. William Dunlap, *A History of the Rise and Progress of the Arts of Design in the United States* (New York, 1834; reprint, New York: Dover Publications, 1969), 2:405.
5. The lost dauphin was the second son of Louis XVI and Marie Antoinette.
6. As quoted in the *New York Times Magazine,* November 29, 1931, 8 ff.
7. Stein lent Cole a treatise on oil painting, and Cole later wrote that much of the book influenced him. Stein, an itinerant portraitist, was in Steubenville, Ohio, in 1820, about the time Audubon was in Cincinnati. See Gary A. Reynolds, *John James Audubon and His Sons* (New York: Grey Art Gallery and Study Center, New York University, 1982), 29.
8. In 1874, Sir Hans Sloane's enormous and varied collection was bought by the British government, along with others, which ensured their continued public display. See Arthur MacGregor, ed., *Sir Hans Sloane, Collector, Scientist, Antiquary, Founding Father of the British Museum* (London: British Museum Press, 1944).
9. Alice Ford, *John James Audubon: A Biography* (New York: Abbeville Press, 1988), 172.
10. Anne Lyles, *Turner and Natural History: The Farnley Project* (London: Tate Gallery, 1988); see also David Hill, comp., *Turner's Birds: Bird Studies from Farnley Hall* (1988).
11. John James Audubon, *Ornithological Biography* 3 (1840–44 ed.; reprint, New York: Volair Books, 1979), 3:12.
12. Ibid., 5:7.
13. Havell was a responsive artistic partner with whom Audubon had an enduring working relationship and friendship. He, too, moved to the United States and settled in 1839 in the New York area, where he devoted himself to painting.
14. In the United States, Audubon could have seen such objects in the homes of wealthy plantation owners such as James Pirrie or in homes in Philadelphia or at Mill Grove.
15. As quoted in Irving T. Richards, "Audubon, Joseph R. Mason, and John Neal," *American Literature* 6, no. 2 (May 1934): 122.
16. Marty Crisp, "Local Mystery Artist Emerges from Audubon's Background," *Lancaster (Pa.) Sunday News,* April 28, 1991, H12.
17. As quoted in Annie Roulhac Coffin, *Maria Martin (1796–1863), The Art Quarterly* (Autumn 1960): 296.
18. M. R. Audubon, *Audubon and His Journals,* 2:108.
19. Ibid., 1:202.

Omega: John James Audubon's Final Artistic Journey

1. For a discussion of Audubon as field naturalist, see Amy R. W. Meyers, "Observations of an American Woodsman: John James Audubon as Field Naturalist," *The Watercolors for "The Birds of America,"* eds. Annette Blaugrund and Theodore E. Stebbins Jr. (New York: Villard Books, Random House and The New-York Historical Society, 1993), 43–54.
2. John James Audubon, and the Reverend John Bachman, *The Quadrupeds of North America* (New York: V. G. Audubon, 1849–54), 2:51.
3. Alice Ford, ed., *The 1826 Journal of John James Audubon* (Norman: University of Oklahoma Press, 1967), 275.
4. Maria R. Audubon, *Audubon and His Journals* 1897; (reprint, Freeport, N.Y.: Books for Libraries Press, 1972), 1:204.
5. M. R. Audubon, *Audubon and His Journals,* 1:210–11.
6. J. J. Audubon, *Quadrupeds,* 1:16.
7. Ibid., 1:147.
8. Parke Godwin, "John James Audubon," in *Homes of American Authors: Comprising Anecdotical, Personal, and Descriptive Sketches by Various Writers* (New York: G. P. Putnam and Co., 1853), 5.
9. Harris's journal from the trip has been published as *Up the Missouri with Audubon: The Journal of Edward Harris,* comp. and ed. John Francis McDermott (Norman: University of Oklahoma Press, 1951). Harris was born September 7, 1799, and died June 8, 1863.
10. Isaac Sprague's journal of the trip is in the manuscript collections of the Boston Athenaeum, which also holds several of his drawings from a collection, including two that come from the 1843 trip. Sprague was born September 5, 1811, and died on March 13, 1895. He met Audubon when the latter came to Boston in 1840; Sprague apparently showed his drawings of birds to Audubon. After the 1843 trip, he did botanical illustrations for Professor Asa Gray of Harvard University.
11. Bell's three-volume journal is in the Beinecke Library at Yale University. He was born July 12, 1812, and died in 1879.
12. Audubon had wanted Spencer Fullerton Baird to go on the journey, but when he declined, Lewis Squires filled the place. Squires appears to have been a neighbor of Audubon's, but little else is known about him.
13. John James Audubon to Victor G. Audubon, St. Louis, April 17, 1843, *Audubon in the West,* ed. John Francis McDermott (Norman: University of Oklahoma Press, 1965), 55–59. The original is in the collection of the National Audubon Society, New York City, and is on loan to the National Museum of American History, Smithsonian Institution, Washington, D.C.
14. M. R. Audubon, *Audubon and His Journals,* 1:463–67.
15. John James Audubon to John Bachman, St. Louis, April 23, 1843, Houghton Library, Harvard University.
16. The *Omega,* a 144-ton side-wheel steamboat, had been built in Pittsburgh, Pennsylvania, in 1840. It was dismantled in 1849, and no images of it have surfaced. Michael M. Casler, "Steamboats of the Fort Union Fur Trade: A Listing of Steamboats on the Upper Missouri River between 1832 to 1867" (manuscript 1996). The log of the *Omega* is in the Missouri Historical Society.
17. M. R. Audubon, *Audubon and His Journals,* 1:455.
18. McDermott, *Up the Missouri with Audubon,* 54.
19. M. R. Audubon, *Audubon and His Journals,* 1:456.
20. J. J. Audubon to V. G. Audubon, April 25, 1843, *Audubon in the West,* 69–73.
21. Ibid., 74.
22. M. R. Audubon, *Audubon and His Journals,* 1:459–60.
23. Sprague journal, 1843, Boston Athenaeum.
24. M. R. Audubon, *Audubon and His Journals,* 1:469.
25. J. J. Audubon to V. G. Audubon, May 5, 1843, *Audubon in the West,* 82.
26. For the history of the publication of the octavo edition, see Ron Tyler, *Audubon's Great National Work: The Royal Octavo Edition of "The Birds of America"* (Austin: University of Texas Press, 1993).
27. William Healey Dall, *Spencer Fullerton Baird: A Biography* (Philadelphia: J. B. Lippincott Co., 1915).
28. J. J. Audubon to V. G. Audubon, May 8, 1843, *Audubon in the West,* 86.
29. Hiram Martin Chittenden, *History of Early Steamboat Navigation on the Missouri River: Life and Adventures of Joseph La Barge* (New York: Francis P. Harper, 1903), 1:144–48.
30. M. R. Audubon, *Audubon and His Journals,* 1:478–82.
31. Chittenden, *History of Early Steamboat Navigation,* 1:150.

32. George Catlin, *Letters and Notes on the Manners, Customs, and Condition of the North American Indians,* 2 vols. (London, 1841; reprint, New York: Dover Publications, 1973).

33. M. R. Audubon, *Audubon and His Journals,* 1:498.

34. J. J. Audubon to V. G. Audubon, Fort Pierre, June 1, 1843, *Audubon in the West,* 95–98.

35. M. R. Audubon, *Audubon and His Journals,* 2:11.

36. J. J. Audubon, *Viviparous Quadrupeds* (New York: John James Audubon, 1845–1848), 2:16.

37. M. R. Audubon, *Audubon and His Journals,* 2:36.

38. Ibid., 2:37.

39. J. J. Audubon, *Viviparous Quadrupeds,* 2:160.

40. Bell journal, vol. 2, July 21, 1843, Beinecke Library, Yale University.

41. Bell journal, vol. 2, July 24, 1843, Beinecke Library.

42. J. J. Audubon, *Viviparous Quadrupeds,* 2:35.

43. Maria R. Audubon to P. F. Madigan, May 31, 1901, collections of Stark Museum of Art, Orange, Texas.

Audubon and Bachman: A Collaboration in Science

1. John James Audubon letter, St. Augustine, East Florida, December 7, 1831, John Bachman Papers, Charleston Museum.

2. J. J. Audubon to John Bachman, Edinburgh, October 27, 1838, *Letters of John James Audubon, 1826–1840,* ed. Howard Corning (Boston: Club of Odd Volumes, 1930), 2:207.

3. The notable exception to this were his trips to Labrador in 1833 and Texas in 1837.

4. Maria R. Audubon, ed., *Audubon and His Journals* (New York: Charles Scribner's Sons, 1897), 1:453. It should be noted that Audubon's diaries were heavily edited, and in some cases rewritten, by Audubon's granddaughter, so it is not entirely certain that these sentiments were Audubon's. Contemporary documents suggest that, as on earlier trips, his greatest interest and enthusiasm were reserved for ornithological discoveries.

5. J. J. Audubon to Benjamin Phillips, June 23, 1839, location of original letter unknown, from a typescript, Audubon Papers, Princeton University Library.

6. Ibid.

7. J. J. Audubon to Thomas McCulloch Jr., June 26, 1841, Audubon Papers, Princeton University Library.

8. J. J. Audubon to Phillips, June 23, 1839, typescript, Princeton University Library.

9. J. J. Audubon to Bachman, New York, January 2, 1840, *Letters of John James Audubon,* 2:230. The FRSL to which Audubon proudly referred in this letter should have been FRS, indicating his status as a Fellow of the Royal Society; the L, which he inserted for emphasis, stands for London, where the society was (and continues to be) based. The DD he attached to Bachman's name indicates the minister's academic degree as a doctor of divinity.

10. Bachman to J. J. Audubon, January 13, 1840, Bachman Papers, Charleston Museum.

11. Bachman to J. J. Audubon, September 13, 1839, Bachman Papers, Charleston Museum.

12. [Charles Wilkins Webber], "The Quadrupeds of North America," *American Review* 4 (December 1846): 627.

13. *Literary World: A Gazette for Authors, Readers and Publishers* 1, no. 6 (March 13, 1847): 128. The same description of Bachman (along with most of the rest of the review) was repeated in *Southern Quarterly Review* 22 (October 1847): 290.

14. Bachman to J. J. Audubon, September 13, 1839, Bachman Papers, Charleston Museum.

15. Bachman to J. J. Audubon, July 5, 1839, Bachman Papers, Charleston Museum.

16. J. J. Audubon to Phillips, June 23, 1839, typescript, Princeton University Library.

17. Bachman to J. J. Audubon, September 13, 1839, Bachman Papers, Charleston Museum, quoted in Ford, *John James Audubon,* 417.

18. Bachman to J. J. Audubon, Charleston, December 24, 1839, Bachman Papers, Charleston Museum.

19. Bachman to J. J. Audubon, Charleston, January 13, 1840, Bachman Papers, Charleston Museum.

20. Bachman to J. J. Audubon, July 5, 1839, Alabama Department of Archives and History.

21. Bachman to Victor Gifford Audubon, February 18, 1846, Bachman Papers, Charleston Museum.

22. The Academy of Natural Sciences (signed by Henry D. Rogers, Samuel G. Morton, and Walter R. Johnson) to J. J. Audubon and Edward Harris, March 21, 1843, Alabama Department of Archives and History.

23. Harris's papers, including his journal and the financial records of the trip, are in the Harris Collection at the Alabama Department of Archives and History.

24. It appears that Harris split the expense of Bell's $500 salary with Audubon ($250 each). Audubon paid all of Bell's equipment and supply costs.

25. J. J. Audubon to Harris, February 3, 1843, Houghton Library, Harvard University.

26. J. J. Audubon to Harris, February 9, 1843, Houghton Library.

27. J. J. Audubon to Spencer Fullerton Baird, February 23, 1843, quoted in W. H. Dall, *Spencer Fullerton Baird* Philadelphia: J. B. Lippincott Co., 1915), 92, and in John Francis McDermott, comp. and ed., *Up the Missouri with Audubon: The Journal of Edward Harris* (Norman: University of Oklahoma Press, 1951), 8. Little is known about Lewis Squires except what appears in the journals of Audubon and Harris.

28. J. J. Audubon, with a P.S. from V. G. Audubon to Harris, March 4, 1843, Houghton Library.

29. Much of Sprague's artistic production on the Missouri River trip has been lost, but examples can be seen in the collections of the Boston Athenaeum and the American Museum of Natural History in New York.

30. Letters at the Houghton Library confirm that Victor was expected to have been a member of the expedition.

31. Victor's first wife, Mary Eliza (née Bachman), died May 25, 1841. Her sister, Maria Rebecca, John Woodhouse Audubon's first wife, died September 15, 1840.

32. J. J. Audubon to Harris, March 4, 1843, Houghton Library.

33. Baird to J. J. Audubon, February 7, 1843, Morris Tyler Family Collection, Beinecke Library, Yale University. Despite Baird's claim to the contrary, it appears he really did not want to go on the expedition, or his family forbade his going, and Baird, self-conscious about his lack of independence, found other reasons to put forth as an excuse. He initially declined Audubon's invitation for reasons of personal finance (Baird to J. J. Audubon, January 28, 1843, Morris Tyler Family Collection). Later, when Audubon offered to cover his traveling expenses, Baird responded with a list of other conflicts, including his unwillingness to disrupt courses he was taking in mathematics and modern languages, and a need to help his uncle with a surveying project (Baird to J. J. Audubon, February 17, 1843, Morris Tyler Family Collection).

34. The cost of this expedition was very large, considering that at the time Bell's salary alone represented a year's rent for a "comfortable house" in St. Louis. J. J. Audubon's "letter to family," March 28, 1843, quoted in John Francis McDermott, ed., *Audubon in the West* (Norman: University of Oklahoma Press, 1965), 37. See also Margaret Curzon Welch, "John James Audubon and His American Audience: Art, Science, and Nature, 1830–1860" (Ph.D. diss., University of Pennsylvania, 1988), 150.

35. Francis Hobart Herrick, *Audubon the Naturalist: A History of His Life and Time* (1917; reprint, New York: Dover Publications, 1968), 2:250, and in Jay Shuler, *Had I the Wings: The Friendship of Bachman and Audubon* (Athens: University of Georgia Press, 1995), 189.

36. St. Louis *Daily People's Organ,* April 4, 1843, quoted in McDermott, *Up the Missouri with Audubon,* 14.

37. *Missouri Republican,* April 5, 1843, quoted in John Francis McDermott, *Up the Missouri with Audubon,* 14.

38. J. J. Audubon, original manuscript of *Ornithological Biography,* Beinecke

Library, Yale University, quoted in Ford, *John James Audubon,* 363.

39. Harris diary, June 12, 1843, Alabama Department of Archives and History.

40. M. B. Audubon, *Audubon and His Journals,* 1:470–71.

41. For Audubon's original behavioral description of the first two species from which Bachman drew sections for the text in the *Quadrupeds,* see J. J. Audubon to Bachman, April 23, 1843, Houghton Library.

42. See entries for July 16, 1843, in both the Audubon and Harris diaries. Audubon's diary and a letter from Harris to Dr. Spencer dated December 1, 1843, both indicate that Audubon was away fishing at the time the buffalo hunt occurred. This curious example of possible plagiarism in Audubon's account was first pointed out by Phillips B. Street in "The Edward Harris Collection of Birds," *Wilson Bulletin* 60, no. 3 (September 1948): 167–84. It is possible that the "borrowing" of Harris's description (which puts Audubon in the action role) could have happened long after Audubon's death, when his granddaughter was preparing his diary for publication.

43. M. R. Audubon, *Audubon and His Journals,* 1:457.

44. Ibid., 1:508–9.

45. John James Audubon and John Bachman, *The Viviparous Quadrupeds of North America* (New York: V. G. Audubon, 1846–54), 2:35.

46. J. J. Audubon to Gideon B. Smith, Fort Union, June 13, 1843, Houghton Library.

47. J. J. Audubon to Bachman, November 12, 1843, Houghton Library.

48. J. J. Audubon to Baird, in Thomas M. Brewer, "Reminiscences of John James Audubon," *Harper's New Monthly Magazine* 61 (1880): 671.

49. J. J. Audubon to his family ("My Dearest Friends"), April 25, 1843, National Audubon Society, quoted in John Francis McDermott, ed., *Audubon in the West* (Norman: University of Oklahoma Press, 1965), 71.

50. J. J. Audubon to Bachman, November 12, 1843, Houghton Library.

51. Ibid.

52. Harris diary, July 19, 1843, Alabama Department of Archives and History.

53. J. J. Audubon to Baird, July 30, 1842, quoted in Herrick, *Audubon the Naturalist,* 2:241.

54. Bachman to J. J. Audubon, March 6, 1846, Bachman Papers, Charleston Museum.

55. For a complete inventory of the specimens collected, see Harris's journal, Alabama Department of Archives and History, and McDermott, *Up the Missouri with Audubon.*

56. Bachman to J. J. Audubon, March 6, 1846, Bachman Papers, Charleston Museum.

57. For a good discussion of this aspect of Audubon's appeal, see Ann Shelby Blum, *Picturing Nature: American Nineteenth-century Zoological Illustration* (Princeton, N. J.: Princeton University Press, 1993).

58. Audubon's family sometimes had to receive news of the naturalist's experiences in the West through newspaper accounts derived from letters he sent to friends for just such a purpose (see Thomas M. Brewer to V. G. Audubon, July 5, 1843, Morris Tyler Family Collection, Beinecke Library). Baird's letter to J. J. Audubon of November 24, 1843, attests to the amount of publicity Audubon's western trip received in the press (same collection). For a further discussion of press coverage of Audubon's western expedition, see Welch, "John James Audubon and His American Audience," 121–22.

59. J. J. Audubon to the Audubon family, June 1, 1843, collection of the National Audubon Society (now on deposit at the Smithsonian Institution), quoted in Ford, *Audubon's Animals,* 42.

60. J. J. Audubon to Bonaparte, July 14, 1830, Museum of Natural History, Nantes, France, American Philosophical Society in Microfilm Collection no. 542, Stroud MSS, 137. See also Patricia Tyson-Stroud, *The Emperor of Nature: Charles Lucien Bonaparte and His World* (Philadelphia: University of Pennsylvania Press, 2000).

61. William Swainson, *The Cabinet Cyclopedia—Taxidermy, Bibliography, and Biography,* ed. the Rev. Dionysius Lardner (London: Longman, Orme, Brown, Green, & Longmans, 1840), 116–17.

62. Quoted in W. H. Dall, *Spencer Fullerton Baird* , 77; Ford, *John James Audubon,* 396; and Herrick, *Audubon the Naturalist,* 2:240.

63. Bachman to J. J. Audubon, December 24, 1839, Bachman Papers, Charleston Museum.

64. Bachman to J. J. Audubon, July 5, 1839, Bachman Papers, Charleston Museum.

65. J. J. Audubon to Increase Smith, August 15, 1841, Audubon Papers, Princeton University Library.

66. J. J. Audubon to McCulloch, June 26, 1841, Audubon Papers, Princeton University Library.

67. J. J. Audubon to Harris, November 18, 1837, Houghton Library.

68. John Woodhouse Audubon to Bachman, July 20, 1848, Houghton Library. For a good account of Waterton's animosity toward Audubon, see Lynn Barber, *The Heyday of Natural History, 1820–1870* (New York: Doubleday, 1980). For a more detailed discussion of who helped Audubon and Bachman by providing specimens and information, see Bachman's acknowledgments, and Welch, "John James Audubon and His American Audience," 80–84.

69. J. J. Audubon to Lieutenant Charles Wilkes, March 15, 1846, Houghton Library.

70. J. J. Audubon to T. R. Peale and Charles Pickering, various dates, Morris Tyler Family Collection, Beinecke Library.

71. J. J. Audubon to Daniel Webster, September 8, 1841, Houghton Library.

72. Peale's published report of the expedition's scientific results was ultimately suppressed, and a second report, authored by John Cassin, was published in its place. For more information on this and other aspects of the U.S. Exploring Expedition, see Herman J. Viola and Carolyn Margolis, eds., *Magnificent Voyagers: The U.S. Exploring Expedition, 1838–1842* (Washington, D.C.: Smithsonian Institution Press, 1985).

73. Bachman to J. J. Audubon, October 31, 1845, Bachman Papers, Charleston Museum.

74. It is also possible that Peale was feigning ignorance to prevent Bachman and Audubon from stealing discoveries made by the U.S. Exploring Expedition, which Peale considered his own. "I fear that Peale is still the same man he was when last I saw him," Audubon wrote in 1835, "i.e. that like the Dog in the Manger he will growl over the food he [?] has, not touch it, and suffer no one else to do so." J. J. Audubon to Harris, May 25, 1835, Houghton Library. Audubon refers to Peale as a "dog in the manger" again in a letter to Harris of September 5, 1835, Houghton Library.

75. Brewer did assist Audubon and Bachman in gathering specimens for the *Quadrupeds,* even though, at first, he acknowledged knowing nothing about mammals. See T. M. Brewer to Bachman, January 9, 1837, Houghton Library. He was rewarded for his efforts by having a new species of mole and a western blackbird named after him.

76. Bachman to J. J. Audubon, August 5, 1841, Bachman Papers, Charleston Museum.

77. Bachman to V. G. Audubon, December 18, 1847, Houghton Library.

78. Bachman to V. G. Audubon, January 6, 1848, Bachman Papers, Charleston Museum.

79. Bachman to J. J. Audubon, August 5, 1841, Bachman Papers, Charleston Museum.

80. Bachman to V. G. Audubon, December 27, 1847, Bachman Papers, Charleston Museum.

81. Bachman to J. J. Audubon, July 5, 1839, Bachman Papers, Charleston Museum. Apparently Bachman was not alone in his low opinion of Harlan's book. A reviewer of Audubon and Bachman's *Quadrupeds* called Harlan "a studious toady of the old school." See *Literary World* 1, no. 6 (March 13, 1847): 127–29 and *Southern Quarterly Review* 22 (October 1847): 291.

82. J. J. Audubon to Bachman, December 10, 1843, Houghton Library.

83. J. J. Audubon to Harris, December 30, 1841, Houghton Library.

84. J. J. Audubon to Bachman, August 20, 1841, Houghton Library.

85. It is hard to know just how productive Audubon was as his eyesight and mental facilities deteriorated, but in March 1846 he was able to write that since December 18, 1845, he had "drawn nearly one hundred figures of Quadrupeds." J. J. Audubon to Wood (first name unknown), March 14, 1846, typescript, Princeton University Library.

86. V. G. Audubon to Bachman, June 1, 1846, Houghton Library.

87. Bachman to J. J. Audubon, November 27, 1845, Bachman Papers, Charleston Museum.

88. J. J. Audubon to the Audubon family, June 1, 1843, collection of the National Audubon Society (now on deposit at the Smithsonian Institution), quoted in Ford, *Audubon's Animals,* 42.

89. J. J. Audubon to Bachman, March 1, 1846, typescript, Houghton Library.

90. J. W. Audubon to V. G. Audubon, November 5, 1833, American Philosophical Society, quoted in Ford, *Audubon's Animals,* 25.

91. J.W. Audubon to Bachman, July 20, 1848, Houghton Library.

92. Bachman to V. G. Audubon, August 4, 1843, Alabama Department of Archives and History.

93. This list of Bachman's working library has been assembled from references in various letters from 1839, when he became involved with the project, until its completion in 1854. Other authors cited in the text for the *Quadrupeds* include Barton, Beverly, Blumenbach, De Blainville, Cowper, the marquis of Chastellux, Home, Marcgrave, Owen, Pison, Tyson, and Valentine. John James Audubon's library during this period is more difficult to construct, though we do know that he owned a copy of Richard Harlan's *Fauna Americana* (1825) (private collection). Both men had access to the *Journal of the Academy of Natural Sciences of Philadelphia* (to which they themselves had contributed descriptions of newly discovered birds and mammals).

94. John James Audubon and John Bachman, *The Quadrupeds of North America* (New York:1849–54), vi.

95. V. G. Audubon to Bachman, February 5, 1848, Houghton Library.

96. V. G. Audubon to Bachman, June 17, 1848, Houghton Library.

97. Bachman to J. J. Audubon, July 5, 1839, Bachman Papers, Charleston Museum.

98. "I never acquiesced in the arrangement in leaving out the Bats," he wrote to Victor in June 1849, "although I was less anxious about the rascally seals. I found you were determined on giving an imperfect work—could not help myself & was silent and sulky." Bachman to V. G. Audubon, June 30, 1849, Bachman Papers, Charleston Museum. As late as 1852, Bachman was still holding out hope that he could prevail upon the Audubons to include the bats and "a synopsis and scientific arrangement of all our American Species including seals, whales, and porpoises" in the letterpress of the third volume. See Bachman to Harris, March 13, 1852, Bachman Papers, Charleston Museum.

99. The title Audubon and Bachman initially considered for the book was *American Mammalia* (Bachman to J. J. Audubon, July 5, 1839, Charleston Museum), but even after the book's title was changed to *The Viviparous Quadrupeds of North America,* it was always assumed that bats and seals would be included. Some of the bat paintings that John James Audubon prepared for the book are in the collection of the New-York Historical Society. Bachman's subsequent monograph on North American bats was never published.

100. Bachman to J. J. Audubon, January 13, 1840, Bachman Papers, Charleston Museum. The reference to the porpoise may be shorthand for the U.S. Exploring Expedition, whose lead ship was the USS *Porpoise.* The expedition, on which Audubon had hoped to arrange for his friend Spencer Fullerton Baird to play a role, was then getting a good deal of national publicity. Bachman and Audubon, however, considered its scientific dimensions severely flawed.

101. Charles Lamman to V. G. Audubon, April 12, 1847, Morris Tyler Family Collection, Beinecke Library.

102. *Boston Atlas,* April 1843, reprinted in McDermott, *Audubon in the West,* 13–14. For an excellent discussion of Audubon's relationship with the press, see Welch, "John James Audubon and His Audience," 118–23.

103. *Southern Quarterly Review* 22 (October 1847): 273.

104. Ibid., 291.

105. *Knickerbocker* 29 (1847): 78.

106. [Webber], "Quadrupeds," 637.

107. Ibid., 638.

108. Audubon and Bachman, *The Viviparous Quadrupeds of North America,* 1:xi.

109. Manuscripts in Audubon's hand survive for many of the first fifty species accounts. Some of these may have been written even before Bachman agreed to serve as coauthor.

110. Audubon and Bachman, *The Viviparous Quadrupeds of North America,* 1:190.

111. Ibid., 1:254.

112. Bachman to J. J. Audubon, December 7, 1841, Bachman Papers, Charleston Museum.

113. Audubon and Bachman, *The Viviparous Quadrupeds of North America,* 1:xi.

114. J. J. Audubon to Wood (first name unknown), March 14, 1846, typescript, Princeton University Library.

115. *Literary World* 1, no. 6 (March 13, 1847): 127–29. Much of this review, including virtually all of this passage, appears to have been lifted verbatim and republished (without attribution) in the *Southern Quarterly Review* 22 (October 1847): 273–306.

116. [Webber], "Quadrupeds," 625. Three years before, on July 23, 1842, the *Spectator* of Washington, D. C., had also praised the Americanness of this "Great National Work."

117. Ibid., 629.

118. Samuel G. Morton to J. J. Audubon, January 5, 1847, Morris Tyler Family Collection, Beinecke Library. In an earlier letter, Morton had complained that the high price of the *Quadrupeds* (imperial folio) would prevent him and many others from ever owning the book. The copy he was praising was evidently a gift from the author.

119. Spencer Fullerton Baird, *Mammals of North America* (Washington, D.C.: Smithsonian Institution, 1859), xiii.

The Publication of
The Viviparous Quadrupeds of North America

1. The octavo format derives its name from the fact that an octavo page is the size of a large sheet of printing paper folded to one-eighth of its former size. The pages were usually 10¾ by 7 inches or 10 by 6½ inches, depending on how much they were trimmed for binding. Needless to say, this is not a precise measurement, because the size of printing paper varies, but it was so common a size that the name is still used.

2. [Charles Wilkins Webber], "The Quadrupeds of North America," *American Review* 4 (December 1846): 625.

3. Audubon had frequently expressed his concern that he would not live to finish *The Birds of America.* First quote in John James Audubon to Benjamin Phillips, June 23, 1839, John James Audubon Papers, Princeton University Library, quoted in Margaret Curzon Welch, "John James Audubon and His American Audience: Art, Science, and Nature, 1830–1860" (Ph.D. diss., University of Pennsylvania, 1988), 45. Alice Ford, *John James Audubon: A Biography* (New York: Abbeville Press, 1988), 449, cites Audubon's letter to Charles-Lucien Bonaparte, January 2, 1831, in the Bibliothèque du muséum d'histoire naturelle in Paris. Audubon drew pictures of both birds and mammals in France as a young man. His first known picture of an American mammal is one of his favorites, *The Trapped Otter,* which he first painted in Henderson, Kentucky, in 1812. See Edward H. Dwight, *Audubon Watercolors and Drawings* (Utica, N.Y., and New York: Munson-Williams-Proctor Institute and The Pierpont Morgan Library, 1965), 50. For Bachman, see J. J. Audubon to Lucy Audubon, Charleston, October 23, 1831, Howard Corning, ed. *Letters of John James Audubon, 1826–1840,* 2 vols. (New York: Kraus Reprint Co., 1969), 1:142–44; and Jay Shuler, *Had I the Wings: The Friendship of Bachman and Audubon* (Athens and London: University of Georgia Press, 1995).

4. Claude Henry Neuffer, ed., *The Christopher Happoldt Journal: His European Tour with the Rev. John Bachman (June–December, 1838),* vol. 13 of *Contributions from the Charleston Museum* (Charleston: The Charleston Museum, 1960), 48. Havell Sr. undertook *The Birds of America* with his son, Robert Jr., but died before it was completed.

5. Lucy Audubon, *The Life of John James Audubon, the Naturalist* (New York: G. P. Putnam & Son, 1869), 400; and John Bachman to the Society of Naturalists and Physicians of Germany, Freiburg, September 21, 1838, John

Bachman Papers, Charleston Museum, Charleston, S C.; Neuffer, ed., *Happoldt Journal,* 177–78; Shuler, *Had I the Wings,* 160–64. Young Christopher Happoldt accompanied Bachman on the journey and kept a journal throughout the trip.

6. Lucy Audubon quoted in Mary Durant and Michael Harwood, *On the Road with John James Audubon* (New York: Dodd, Mead & Company, 1980), 536. Waldemar H. Fries, *The Double Elephant Folio: The Story of Audubon's "Birds of America"* (Chicago: American Library Association, 1973), 112, 115–16. For Audubon's debt to Havell, see Victor Gifford Audubon to John Woodhouse Audubon, New York, April 25, and July 19, 1840, John James Audubon Papers (Box 2, Folder 50), and August 17, 1840 (Box 2, Folder 47), Beinecke Rare Book and Manuscript Library, Yale University; and J. J. Audubon to V. G. Audubon, New York, January 9, 1841, John James Audubon Papers (B/Au25), American Philosophical Society, Philadelphia. Havell, too, left England in 1839 and immigrated to America, but he did not intend to continue as an engraver.

7. Waterhouse is quoted in Jeannette E. Graustein, *Thomas Nuttall, Naturalist: Explorations in America, 1808–1841* (Cambridge: Harvard University Press, 1967), 335; J. J. Audubon to Richard Harlan, June 30, 1839, Audubon Papers, Beinecke Library, quoted in Ford, *John James Audubon,* 364–65.

8. Victor had learned of the decision, if he did not already know of it, in a letter from Lucy Audubon on June 30, 1839, John James Audubon Papers, Princeton University Library, quoted in Shirley Streshinsky, *Audubon: Life and Art in the American Wilderness* (New York: Villard Books, 1993), 327. Quote in J. Bachman to J. J. Audubon, Charleston, July 5, 1839, Bachman Papers, John K. Townsend to J. Bachman, Philadelphia, June 6, 1838, Bachman Papers, suggests that Bachman began corresponding with colleagues in an effort to obtain more information on quadrupeds. For Bachman's quote, see J. Bachman to J. J. Audubon, Charleston, September 13, 1839, Bachman Papers. Bachman is apparently referring to John Edwards Holbrook's *North American Herpetology, or, A Description of the Reptiles Inhabiting the United States,* 4 vols. (Philadelphia: J. Dobson, 1836–38).

9. Charlotte M. Porter, *The Eagle's Nest: Natural History and American Ideas, 1812–1842* (University: University of Alabama Press, 1986), 4, 32–33; Victor H. Cahalane, ed., *The Imperial Collection of Audubon Animals: The Quadrupeds of North America* (New York: Bonanza Books, 1967), x; and J. Bachman to J. J. Audubon, Charleston, July 5, 1839, Bachman Papers. "What have you done in England with the rare American species?" Bachman asked after Audubon had arrived in the United States. J. Bachman to J. J. Audubon, Charleston, September 13, 1839, Bachman Papers. One hundred dollars in 1839 would be approximately one thousand, five hundred dollars in today's dollars. See John J. McCusker, "How Much Is That in Real Money? A Historical Price Index for Use as a Deflator of Money Values in the Economy of the United States," *Proceedings of the American Antiquarian Society* 101 (1991): 332; and McCusker, "How Much Is That in Real Money? Addenda and Corrigenda," *Proceedings of the American Antiquarian Society* 106 (1996): 333.

10. J. J. Audubon to Thomas M. Brewer, New York, September 15, 1839, John James Audubon Papers (fMS Am 1265), Houghton Library, Harvard University. See also J. J. Audubon to Thomas McCulloch Jr., October 16, 1841, photostat Audubon Papers, American Philosophical Society; and J. J. Audubon to Spencer Fullerton Baird, New York, July 29, 1841, Francis Hobart Herrick, *Audubon the Naturalist: A History of His Life and Time* 2 vols. (New York: D. Appleton and Co., 1917), 2:226.

11. J. J. Audubon to J. Bachman, Boston, December 8, 1839, and New York, January 2, 1840, Corning, *Letters,* 2:227, 230–31; J. J. Audubon to Baird, New York, December 25, 1840, quoted in Herrick, *Audubon the Naturalist,* 2:222; the "holy zeal" remark is from George Shattuck, quoted in Welch, "John James Audubon and His American Audience," 163. Like "double elephant folio," Audubon adopted "royal octavo" as a means of hyping his product. See its use in the prospectus for the octavo *Birds* in *New York Albion,* January 25, 1840, p. 32, col. 2.

12. J. Bachman to J. J. Audubon, Charleston, September 13, 1839, Bachman Papers; and Cahalane, *Audubon Animals,* ix. Bachman was right about the state of quadruped knowledge in America at that time. See George E.

Watson, "Vertebrate Collections: Lost Opportunities," in Herman J. Viola and Carolyn Margolis, eds., *Magnificent Voyagers: The U.S. Exploring Expedition, 1838–1842* (Washington, D. C.: Smithsonian Institution Press, 1985), 48.

13. J. Bachman to J. J. Audubon, Charleston, January 13, 1840, Bachman Papers. Bachman is probably talking about Harlan's *Fauna Americana* and Godman's *American Natural History.* Bachman's appraisal of the state of mammalology is more or less correct. See Porter, *Eagle's Nest,* 37–38.

14. J. Bachman to J. J. Audubon, Charleston, November 22, 1841, Audubon Papers (Box 3, Folder 85), Beinecke Library; J. Bachman to J. J. Audubon, August 5, 1841, Bachman Papers, quoted in Shuler, *Had I the Wings,* 186–87.

15. J. Bachman to J. J. Audubon, Charleston, November 22, 1841, Audubon Papers (Box 3, Folder 85), Beinecke Library; J. Bachman to J. J. Audubon, Charleston, August 5, 1841, Bachman Papers.

16. Maria R. Audubon, ed., *Audubon and His Journals,* 2 vols. (New York: Charles Scribner's Sons, 1897), 1:37. See Peale's journal in *Missouri Historical Review* 41 (October 1846 and April 1847): 147–63, 266–84. See also Howard Corning, ed., *Journal of John James Audubon Made During His Trip to New Orleans in 1820–1821* (Boston: Club of Odd Volumes, 1929), 75–76, 227; and J. J. Audubon to Lucy Audubon, Louisville, November 29, 1831, in Corning, *Letters,* 1:158. The newspaper article Bachman wrote the day after he and Audubon met contained a reference to Audubon's intended expedition to the Rocky Mountains. See Shuler, *Had I the Wings,* 7; J. J. Audubon to J. Bachman, London, April 20, 1835, New York, October 2, 1836, and Philadelphia, October 23, 1836, *Letters,* 2:71, 133–34, 135–36; Lucy Audubon, *John James Audubon,* 388–89; John Kirk Townsend, *Narrative of a Journey across the Rocky Mountains to the Columbia River* (Philadelphia: Henry Perkins, 1839): and Graustein, *Nuttall,* 294–320.

17. Thomas M. Brewer, "Reminiscences of John James Audubon," *Harper's New Monthly Magazine* 61 (1880): 674; J. J. Audubon to Edward Harris, New Orleans, March 4, 1837, Audubon Papers (pfMS Am 21 [36]), Houghton Library; Samuel W. Geiser, "Audubon's Visit to Texas in 1837," *Southwest Review* 16 (Autumn 1930): 109–35; J. J. Abert to J. J. Audubon, Washington, January 30, 1831, and September 20, 1841, Audubon Papers (Box 3, Folder 76), Beinecke Library. In the second letter, Abert advised Audubon that the American Fur Company steamboat *Yellow Stone* made regular trips up the Missouri River. See also Lucy Audubon, *John James Audubon,* 395–98.

18. Most such books were issued in fascicles and sold by subscription, that being the only way an author or artist could raise sufficient money for such a publication. See Christine E. Jackson, *Bird Etchings: The Illustrators and Their Books, 1655–1855* (Ithaca, N. Y., and London: Cornell University Press, 1985), 43. See also Conrad Gesner, *Historia Animalium,* 4 vols. (Zurich, 1551–58); Pierre Belon, *Histoire de la nature des Oyseaux* (Paris, 1555); Ulisse Aldrovandi, *Ornithologia* 3 vols., (Bologna, 1599–1603), and Elsa Guerdrum Allen, "The History of American Ornithology Before Audubon," *Transactions of the American Philosophical Society,* 41 (1951): 558–564.

19. See Aloys Senefelder, *Complete Course of Lithography* (New York: Da Capo Press, 1977). Sally Pierce and Catharine Slautterback, *Boston Lithography, 1825–1880: The Boston Athenaeum Collection* (Boston: The Boston Athenaeum, 1991), 2–3.

20. The basic method of printing today is called offset lithography, although it has developed far beyond the primitive process described here.

21. Although lithographic stones can be reused, and therefore stones for specific images do not often survive, the stone for *American White Wolf* probably survives because it was Audubon's practice to acquire the plates from which his images were printed so that he could reprint the books. *The Viviparous Quadrupeds of North America* was reprinted at least one time, probably about 1865. Joseph Sabin in *A Dictionary of Books Relating to America, from Its Discovery to the Present Time* (New York, 1868 [i.e. 1867]–1936), entry 2365, says that the reprint is dated 1855, but 1865 is probably a more nearly correct date. The family probably sold the stone some time after that. For a description of the lithographic process as related to Audubon's octavo *Birds,* see Ron Tyler, *Audubon's Great National Work: The Royal Octavo Edition of "The Birds of America"* (Austin: University of Texas Press, 1993), 53–55.

22. J. J. Audubon to Little and Brown, New York, April 29, 1841, quoted in

Herrick, *Audubon the Naturalist,* 2:230.

23. I examined four copies of the *Quadrupeds* side by side at the Beinecke Rare Book and Manuscript Library, Yale University. Three of the sets belong to Yale, and the fourth to William S. Reese of New Haven.

24. The prospectus for *The Viviparous Quadrupeds of North America* is reprinted in the *New York Albion,* March 11, 1843, p. 128.

25. *Philadelphia Saturday Courier,* January 4, 1840, quoted in Nicholas Wainwright, *Philadelphia in the Romantic Age of Lithography* (Philadelphia: Historical Society of Pennsylvania, 1958), 54.

26. Audubon first announced the project to his friends. See J. J. Audubon to Samuel G. Morton, New York, September 9, 1839, Samuel G. Morton Papers, American Philosophical Society; and J. J. Audubon to Brewer, New York, September 15, 1839, Audubon Papers (fMS Am 1265), Houghton Library. Then he announced it to newspapers. See *New York Albion,* September 4 and December 11, 1841, pp. 317 and 435. Audubon feared that someone would copy his work and publish it in America before he could secure the copyright. In fact, John Kirk Townsend did begin publication of his *Ornithology of the United States of America* (Philadelphia, 1839) that year. See Tyler, *Audubon's Great National Work,* 48–49.

27. Victor did most of the backgrounds for the *Quadrupeds.* See, for example, V. G. Audubon to Harris, New York, August 31, 1842, Audubon Papers (pfMS Am21 [71]), Houghton Library; and Gary A. Reynolds, *John James Audubon & His Sons* (New York: Grey Art Gallery and Study Center, New York University, 1982), 59–60. Just because he met the standards of the day does not mean that everyone was happy about the recognition they received. Mason, for one, felt that Audubon had cheated him of deserved recognition. See Irving T. Richards, "Audubon, Joseph R. Mason, and John Neal," *American Literature* 6, no. 2 (May 1934): 122–40.

28. The process of reducing or enlarging drawings was difficult in the days before photographic lenses made it routine. The camera lucida offered a somewhat distorted but successful method. Designed by the English scientist William Hyde Wollaston in 1807, the camera lucida permitted the artist, viewing through a peephole positioned over the edge of the prism, to see both the object to be drawn and the paper. The object could be enlarged or reduced by changing both the distance between the camera and the object and the distance between the camera and the paper. John H. Hammond and Jill Austin, *The Camera Lucida in Art and Science* (Bristol, England: Adam Hilger, 1987), 30–36.

29. Jackson, *Bird Etchings,* 32; V. G. Audubon note in Lucy Audubon to J. J. Audubon, March 1, 1840, Audubon Papers (Box 1, Folder 34), Beinecke Library; *Philadelphia Saturday Courier,* January 4, 1840; and Cahalane, *Imperial Collection of Audubon's Animals,* xiv–xv.

30. See Tyler, *Audubon's Great National Work,* 51–52; J. J. Audubon to Dr. George Parkman, New York, June 20, 1841, *Auk* 33 (April 1916): 117; Baird to J. J. Audubon, Carlisle, Pa., June 20, 1840, Audubon Papers (Box 3, Folder 95), Beinecke Library; and J. Bachman to Townsend, Charleston, November 2, 1842, quoted in Howard C. Rice Jr., comp., "The World of John James Audubon: Catalogue of an Exhibition in the Princeton University Library, 15 May–30 September 1959," *Princeton University Library Chronicle* 21 (Autumn 1959–Winter 1960): 72. Webber discusses the Audubon team in "The Quadrupeds of North America," 626–29.

31. [Webber], ""The Quadrupeds of North America," 637; and Ann Shelby Blum, *Picturing Nature: American Nineteenth-Century Zoological Illustration* (Princeton, N. J.: Princeton University Press, 1993), 111–12. The fact that after Audubon's death John Cassin tried to get John and Victor to agree to a copublication arrangement, whereby Cassin would update, correct, and add to the octavo *Birds of America,* also suggests the value of Audubon's works. See Tyler, *Audubon's Great National Work,* 109. Prince Maximilian of Wied also apparently respected Audubon's work. See Porter, *Eagle's Nest,* 146.

32. [Webber], "The Quadrupeds of North America," 636; J. Bachman to V. G. Audubon, Charleston, November 27, 1845, Bachman Papers; *New York Albion,* December 11, 1841, p. 435; and Welch, "John James Audubon and His American Audience," 57.

33. Ford, *John James Audubon,* 383; J. J. Audubon to V. G. Audubon,

January 25, 1841, quoted in Albert E. Lownes, ed., "Ten Audubon Letters," *Auk* 52 (April 1935): 161–65; J. J. Audubon to V. G. Audubon, New York, January 25, 1841, typescript, Audubon Memorial Museum, Henderson, Ky.; M. R. Audubon, *Audubon and His Journals,* 1:202–3; J. J. Audubon to Parkman, New York, June 20 and July 29, 1841, and J. J. Audubon to Baird, New York, July 29, 1841, Herrick, *Audubon the Naturalist,* 2:226–27; J. J. Audubon to McCulloch, New York, June 26, 1841, Rice, "The World of John James Audubon," 72; J. J. Audubon to V. G. Audubon, Charleston, December 23, 1833, American Philosophical Society, quoted in Waldemar H. Fries, "John James Audubon: Some Remarks on His Writings," *Princeton University Library Chronicle* 21 (Autumn 1959–Winter 1960): 5.

34. Marshall B. Davidson, introduction to *The Original Water-Color Paintings by John James Audubon for "The Birds of America"* (New York: American Heritage/Bonanza Books, 1985), xxx; J. J. Audubon to Harris, New York, December 30, 1841, Audubon Papers (pfMS Am 21 [53]), Houghton Library; Parke Godwin, "John James Audubon," in *Homes of American Authors: Comprising Anecdotical, Personal, and Descriptive Sketches by Various Writers* (New York: G. P. Putnam and Co., 1853), 5; and Parke Godwin, "John James Audubon," *United States Magazine and Democratic Review* 10 (May 1842): 449.

35. Roderick Nash, *Wilderness and the American Mind,* rev. ed. (New Haven and London: Yale University Press, 1976), 85; Paul F. Boller Jr., *American Transcendentalism, 1830–1860: An Intellectual Inquiry* (New York: Capricorn Books, 1974), 68–69.

36. Audubon claimed to have studied with Napoleon's court painter, Jacques-Louis David, but there is no confirmation of his claim. See Theodore E. Stebbins Jr., "Audubon's Drawings of American Birds, 1805-38," in *John James Audubon: The Watercolors for "The Birds of America,"* ed. Annette Blaugrund and Theodore E. Stebbins Jr. (New York: Villard Books, Random House and the New-York Historical Society, 1993), 3. The prospectus for the *Quadrupeds* was reproduced in the *New York Albion,* March 11, 1843, p. 128, col. 1–2; J. J. Audubon to J. Bachman, Edinburgh, December 3, 1834, *Letters,* 2:54.

37. Welch, "John James Audubon and His American Audience," 54–55, 72; George Washington Doane, quoted in Margaret Welch, *The Book of Nature: Natural History in the United States, 1825–1875* (Boston: Northeastern University Press, 1998), 199; and Rhett to J. J. Audubon, February 4, 1841, Audubon Papers (Box 5, Folder 234), Beinecke Library.

38. J. J. Audubon to Lucy Audubon, Edinburgh, December 21, 1826, *Letters,* 1:8; J. J. Audubon to Henry McMurtrie, Edinburgh, February 21, 1831, *Letters,* 1:129; and J. Bachman to J. J. Audubon, Charleston, February 28, 1846, Audubon Papers (Box 3, Folder 86), Beinecke Library. Bachman is probably referring to John Edwards Holbrook, *North American Herpetology,* 5 vols. (Philadelphia: J. Dobson; London: R. Baldwin, 1842), and, perhaps, the *Transactions of the Zoological Society of London.* See Welch, "Audubon and His American Audience," 56.

39. For examples of the difficulty Audubon had in presenting himself and his pictures when he first arrived in England, see Alice Ford, ed., *The 1826 Journal of John James Audubon* (Norman: University of Oklahoma Press, 1967), 81–83, 101. See also David Kaser, *Messrs. Carey & Lea of Philadelphia: A Study in the History of the Booktrade* (Philadelphia: University of Pennsylvania Press, 1957), 128–29, 137, 140; Tyler, *Audubon's Great National Work,* 157–60; and McCusker, "How Much Is That in Real Money?" Annette Blaugrund, "The Artist as Entrepreneur," also discusses Audubon's developing marketing techniques in Blaugrund and Stebbins, *Watercolors,* 31–35.

40. J. J. Audubon to V. G. Audubon, Charleston, May 4, 1840, *Letters,* 2:267; and *Journal,* 16. Names of many of the agents, and sometimes the percentages paid them, are listed in the "Birds of America Day Book" and "Audubon Journals and Ledgers," Audubon Papers, Houghton Library.

41. J. J. Audubon to L. Audubon, Baltimore, March 1, 1840, *Letters,* 2:239–40.

42. Corning, *Journal,* 4. See also 5, 7, 8, 10, 13–14, 21, 22, 33, 36, 44, 45, 47, 50, 52, 55, 57, 58, 62, 82, 84, 86, 121, 125, 131, and 137. For the number of subscribers in Baltimore, see Tyler, *Audubon's Great National Work,* 160, Table 3. See also J. J. Audubon to the family, Baltimore, February

21, 1840, in *Auk* 25 (April 1908): 168,

43. J. Bachman to J. J. Audubon, Charleston, December 24, 1839, Bachman Papers; J. J. Audubon to L. Audubon, Baltimore, March 1, 1840, *Letters,* 2:239; and V. G. Audubon note in Lucy Audubon to J. J. Audubon, Minnie's Land, May 29, 1843, Audubon Papers (Box 1, Folder 37), Beinecke Library.

44. J. J. Audubon to V. G. Audubon, Hartford, August 25, 1842, Audubon Papers, American Philosophical Society.

45. J. J. Audubon to the family, Fort Pierre, June 1, 1843, John Francis McDermott, ed., *Audubon in the West* (Norman: University of Oklahoma Press, 1965), 99–100. Victor apparently did a good job, because articles on Audubon and his trip appeared in the *Louisville Journal,* the *St. Louis Missouri Republican,* the *Washington Daily Madisonian, Niles' Weekly Register,* the *St. Louis Missouri Reporter,* and the *New York Albion,* December 2, 1843, 59, among others. See also Corning, *Journal,* 5, 8, 10, 16, 18, 19, 26, 27 (Washington), 32 (Providence and New Bedford), 42, 45, 49, 53, 67 (Washington), 74, 82, 87 (Worcester), 97, 101 (Troy), 127; J. J. Audubon to J. W. Audubon, Providence, August 9, 1840, in *Auk* 52 (April 1935): 159; Yarrell to J. J. Audubon, London, December 17, 1842, Audubon Papers, Missouri Historical Society, St. Louis; J. W. Audubon to the family, St. Louis, April 2, 8, 17, and 23, 1843, and J. J. Audubon to the family, Steamer *Omega,* St. Charles, Missouri River, April 25, 1843, *Audubon in the West,* 50, 54, 57, 67, and 72; J. J. Audubon to Lucy Audubon, Philadelphia, May 22, 1845, Audubon Papers (Box 1, Folder 9), Beinecke Library; and J. J. Audubon to V. G. Audubon, Baltimore, March 7, 1840, *Letters,* 2:249. Corning, *Journal,* 3, 10. Audubon received copies of his reviews on his next trip. J. Bachman to V. G. Audubon, Charleston, April 26, 1847, Bachman Papers.

46. Maria died on September 15, 1840, and Eliza on May 25, 1841. See Corning, *Journal,* 6, 99; and Shuler, *Had I the Wings,* 184; and J. J. Audubon to J. Bachman, Boston, December 8, 1839, *Letters,* 2:225–27.

47. In a blank book embossed with the title *Land Birds,* in the John James Audubon Museum, Henderson, Ky., the Audubons kept a record of the quadruped stories that they sent to Bachman. See also Shuler, *Had I the Wings,* 186; John Bachman to John James Audubon, Charleston, January 15, 1840; and J. Bachman to J. J. Audubon, Charleston, August 5, 1841, Bachman Papers.

48. Harris to J. J. Audubon, Moorestown, January 9, 1842, Audubon Papers, Missouri Historical Society, St. Louis; and J. Bachman to J. J. Audubon, Charleston, January 26, 1840, Bachman Papers.

49. V. G. Audubon to Harris, New York, February 24, 1842, Audubon Papers (pfMS AM21), Houghton Library.

50. Original painting in the collection of the American Museum of Natural History.

51. All these pictures are illustrated in Reynolds, *Audubon & His Sons,* 60–61, 71, and 74.

52. Dwight, *Audubon Watercolors and Drawings,* 53, 55.

53. J. Bachman to J. J. Audubon, Charleston, October 31, 1843, Bachman Papers.

54. *Boston Atlas,* April 12, 1843, quoted in McDermott, *Audubon in the West,* 3–4.

55. *New York Albion,* March 11, 1843, p. 128; McCusker, "How Much Is That in Real Money?" 333.

56. V. G. Audubon note in Lucy Audubon to J. J. Audubon, Minnie's Land, May 29, 1843, and V. G. Audubon note in Lucy Audubon to J. J. Audubon, Minnie's Land, July 2, 1843, Audubon Papers (Box 1, Folder 37), and J. Bachman to J. J. Audubon, Charleston, June 14 and October 21, 1842, Audubon Papers (Box 3, Folder 85), Beinecke Library; J. J. Audubon to V. G. Audubon, Philadelphia, January 7, 1841, and February 12, 1842, Audubon Papers, American Philosophical Society; Harris to J. J. Audubon, Moorestown, January 9, 1842, Audubon Papers, Missouri Historical Society. Green is quoted in Graustein, *Nuttall,* 335. A number of other friends told Audubon similar stories. See Corning, *Journal,* 89.

57. J. J. Audubon to V. G. Audubon, Philadelphia, July 12, 1842, and George Ord to Charles Waterton, Philadelphia, June 22, 1845, Audubon Papers, American Philosophical Society; Corning, *Journal,* 65; Morton to J. Bachman, Philadelphia, January 28, 1843, Audubon Papers (fMS Am 1265

[64]), Houghton Library; Harris to J. J. Audubon, Moorestown, February 15, 1847, Audubon Papers, Missouri Historical Society.

58. Maximilian, Prince of Wied, suggested to Audubon that they exchange publications: an uncolored copy of his *Reise in das inner NordAmerica in den Jahren 1832 bis 1834,* 2 vols. and atlas (Koblenz: J. Hölscher, 1839–[41]) for an octavo edition of *The Birds of America.* See also Harlan to J. J. Audubon, Philadelphia, January 9, 1841, Audubon Papers, Missouri Historical Society; William H. Truettner, *The Natural Man Observed: A Study of Catlin's Indian Gallery* (Washington, D.C.: Smithsonian Institution Press, 1979), 43; William Stanton, *The United States Exploring Expedition of 1838–1842* (Berkeley, Los Angeles, and London: University of California Press, 1975), 281–82; and Viola and Margolis, *Magnificent Voyagers.*

59. Porter, *Eagle's Nest,* 128–30, suggests that professional natural-history organizations, such as the New-York Lyceum of Natural History and the Philadelphia Academy of Natural Sciences, often refused permission to field naturalists to study their collections and discouraged their publications. This might have been one reason Wilkes did not let Audubon see the quadrupeds from his trip. Another reason might have been that he wanted to publish them first. Bachman was later permitted to study them, but Victor was denied permission. J. J. Audubon to V. G. Audubon, Washington, July 17, 1842, Audubon Papers, American Philosophical Society; Townsend to V. G. Audubon, Philadelphia, March 9, 1846, typescript, Audubon Papers, Missouri Historical Society; J. Bachman to J. J. Audubon, Charleston, October 31, 1845, Bachman Papers; and V. G. Audubon to J. Bachman, New York, March 11, 1847, Audubon Papers (fMS Am 1265), Houghton Library.

60. Abert to J. J. Audubon, Washington, September 20, 1841, Audubon Papers (Box 3, Folder 76), Beinecke Library; Corning, *Journal,* 68, 70–71, 74; J. J. Audubon to V. G. Audubon, Washington, July 17, 1842, Audubon Papers, American Philosophical Society.

61. J. Bachman to J. J. Audubon, Charleston, March 12, 1843, Audubon Papers (Box 3 Folder 86), Beinecke Library.

62. J. J. Audubon to the family, St. Louis, April 17, 1843, *Audubon in the West,* 56.

63. The Lewis and Clark volume is now in the collections of the Missouri Historical Society, St. Louis. See Ford, *John James Audubon,* 401; *St. Louis Daily People's Organ,* April 4, 1843, quoted in Rice (comp.), "The World of John James Audubon," 73; *St. Louis Old School Democrat,* April 28, 1843, and J. J. Audubon to the family, St. Louis, April 17, 1843, quoted in McDermott, ed., *Audubon in the West,* 14, 57.

64. Audubon secured letters from Lord Ashburton, Colonel Abert, General Winfield Scott, Daniel Webster, Secretary of War John C. Spencer, President John Tyler, and several others. See J. J. Audubon to V. G. Audubon, Washington, July 25, 1842, Audubon Papers, American Philosophical Society; and J. J. Audubon to the family, St. Louis, April 2, 17, 1843, *Audubon in the West,* 49, 58. McDermott suggests that Audubon might have been referring to Dr. George Engelmann and Dr. Frederick Adolph Wislizenus. J. J. Audubon to the family, St. Louis, March 31, 1843, *Audubon in the West,* 42. See also 14.

65. M. R. Audubon, *Audubon and His Journals,* 2:29; Ford, *John James Audubon,* 405–06.

66. See, for example, Henry Nash Smith's discussion of Charles W. Webber and his writings in *Virgin Land: The American West as Symbol and Myth* (Cambridge: Harvard University Press, 1950), 71–80. See also M. R. Audubon, *Audubon and His Journals,* 1:497, 528, 2:27; J. J. Audubon to the family, Fort Union, June 13, 1843, *Audubon in the West,* 117; and Isaac Sprague diary, 1843, 19, (Boston Athenaeum).

67. Audubon wrote some about the buffalo hunt, but asked young Squires to write an account in his journal because Squires was a participant—such an exuberant participant, in fact, that he begged Audubon to permit him to stay until the fall. M. R. Audubon, *Audubon and His Journals,* 2:57–62. Harris also gives an account of the hunt in his journal, as well as a more sympathetic view of Catlin and his work: "It gives me pleasure to bear testimony to the faithfulness of that representation [Catlin's wounded bull], particularly in this country where poor Catlin finds no quarter, and if we are able to believe all we hear of him there is not a word of truth nor a faithful illustration in the whole of his book." John Francis McDermott, ed., *Up the Missouri with*

Audubon: The Journal of Edward Harris (Norman: University of Oklahoma Press, 1951), 139.

68. J. J. Audubon to V. G. Audubon, Fort Union, June 17, 1843, in *Auk* 52 (April 1935): 166–67; and M. R. Audubon, *Audubon and His Journals*, 2:40. At Mill Grove, Audubon began to mount the birds on a board marked with squares. He had the same set of squares on his drawing paper. Then he would complete the drawing square by square, giving him a life-size figure.

69. M. R. Audubon, *Audubon and His Journals*, 2:111.

70. Ibid., *Audubon and His Journals*, 2:35—36, 147.

71. J. J. Audubon to the family, steamer *Omega*, St. Charles, Missouri River, April 25, 1843, *Audubon in the West*, 69. Captain La Barge claimed in a memoir of this trip that Audubon offended the crew by his "overbearing manner," leading them to render him poor service. He tells of an incident in which he supplied Audubon with a specimen of a black squirrel, to which Audubon said, "*That* is what you call a black squirrel, is it? It *is* very strange that people born and raised in a country do not know the names of the animals and birds which it produces." La Barge claimed that one of Audubon's assistants later told him that Audubon had pronounced the squirrel "the best specimen of a black squirrel that he had ever painted." See Hiram Martin Chittenden, *History of Early Steamboat Navigation on the Missouri River: Life and Adventures of Joseph La Barge* (New York: Francis P. Harper, 1903), 2:150–52.

72. M. R. Audubon, *Audubon and His Journals*, 2:172–73. James Henry Carleton to J. J. Audubon, Fort Leavenworth, February 28, 1844, Audubon Papers (Box 3, Folder 117), Beinecke Library.

73. Ford, *John James Audubon*, 410.

74. M. R. Audubon, *Audubon and His Journals*, 2:154–55.

75. J. J. Audubon to J. Bachman, Minnie's Land, November 12, 1843, Audubon Papers (bMS Am 1482 [160]), Houghton Library; J. Bachman to J. J. Audubon, Charleston, June 6, 1846, and November 29, 1843, Bachman Papers; and J. J. Audubon to J. Bachman, Minnie's Land, December 10, 1843, Audubon Papers (bMS Am 1482 [161]), Houghton Library.

76. J. Bachman to J. J. Audubon, Charleston, March 6, 1846, Bachman Papers; J. Bachman to V. G. Audubon, Charleston, January 17, and February 7, 1846, Audubon Papers (Box 3, Folder 89), Beinecke Library; and J. J. Audubon to Harris, Minnie's Land, February 23, 1845, Audubon Papers (pfMS Am21 [63]), Houghton Library, asking Harris if he has the measurements for the bison.

77. J. Bachman to V. G. Audubon, Charleston, January 23, 1846, Audubon Papers, Charleston Museum.

78. Quoted in the *Philadelphia Saturday Courier*, November 11, 1843, p. 2, col. 2.

79. Welch, "John James Audubon and His American Audience," 126.

80. See the *Goshawk. Stanley Hawk*, plate 141 in *The Birds of America*, for an example of an engraving for which Havell provided the background. Davidson, *Original Water-Color Paintings*, 49, 139; and Shuler, *Had I the Wings*, 185.

81. The manuscript introduction is dated December 23, 1844, Audubon Papers (Box 8, Folder 455), Beinecke Library.

82. Abert to J. J. Audubon, Washington, January 22, 1845, Audubon Papers (Box 3, Folder 76), Beinecke Library.

83. Ford, *John James Audubon*, 465; V. G. Audubon note in J. J. Audubon to J. W. Audubon, Philadelphia, May 28, 1845, Audubon Papers (Box 1, Folder 9), Beinecke Library; and Welch, "John James Audubon and His American Audience," 112.

84. J. Bachman to V. G. Audubon, Charleston, August 5, 1843, Bachman Papers; J. Bachman to V. G. Audubon, Charleston, August 12, 1846, Audubon Papers (Box 3, Folder 90), Beinecke Library; Shuler, *Had I the Wings*, 197–200; J. J. Audubon to J. Bachman, Minnie's Land, March 30, 1845, Audubon Papers (fMS Am 1265), Houghton Library; J. Bachman to V. G. Audubon, June 14, 1843, Bachman Papers (quoted in Shuler, *Had I the Wings*, 191); J. Bachman to Harris, Charleston, December 24, 1845, *Audubon the Naturalist*, 2: 269–70.

85. J. Bachman to J. J. Audubon, Charleston, October 31, 1845, J. Bachman to V. G. Audubon, Charleston, December 14, 1846, Bachman Papers; and

Shuler, *Had I the Wings*, 195–96.

86. J. Bachman to V. G. Audubon, Charleston, February 5, February 18, February 28, March 22, May 7, December 8, 1846; J. Bachman to J. J. Audubon, Charleston, February 28, Bachman Papers; J. Bachman to V. G. Audubon, Charleston, May 7, May 14, May 22, 1846, Audubon Papers (Box 3, Folder 89), Beinecke Library; J. Bachman to V. G. Audubon, Charleston, July 27, August 15, 1846, Audubon Papers (Box 3, Folder 90), Beinecke Library; Harris to J. J. Audubon, Moorestown, February 15, 1847, Audubon Papers, Missouri Historical Society; and J. Bachman to J. J. Audubon, Charleston, December 23, 1846, Audubon Papers (Box 3, Folder 86), Beinecke Library.

87. Harris to J. J. Audubon, Moorestown, October 5, 1845, Audubon Papers, Missouri Historical Society; J. J. Audubon to Baird, September 30, 1845, quoted in Herrick, *Audubon the Naturalist*, 2:272–73; J. J. Audubon to Phillips, Minnie's Land, November 25, 1845, quoted in W. Graham Arader III *Autographs* catalogue, entry #5; and J. Bachman to V. G. Audubon, Charleston, November 24, 1845, Bachman Papers.

88. V. G. Audubon to J. Bachman, New York, February 2, 1846, Audubon Papers (fMS Am 1265), Houghton Library; John James Audubon and John Bachman, *The Viviparous Quadrupeds of North America*, 3 vols. (New York: John J. Audubon and Victor G. Audubon, 1845–54), 2:258–62; and *Galveston News*, quoted in *Clarksville Northern Standard*, December 25, 1845, p. 1, col. 4.

89. V. G. Audubon to J. Bachman, New York, February 2, 1846, Audubon Papers (fMS Am 1265); J. J. Audubon to J. Bachman, Minnie's Land, March 1, 1846, Audubon Papers (bMS Am 1482 [167]), Houghton Library; and J. Bachman to V. G. Audubon, Charleston, March 22, 1846, Bachman Papers. Also see excerpts from J. W. Audubon's journal in Audubon and Bachman, *Quadrupeds*, black-tailed hare, 2:95–99; red Texan wolf, 2:240–43; ocelot, 2:258–62; ring-tailed bassarisk, 2:314–18; and jaguar, 3:1–10.

90. J. J. Audubon to J. Bachman, Minnie's Land, March 12, 1846, Audubon Papers (bMS Am 1482 [168]), Houghton Library; J. Bachman to V. G. Audubon, Charleston, March 22, 1846, Bachman Papers; and J. W. Audubon to Harris, Minnie's Land, April 15, 1846, Audubon Papers (pfMS Am21 [74]), Houghton Library.

91. J. Bachman to V. G. Audubon, Charleston, March 29, 1846, Audubon Papers (Box 3, Folder 89), Beinecke Library; V. G. Audubon to J. Bachman, New York, March 27, 1846, and April 17, 1847, Audubon Papers (fMS Am 1265), Houghton Library; J. J. Audubon to J. Bachman with V. G. Audubon note, Minnie's Land, May 31, 1846, Audubon Papers (fMS Am 1265), Houghton Library; J. Bachman to V. G. Audubon, Charleston, Audubon Papers (Box 3, Folder 91), Beinecke Library. J. J. Audubon to Harris, Minnie's Land, February 22, 1847, Audubon Papers (pfMS Am21, Houghton Library; and J. W. Audubon to J. J. Audubon, London, June 5, 1847, Audubon Papers, Missouri Historical Society.

92. J. Bachman to V. G. Audubon, Charleston, December 13, 1847, Bachman Papers; and Shuler, *Had I the Wings*, 202–7.

93. J. Bachman to Maria Martin, New York, May 11, 1848; J. Bachman to V. G. Audubon, Charleston, December 14, 1846, Bachman Papers; and V. G. Audubon to J. Bachman, June 17, 1848, Audubon Papers (bMS AM 1482 [279]), Houghton Library; J. Bachman to V. G. Audubon, Charleston, December 18, 1848, Bachman Papers; J. Bachman to V. G. Audubon, Charleston, June 4, 1849, Audubon Papers (Box 3, Folder 93), Beinecke Library.

94. V. G. Audubon to J. Bachman, Minnie's Land, June 17, 1848, and V. G. Audubon to J. Bachman, New York, October 14, 1847, August 1, 1848, Audubon Papers (bMS Am 1482), Houghton Library; and J. Bachman to Maria Martin, May 11, 1848, Bachman Papers; V. G. Audubon to J. Bachman, Minnie's Land, June 17, 1848; and V. G. Audubon to Daniel Rice, New York, October 30, 1848, Victor Gifford Audubon Papers, Beinecke Library.

95. Ford, *John James Audubon*, 429. Audubon probably had a series of strokes and had grown increasingly unsound mentally.

96. V. G. Audubon to J. W. Audubon, Boston (?), December 3, 1850, Audubon Papers (Box 2, Folder 52), Beinecke Library; V. G. Audubon to J.

W. Audubon, Philadelphia, May 16, 18, 21, and 23, 1851, Audubon Papers (Box 2, Folder 53), Beinecke Library. First, in 1849, John organized an expedition to the California goldfields. He returned not only empty-handed but with a plan to publish a series of illustrations that he had done on the trip, which cost the family even more money when they did not sell. In addition, a foundry that they had purchased as an investment collapsed, dragging them further into debt. Victor tried to arrange several joint publications—with a Mr. Jenks of Boston, with Daniel Rice of Philadelphia, and with John Cassin of Philadelphia to reprint the "little work," with new birds to be added by Cassin. All the deals fell through. He raised some money by selling off lots at Minnie's Land, being sure to save enough for the houses that he and John planned to build. See V. G. Audubon to Harris, New York, February 9, 1849, Audubon Papers (pfMS Am21), and V. G. Audubon to J. Bachman, New York, October 25, 1851, Audubon Papers (fMS Am1265), Houghton Library; V. G. Audubon to J. W. Audubon, Boston, December 17, 1850, and Philadelphia, June 22, 1851, Audubon Papers (Box 2, Folder 53), Beinecke Library; V. G. Audubon to Rice, New York, November 5, 1856, Audubon Papers, Beinecke Library; and J. Bachman to Dr. Jared P. Kirtland, Charleston, March 26, 1852, Cleveland Public Library, quoted in Shuler, *Had I the Wings,* 210.

97. V. G. Audubon to J. Bachman, New York, September 4, 1852, Audubon Papers (bMS 1482 [305]), Houghton Library.

98. V. G. Audubon to J. Bachman, Baltimore, January 12, 1852, Audubon Papers (bMS Am 1482 [290]), and V. G. Audubon to Mrs. J. Bachman, New York, December 20, 1852, Audubon Papers (fMS Am 1265), Houghton Library; and Welch, *Book of Nature,* 194.

99. J. J. Audubon to J. Bachman, Minnie's Land, December 10, 1843, Audubon Papers (bMS Am 1482 [161]), Houghton Library; Dwight, *Audubon Watercolors and Drawings,* 51; and Welch, "Audubon and His American Audience," 214; and [Webber], "Quadrupeds," 636–37.

100. Bowen to V. G. Audubon, June 8, 1848, Audubon Papers (fMS Am 1265), Houghton Library; and [Webber], "Quadrupeds of North America," 625. Bowen also labored to restore the plate of the *American Beaver* (plate 46). See V. G. Audubon to J. W. Audubon, Philadelphia, May 7, 1851, Audubon Papers (Box 2, Folder 53), Beinecke Library.

101. [Webber], "Quadrupeds," 626; and C. W. Webber, "The Viviparous Quadrupeds of North America," *Southern Quarterly Review* 12 (October 1847): 201. See Welch, *Book of Nature,* 194–202, for a discussion of Audubon's *Quadrupeds* patrons.

102. J. Bachman to V. G. Audubon, Charleston, February 8, 1844, and J. Bachman to J. J. Audubon, Charleston, March 14, 1844, Bachman Papers; J. Bachman to J. J. Audubon, November 29, 1843, quoted in Shuler, *Had I the Wings,* 192; J. J. Audubon to J. Bachman, December 10, 1843, Audubon Papers, Houghton Library, quoted in Shuler, *Had I the Wings,* 192. J. Bachman to V. G. Audubon, Charleston, January 17, 1846, quoted in Shuler, *Had I the Wings,* 198; and Cahalane, *Audubon's Animals,* xiv, 115.

103. [Charles W. Webber], "Viviparous Quadrupeds of North America," *Southern Quarterly Review* 12 (October 1847): 287.

Chronology

April 26, 1785
Audubon is born Jean Rabin, the illegitimate son of Jean Audubon and Jeanne Rabin, at Les Cayes, Saint-Domingue (now Haiti).

November 10, 1785
His mother, Jeanne Rabin, dies.

1788
He is taken to France to live with his father and to be brought up by his father's wife, Anne Moynet.

1789
He is adopted by his father and given the name Jean-Jacques Fougere.

1803
He goes to America to learn English and enter a trade. He settles at his father's farm, Mill Grove, near Philadelphia.

December 15, 1804
He becomes engaged to Lucy Bakewell.

January 1805
He walks to New York and gets passage to France from his future father-in-law, Benjamin Bakewell. He spends a year with his family in France.

May 1806
He returns to New York, then Mill Grove, and gives the drawings he did in France to Lucy.

1806–7
He clerks at Bakewell's commission house in New York. He continues his studies of birds, and works for Dr. Mitchell's Museum.

1807
He opens a store in Kentucky.

1808
He marries Lucy in Pennsylvania, and they return to Kentucky.

June 12, 1809
Victor Gifford Audubon is born in Louisville.

1811
Audubon returns from a yearlong birding trip on foot. He joins the business of his brother-in-law Thomas Bakewell.

1812
July. He becomes an American citizen. More than 200 drawings are destroyed by rats.
August. Audubon and Bakewell open a commission house in New Orleans. War breaks out, and he returns to Kentucky and starts a store on his own.
November 30. John Woodhouse Audubon is born in Kentucky.

1815
His daughter Lucy is born.

1816
He enters another partnership with Bakewell for a steam gristmill and sawmill.

1817
His daughter Lucy dies.

1818
Audubon's father dies in France.

1819
The mill fails and Audubon goes to jail for debt; he declares bankruptcy and is left with only his clothes and a gun. He resorts to doing crayon portraits for money and is successful.
His daughter Rose is born.

1819–20
His daughter Rose dies.
He works three to four months as a taxidermist and background painter at the Western Museum in Cincinnati, Ohio, for $125 a month. He returns to portraiture and starts a drawing school.

1820
He decides to publish his bird paintings.
October 12. With no funds and with Joseph R. Mason as his assistant, he starts down the Ohio and Mississippi Rivers to New Orleans, exploring for birds. He begins keeping a regular journal.

1821
January 7. He reaches New Orleans without even enough money for a night's lodging.
February 7. He sends Lucy twenty drawings. He takes a job as a tutor and moves to the Pirrie plantation at St. Francisville, where he does some of his finest drawings.
October 12. He returns to New Orleans, where he is joined by his family. They have a very difficult winter financially.

1823
Lucy is hired to start a school at the Beech Woods plantation in West Feliciana, which will allow her to support herself and her sons until 1830.
October 3. Audubon and Victor start for Louisville, walking part of the way. Victor becomes a clerk for his uncle Nicholas A. Berthoud. Audubon paints portraits and street signs.

1824
Audubon goes to Philadelphia, unsuccessfully seeking a publisher, and is advised to go to Europe.
August. He travels from New York to Pennsylvania, earning his European passage doing portraits.

1825–26
He returns to Lucy for the winter, teaching and giving dancing lessons to raise additional funds.

1826
May 17. He sails to Liverpool and arrives knowing no one. In less than a week he is invited to exhibit at the Royal Institution and is proclaimed the "Great American Genius."
October. He goes to Edinburgh, Scotland, where William Lizars begins engraving his artwork. A proof of the *Turkey Cock* is delivered November 28.

1827
He exhibits the first engraved prints at the Royal Institution in Edinburgh. Lizars quits after ten plates, and the work goes to Robert Havell Jr. in London. It will take eleven years for the work on *The Birds of America* to be completed.

1829
He returns to New York, then to Louisville.

1830
Audubon and Lucy sail for Europe, where he sells more subscriptions. He settles in Edinburgh and meets William MacGillivray, and they begin volume 1 of the text for the *Birds*.

March 1, 1831.
Text for the *Birds (Ornithological Biography)*, volume 1, is published to accompany the first one hundred double elephant folio plates.
October–November. Audubon meets John Bachman and stays with him in Charleston, South Carolina.

1833
Audubon, Lucy, and John Woodhouse spend the winter with the Reverend John Bachman in Charleston, South Carolina.

December 1834
Volume 2 of the *Birds* text is published.

1835
He returns to Edinburgh with Lucy.
Fire in New York destroys drawings, papers, and books.
December. Volume 3 of the *Birds* text is published.

1836
Audubon, with both his sons and assistants, tours Europe for five months, returning to New York in August.

1836–37
Audubon spends the winter with Bachman, planning the *Quadrupeds*.

1837
June 8. John Woodhouse marries Maria Rebecca Bachman.
July. Audubon sails with John Woodhouse and Maria to England. He loses many subscriptions in the financial panic but decides to extend the *Birds* to eighty-seven parts to add new birds.

1838
The eighty-seventh part, fourth and final volume, of *The Birds of America* is published, concluding the work started in 1826.

May 1839
Victor marries Mary Eliza Bachman.
The fifth and final volume of the *Birds (Ornithological Biography)* text is published.

1840
Audubon begins work on the *Quadrupeds*.
He begins the octavo edition of the *Birds*.
September 14. John Woodhouse's wife, Maria, dies.

1841
Audubon purchases land along the Hudson River and builds Minnie's Land.
May 25. Victor's wife, Mary, dies.
October 2. John Woodhouse marries Caroline Hall.

1843
Audubon travels to the West for several months.
March 2. Victor marries Georgiana Richards Mallory.

1844
The octavo edition of the *Birds* is completed and published.

1845
The first imperial folio volume of the *Quadrupeds of North America* is published.
Birds plates damaged in a New York fire.
October. John Woodhouse travels to Corpus Christi, Texas, seeking specimens for the *Quadrupeds*.

1846
The second volume of the *Quadrupeds* is published. Audubon personally abandons the project due to failing eyesight. John Woodhouse goes to England to paint pictures for the *Quadrupeds*.

1847
Audubon suffers a stroke and increasing mental impairment.

1848
The third and final volume of the *Quadrupeds* is published.

February 8, 1849
John Woodhouse sets out for the California goldfields, meets with difficulties, and returns the following year.

January 27, 1851
John James Audubon dies at Minnie's Land, age sixty-five.

Bibliography

Adams, Alexander B. *John James Audubon: A Biography*. New York: G. P. Putnam's Sons, 1966.

Alexander, Pamela. *Commonwealth of Wings: An Ornithological biography Based on the Life of John James Audubon*. Hanover, N.H.: University Press of New England, 1991.

Allen, Elsa Guerdrum. "The History of American Ornithology Before Audubon." *Transactions of the American Philosophical Society* 41 (1951).

Arthur, Stanley C. *Audubon: An Intimate Life of the American Woodsman*. New Orleans: Harmanson, 1937.

Audubon, John James. *The Art of Audubon: The Complete Birds and Mammals*. With an introduction by Roger Tory Peterson. New York: Times Books, 1979. Audubon's two major works presented in a single volume, without text.

——. *Audubon in Louisiana*. New Orleans: Louisiana State Museum, 1966.

——. *Audubon Reader: The Best Writings of John James Audubon*. Edited by Scott R. Sanders. Bloomington: Indiana University Press, 1986.

——. *Audubon's "Birds of America."* New York: Macmillan, 1937. Reprint, 1953.

——. *Audubon's "Birds of America."* 2 vols. New York: American Heritage Publishing, 1966.

——. *Audubon's "Birds of America."* New York: Harry N. Abrams, 1979.

——. *Audubon's "Birds of America."* Edited by Roger T. Peterson and V. M. Peterson. New York: Abbeville Press, 1981.

——. *Audubon's Wildlife: Quadrupeds of North America*. Stamford, Conn.: Longmeadow Press, 1989.

——. *The Birds of America*. 7 vols. Edinburgh: Lizars and London, 1826–38.

——. *The Birds of America*. 1840–44. Reprint, with an introduction by Dean Amadon. 7 vols. New York: Dover Publications, 1967.

——. *The Complete Audubon*. 5 vols. National Audubon Society, 1978–79.

——. *Delineations of American Scenery and Character*. New York: G. A. Baker & Co., 1926.

——. *The 1826 Journal of John James Audubon*. Edited by Alice Ford. Norman: University of Oklahoma Press, 1967. Reprint, New York: Abbeville Press, 1987.

——. *My Style of Drawing Birds*. Ardsley, N.Y.: Overland Press for the Haydn Foundation, 1979.

——. *Ornithological Biography*. 5 vols. Edinburgh: A. Black, 1840–44. Reprint, New York: Volair Books, 1979.

——. *Selected Journals and Other Writings*. Edited by Ben Forkner. New York: Penguin Books, 1996.

——. *A Selection from "The Birds of America," by John James Audubon: An Exhibition, 26 September–10 October 1972, North Carolina Museum of Art, Raleigh*. Catalogue. Raleigh: North Carolina Museum of Art, 1976.

Audubon, John James, and the Reverend John Bachman. *The Imperial Collection of Audubon Animals: The Quadrupeds of North America*. Edited by Victor H. Cahalane. New York: Bonanza Books, 1967.

——. *The Quadrupeds of North America*. 3 vols. New York: V. G. Audubon, 1849–54. Royal octavo edition; text is interleaved with 155 hand-colored lithographs. Issued by subscription in 31 parts of 5 plates each (155 plates).

——. *The Quadrupeds of North America*. Edited by Keir B. Sterling. 3 vols. New York: Arno Press, 1974.

——. *Selected Quadrupeds of North America*. Kent, Ohio: Volair, 1977.

——. *The Viviparous Quadrupeds of North America*. 3 vols. New York: John James Audubon, 1845–48. First Edition of *The Quadrupeds'* hand-colored lithographs; imperial folio, 150 plates, issued in 30 parts of 5 prints each (with wrappers). Ten parts to a volume (when bound in 2 vols. with less brilliant coloring, considered to be a later issue). Text volumes published subsequently (see below), and followed by a 93-page supplement with 6 additional plates originating with the octavo edition.

——. *The Viviparous Quadrupeds of North America*. 3 vols. New York: John James Audubon and V. G. Audubon, 1846–54. Text-only octavo volumes

containing animal biographies. Published to augment the imperial-size colorplates.

Audubon, Lucy. *The Life of John James Audubon*. New York: G. P. Putnam & Son, 1871.

Audubon, Maria R., ed. *Audubon and His Journals, with Zoological and Other Notes by Elliott Coues*. 2 vols. New York: Charles Scribner's Sons, 1897. Reprint, Freeport, N.Y.: Books for Libraries Press, 1972; New York: Dover Publications, 1994.

Bachman, John. *Additional remarks on the Genus Lepus, with corrections of a former paper, and descriptions of other species of Quadrupeds found in North America*, 75–105. Philadelphia: Academy of Natural Sciences, 1841.

Bannon, Lois. *Handbook of Audubon Prints*. Gretna, La.: Pelican Publishing Co., 1980.

Barber, Lynn. *The Heyday of Natural History, 1820–1870*. New York: Doubleday & Co., 1980.

Bland, D. S. *John James Audubon in Liverpool, 1826–27*. Liverpool: D. S. Bland, 1977.

Blaugrund, Annette. "Audubon: Artist and Entrepreneur," *Magazine Antiques* 144, no. 5 (1993): 672–81.

Blaugrund, Annette, and Theodore E. Stebbins Jr., eds. *John James Audubon: The Watercolors for "The Birds of America."* New York: Random House, Villard Books, and the New-York Historical Society, 1993.

Blum, Ann Shelby. *Picturing Nature: American Nineteenth-century Zoological Illustration*. Princeton, N.J.: Princeton University Press, 1993.

Bradford, Mary F. *Audubon: By Mary Fluker Bradford*. New Orleans: Press of L. Graham & Son, 1897.

Brewer, Thomas M. "Reminiscences of John James Audubon," *Harper's New Monthly Magazine*, 56 (1880): 665–75.

Buchanan, R. *The Life and Adventures of Audubon the Naturalist*. London: Dent, 1868.

Burroughs, John. *Squirrels and Other Fur-Bearers*. New York: Houghton Mifflin, 1901.

——. *John James Audubon*. Boston: Small, Maynard and Co., 1902. Reprint, Woodstock, N.Y.: Overlook Press, 1987.

Butterworth, Hezekiah. *In the Days of Audubon (Nature)*. New York and London: D. Appleton and Co., 1901.

Catalogue of the New Birds of America Section of the Audubon Archives, Department of Ornithology, American Museum of Natural History, New York City: A Condensation of the Data in the New Section. New York: American Museum of Natural History, 1991.

Chancellor, John. *Audubon: A Biography*. New York: Viking, 1978.

Chebel, Claude. *Audubon: The Man Who Loved Nature*. London: W. H. Allen, 1987.

Christie, Manson and Woods International. *John James Audubon and His Circle: The Collections of Dr. Evan Morton Evans (1870–1955) and his son Daniel Webster Evans (1907–1966): The Property of the American Foundation Trust and from Various Sources, Friday, October 29, 1993, at 2:00 PM*. New York: Christie, Manson and Woods International Inc., 1993.

Clement, Roland C. *The Living World of Audubon*. New York: Grosset & Dunlap, 1974.

Corning, Howard, ed. *Journal of John James Audubon Made During His Trip to New Orleans, 1820–21*. Boston: Club of Odd Volumes, 1929.

——. *The Letters of John James Audubon, 1826–1840*. 2 vols. Boston: Club of Odd Volumes, 1930. Reprint, New York: Kraus Reprint Co., 1969.

Coues, Elliott. *Fur-Bearing Animals: A Monograph of North American Mustellidae*. U.S. Geological Survey Miscellaneous Publication no. 8, n.p., 1877.

Craig, Hugh. *The Animal Kingdom Based upon the Writings of the Eminent Naturalists, Audubon, Wallace, Brehm, Woo*. New York: Johnson & Bailey, 1897.

DeLatte, Carolyn E. *Lucy Audubon: A Biography*. Baton Rouge: Louisiana State University Press, 1982.

DiSilvestro, Roger. "Stories Behind the Paintings," *National Wildlife* 32, no. 6 (1994), 52–59.

Dorman, James H., ed. *Audubon: A Retrospective*. Lafayette: University of Southwestern Louisiana Center for Louisiana Studies, 1990.

Dunlap, William. *A History of the Rise and Progress of the Arts of Design in the United States*. 2 vols. New York, 1834. Reprint, New York: Dover Publications, 1994.

Durant, Mary, and Michael Harwood. *On the Road with John James Audubon*. New York: Dodd, Mead & Co., 1980.

Dwight, Edward H., ed. *Audubon Watercolors and Drawings*. Utica, N.Y.: Munson-Williams-Proctor Institute; New York: The Pierpont Morgan Library, 1965.

Fisher, Clyde. *The Life of Audubon*. New York: Harper and Brothers, 1949.

Ford, Alice. *John James Audubon*. Norman: University of Oklahoma Press, 1964.

—. *The 1826 Journal of John James Audubon*. University of Oklahoma Press, 1967.

—. *John James Audubon: A Biography*. New York: Abbeville Press, 1988.

—. *Audubon, by Himself: A Profile of John James Audubon, from Writings Selected, Arranged and Edited by Alice Ford*. Garden City, N.Y.: Natural History Press, 1969.

—, ed. *Audubon's Animals: "The Quadrupeds of North America."* New York: The Studio Publications in association with Thomas Y. Crowell, 1951. First major work on *The Quadrupeds* with a biographical introduction, historical overview, reproductions of selected original studies, and reprints of the imperial folio plates with abridged text.

—, ed. *Audubon's Butterflies, Moths and Other Studies*. New York: The Studio Publications, 1952.

Foshay, Ella M. *Audubon*. New York: Harry N. Abrams, in association with the National Museum of American Art, Smithsonian Institution, 1997.

Fries, Waldemar H. *The Double Elephant Folio: The Story of Audubon's "Birds of America."* Chicago: American Library Association, 1973.

—. "John James Audubon: Some Remarks on His Writings." Princeton University Library Chronicle #21 (1959–60).

Godwin, Parke. "John James Audubon." In *Homes of American Authors: Comprising Anecdotical, Personal, and Descriptive Sketches by Various Writers*. New York: G. P. Putnam and Co., 1853.

Graustein, Jeannette E. *Thomas Nuttall, Naturalist: Explorations in America, 1808–1841*. Cambridge, Mass.: Harvard University Press, 1967.

Griscom, Ludlow. *Audubon's "Birds of America."* New York: Macmillan, 1950.

Hart, Mary Bell. *Audubon's Texas Quadrupeds: A Portfolio of Color Prints with an Explanatory Text*. Austin: Hart Graphics, 1979.

Herrick, Francis Hobart. *Audubon the Naturalist: A History of His Life and Time*. 2 vols. New York and London: D. Appleton and Co., 1917. Rev. 1938. Reprint, New York: Dover Publications, 1968.

Hogeboom, Amy. *Audubon and His Sons*. 1891. Reprint, New York: Lothrop, Lee & Shepard Co., 1956.

Holbrook, John Edwards. *North American Herpetology; or, A Description of the Reptiles Inhabiting the United States*. 4 vols., Philadelphia: J. Dobson, 1836–38.

Howard, Joan. *The Story of John James Audubon*. 1904. Reprint, New York: Grosset & Dunlap, 1954.

Irmscher, Christoph. "Violence and Artistic Representation in John James Audubon." *Raritan: A Quarterly Review* 15, no. 2 (fall 1995): 1–35.

Jackson, Christine E. *Bird Etchings: The Illustrators and Their Books, 1655–1855*. Ithaca, N.Y., and London: Cornell University Press, 1985.

Keating, L. Clark. *Audubon: The Kentucky Years*. Lexington: University Press of Kentucky, 1976.

Knaggs, Nelson S. *The Rediscovery of John J. Audubon's "White Wolf."* [Cincinnati?]: n.p., 1970.

Lindsey, Alton A. *The Bicentennial of John James Audubon*. Bloomington: Indiana University Press, 1985.

Low, Susanne M. *An Index and Guide to Audubon's Birds of America*. New York: American Museum of Natural History/Abbeville Press, 1988.

Mason, Miriam F. *Young Audubon: Boy Naturalist*. Indianapolis: Bobbs Merrill, 1943.

May, Stephen. "Audubon's Land of Wonders: Mill Grove Estate in Pennsylvania Is a 170-Acre Refuge of Forest, Meadows and Birds." *The New York Times*, October 23, 1994, sec. 5, p. 28, col. 3.

McDermott, John Francis, comp. and ed. *Audubon in the West*. Norman: University of Oklahoma Press, 1965.

—. *Up the Missouri with Audubon: The Journal of Edward Harris*. Norman: University of Oklahoma Press, 1951.

McKelvey, Susan D. *Botanical Explorations of the Trans-Mississippi West, 1790–1850*. Jamaica Plain, Mass.: Arnold Arboretum of Harvard University, 1955.

Murphy, R. C. "John James Audubon (1785–1851): An Evaluation of the Man and His Work." *New York Historical Society Quarterly* (October 1956): 315–50.

Nash, Roderick. *Wilderness and the American Mind*. Rev. ed. New Haven, Conn., and London: Yale University Press, 1976.

Owens, Carlotta J. *John James Audubon: The Birds of America*. Washington, D.C.: National Gallery of Art, 1984. Catalogue of an exhibition at the National Gallery of Art, October 14, 1984, to April 14, 1985.

Peattie, Donald C. *Singing in the Wilderness: A Salute to John James Audubon*. New York: G. P. Putnam, 1935.

Peattie, Donald C., ed. *Audubon's America: The Narratives and Experiences of John James Audubon*. New York: Houghton Mifflin, 1940.

Porter, Charlotte M. *The Eagle's Nest: Natural History and American Ideas, 1812–1842*. University: University of Alabama Press, 1986.

Proby, Kathryn H. *Audubon in Florida*. Coral Gables, Fla.: University of Miami Press, 1974.

Reynolds, Gary A. *John James Audubon and His Sons*. New York: Grey Art Gallery and Study Center, New York University, 1982.

Ridge, Davy-Jo. *A Load of Gratitude: Audubon and South Carolina*. Catalogue of an exhibition at the University of South Carolina, November 15, 1985, to January 26, 1986. Columbia, S.C.: University of South Carolina, 1985.

Rourke, Constance. *Audubon*. New York: Harcourt, Brace and Company, 1936.

Savage, Henry. *Lost Heritage: Wilderness America through the Eyes of Seven Pre-Audubon Naturalists*. New York: William Morrow & Co., 1970.

Shuler, Jay. *Had I the Wings: The Friendship of Bachman and Audubon*. Athens, Ga.: University of Georgia Press, 1995.

Sorel, Nancy C. "Sir Walter Scott and John James Audubon." *Atlantic Monthly* 273, no. 3 (1994): 109.

St. John, Mrs. Horace. *Audubon: The Naturalist of the New World, His Adventures and Discoveries*. N.p.: C. S. Francis, 1856.

—. *Audubon the Naturalist*. Boston: Crosby, Nichols, Lee and Co., 1861.

Stephens, Lester D. *Science, Race and Religion in the American South: John Bachman and the Charleston Circle of Naturalists, 1815–1895*. Chapel Hill: University of North Carolina Press, 2000.

Streshinsky, Shirley. *Audubon: Life and Art in the American Wilderness*. New York: Villard Books, 1993.

Szczesiul, Anthony. "Robert Penn Warren's 'Audubon': Vision and Revision." *Mississippi Quarterly* 47, no. 1 (Winter 1993): 3–15.

Teale, Edwin W. *Audubon's Wildlife*. New York: Viking Press, 1964.

Thompson, Larry S. *Montana's Explorers: The Pioneer Naturalists*. Helena: Montana Magazine, 1985.

Thorpe, James E. *Audubon: "The Birds of America."* San Marino, Calif.: Huntington Library, 1978.

Townsend, John Kirk. *Narrative of a Journey across the Rocky Mountains to the Columbia River*. Philadelphia: Henry Perkins, 1839.

Tree, I. *The Ruling Passion of John Gould: A Biography of the British Audubon*. New York: Weidenfeld, 1992.

Truettner, William H. *The Natural Man Observed: A Study of Catlin's Indian Gallery*. Washington, D.C.: Smithsonian Institution Press, 1979.

Tyler, Alice J. *I Who Should Command All*. New Haven, Conn.: Framamat Publishing Co., 1937 (in honor of the opening of the Audubon Memorial Park and Museum at Henderson, Ky.). Reprint, Gretna, La.: Pelican Publishing Co., 1985.

Tyler, Ron. *Audubon's Great National Work: The Royal Octavo Edition of "The Birds of America."* Austin: University of Texas Press, 1993.

—. *Nature's Classics: John James Audubon's Birds and Animals*. Orange, Texas: Stark Museum of Art, 1992.

Warren, Robert Penn. *Audubon: A Vision*. New York: Random House, 1969.

Welch, Margaret. *The Book of Nature: Natural History in the United States, 1825–1875*. Boston: Northeastern University Press, 1998.

Wells, Mary L., and Dorothy Fox. *Boy of the Woods: The Story of John James Audubon*. New York: Dutton, 1950.

Wilmerding, John. *Audubon, Homer, Whistler and Nineteenth-Century Americana*. New York: McCall Publishing Co., 1970.

Additional References Related to Audubon's 1843 Trip

Brannon, Peter A. *Edward Harris, Friend of Audubon*. New York: Newcomen Society, 1947.

Chittenden, Hiram Martin. *History of Early Steamboat Navigation on the Missouri River: Life and Adventures of Joseph La Barge*. New York: Francis P. Harper, 1903.

Culbertson, Thaddeus. *Journal of an Expedition to the Mauvaises Terres and the Upper Missouri in 1850*. Edited by John F. McDermott. Smithsonian Institution Bureau of American Ethnology Bulletin 147, Washington D.C., 1952.

DeVore, Steven L. *Fort Union Trading Post National Historic Site (32WI17) Material Culture Reports*. Part 9, Personal, Domestic, and Architectural Artifacts. U.S. Department of the Interior, National Park Service. Lincoln, Neb.: Midwest Archeological Center, 1993.

Evans, Howard E. *Pioneer Naturalists: The Discovery and Naming of North American Plants and Animals*. New York: Henry Holt, 1993.

Klem, Mary J. "The History of Science in St. Louis." *Transactions of the Academy of Science of St. Louis* 23, no. 2 (December 1914): 79–127.

Multimedia Audubon's Mammals. Cornell Library of Natural Sounds, 1992. CD-ROM containing text, images, and sound.

Peterson, Lynelle A., and William J. Hunt. *The 1987 Investigations at Fort Union Trading Post: Archeology and Architecture*. U.S. Department of the Interior, National Park Service. Lincoln, Neb.: Midwest Archeological Center, 1990.

Point, Nicolas, S. J. *Wilderness Kingdom: Indian Life in the Rocky Mountains 1840–1847. The Journals and Paintings of Nicolas Point*. New York: Holt, Rinehart and Winston, 1967.

Sunder, John E. *The Fur Trade on the Upper Missouri*. Norman: University of Oklahoma Press, 1965.

Trimble, Michael K. *An Ethnohistorical Interpretation of the Spread of Smallpox in the Northern Plains Utilizing Concepts of Disease Ecology*. Reprints in Anthropology 33. Lincoln, Neb.: J & L Reprint Co., 1986.

Viola, Herman J., and Carolyn Margolis, eds. *Magnificent Voyagers: The U.S. Exploring Expedition, 1838–1842*. Washington, D.C.: Smithsonian Institution Press, 1985.

Weist, Katherine M., E. Earl Willard, and J. H. Lowe. *Current and Historic Natural Resources of the Fort Union Trading Post National Historic Site*. Missoula: University of Montana, 1980.

Children's Books on Audubon

Anderson, Peter. *John James Audubon: Wildlife Artist*. Danbury, Conn.: Franklin Watts, 1995.

Ayars, James Sterling. *John James Audubon: Bird Artist*. Champaign, Ill.: Garrard Publishing Co., 1966.

Brenner, Barbara. *On the Frontier with Mr. Audubon*. New York: Coward, McCann and Geoghegan, 1977.

Gleitner, Jan. *John James Audubon*. Milwaukee: Raintree Children's Books, 1988.

Kastner, Joseph. *John James Audubon*. New York: Harry N. Abrams, 1992.

Kendall, Martha E. *John James Audubon: Artist of the Wild*. Brookfield, Conn.: Millbrook Press, 1993.

Kieran, Margaret F., and John Kieran. *John James Audubon*. New York: Random House, 1954.

Roop, Peter, and Connie Roop, eds. *Capturing Nature: The Writings and Art of John James Audubon*. New York: Walker & Co., 1993.

Smaridge, Norah. *Audubon: The Man Who Painted Birds*. New York: World Publishing Co., 1970.

Index

Page numbers in *italics* refer
to illustrations.
All works are by John James
Audubon unless otherwise indicated.

A

Abert, John James, 126, 154, 168
Academy of Natural Sciences, 92, 93,
 115, 154
Agassiz, Louis, 96, 174
American Badger, 97; *98*
American Beaver, 138, 139; *139*
American Black or Silver Fox (J. W.
 Audubon), 101; *104*
American Cross Fox, 33
American Elk-Wapiti Deer, 178, 179;
 179
American Goldfinch, 22; *24*
American Grizzly Bear (J. W.
 Audubon), 157; *157*
American Ornithology (Wilson), 14,
 18, 119, 138, 179
American Rein Deer. See Caribou
American Review, 110, 113
American Souslik, Oregon Meadow
 Mouse, Texan Meadow Mouse
 (J. W. Audubon), 162; *162*
American White Wolf (J. W.
 Audubon), 130; *130*
aquatint engravings, 21, 27, 29
Arctic Hare, or Polar Hare, 161; *160*
Audubon, John James, 164; *10, 54,*
 74, 118
 artists' influences on, 13–14,
 15–17, 18–19, 22, 36
 childhood of, 12–13
 children of, 14, 40–43, 74. *See also*
 Audubon, John Woodhouse;
 Audubon, Victor Gifford
 death of, 30, 115, 175
 financial difficulties of, 14, 38, 39,
 121 health of, 14, 21, 26, 65,
 115, 174
 on hunting, 39, 81–84
 influence on landscape painting, 17
 marriage of, 14–15; *15. See also*
 Audubon, Lucy Bakewell
 mediums used, 21–22, 29–30, 135
 at Minnie's Land. *See* Minnie's
 Land
 painting technique. *See* painting
 technique
 parents of, 11, 12
 personality of, 18, 55–57, 89, 142
 as portrait artist, 17
 portraits of, 11, 119; *10, 74, 118*
 pragmatic approach to art, 36

John James Audubon
in the West

196

and role of assistants, in work, 77,
 132–35. *See also specific assistants'*
 names
Audubon, John Woodhouse, 14; *26*
 artistic style of, 26, 62, 65, 101
 as Audubon's assistant, 135, 144
 marriages of, 25, 120, 144
 role of, in *Quadrupeds,* 25–26,
 62–63, 65, 101, 171
Audubon, Lucy Bakewell, 14–15, 43,
 126, 141, 144, 155; *15*
Audubon, Maria R. (granddaughter),
 65
Audubon, Victor Gifford, 14, 26; *26*
 as Audubon's assistant, 135, 144
 collaboration with J. W. Audubon,
 on work, 11, 26
 marriages of, 25, 43, 78, 120, 144
 role of, in *Quadrupeds,* 25–26,
 97–101, 170, 175
Audubon's Coat (photograph), *54*

B

Bachman, John, 73; *75, 121*
 advice on specimen-collecting, 73,
 76, 92
 on Audubon's style, 138
 children of, 25, 74, 75, 120, 144,
 174
 criticism of Missouri River trip,
 161–62
 criticisms of *Quadrupeds,* 74, 76,
 107, 151, 154
 designated co-author of
 Quadrupeds, 26, 75, 120–21,
 122–23, 144
 as friend of Audubon, 73, 174
 health of, 121, 170, 174
 as mammalogy expert, 74, 96–97,
 119–20, 123
 marriages of, 26, 135, 174
 text-writing for *Quadrupeds,*
 101–7, 110, 141, 170, 174, 175
Background for Northern Hare, 147;
 147
Baird, Spencer Fullerton, 78–79,
 115, 123, 137
Baird's Bunting, 79, 86; *79*
Bakewell, Thomas Woodhouse,
 38–39
Bakewell, William, 78
Barred Owl, 29, 36, 139; *31, 32*
bats, and omission from *Quadrupeds,*
 107
beavers, in *Quadrupeds* text, 139
Bell, John G.
 and Bell's Vireo, 55, 86

on Missouri River trip, 50, 63, 76,
 77, 79, 156, 181
Bell's Vireo, 55, 57; *56, 57*
Bell's Vireo (*Vireo bellii*), 90; *91*
Belted Kingfisher, 13, 21; *12*
Berthoud, Nicholas Augustus, 17; *16*
Bingham, George Caleb, 29, 30
Birds of America, The, 11, 71, 121,
 137
 Audubon's opinion of, 138, 141
 bird-of-prey compositions, in, 73,
 138–39
 in copperplate engraving, 129
 double elephant folio, defined,
 168–70
 natural setting poses, in, 21, 36
 popularity of, versus *Quadrupeds,*
 30
 price of, 141
 use of assistants, for, 22, 132
Birds of America, The (octavo
 edition), 72, 122, 141
 defined, 55, 168–70
 price of, 141
 production of, 119, 135, 137
 species added to, after Missouri
 River trip, 26, 55, 57, 79, 86,
 89, 120, 164; *56, 57, 164*
 success of, 137, 142–44
bison. *See* buffalo
Black American Wolf (J. W.
 Audubon), 167, 168; *167*
Black Fox Squirrel (J. W. Audubon),
 101
Black Rats, or Black Rats Eating Eggs
 (J. J. Audubon/V. G. Audubon),
 144, 147; *146*
Blackfoot Shirt (photograph), *51*
Black-Footed Ferret (J. W. Audubon),
 162; *163*
Black-Tailed Deer (J. W. Audubon),
 168; *168*
Black-Tailed Hare, 171; *172*
Boatmen on the Missouri (Bingham),
 31
Bodmer, Karl, 126, 132
 and Missouri River expedition, 27,
 29, 60, 129
 works by, *62, 129*
Bonaparte, Charles-Lucien, 90, 119
Bos Americanus, American Bison or
 Buffalo, 65; *66, 67*
Bowen, J. T., 79
 and *The Birds of America,* 55, 131,
 132, 135–37, 144
 as *Quadrupeds* lithographer, 43,
 131, 132, 144, 178
Brewer, Thomas M., 96, 122, 126,
 148

Brewers Black Bird, 164; *164*
Brown Thrasher, 19; *20*
buffalo, 57, 63–65
 and buffalo hunts, 63–65, 81–84,
 155–56
 portrayals of, 63–65, 141, 178
 Quadrupeds text on, 63, 65, 81
Buffalo and Elk on the Upper Missouri
 (Bodmer), 27, 29; *28*
Buffalo Chase, Mouth of Yellowstone
 (Catlin), 27–29; *27*
Buffalo Hunt (Stanley), 29; *31*

C

California Grey Squirrel (J. W.
 Audubon), 177; *177*
Californian Marmot Squirrels, 113;
 112
camera lucida, 55, 135, 156
Canada Lynx, 142; *143*
Canada Pouched Rat, 47, 50, 154,
 158; *49*
Caribou or American Rein Deer (J. W.
 Audubon), 93; *94*
Carleton, James Henry, 37, 151, 156
Carolina Gray Squirrel, 139
Carolina Parakeet (*Conuropsis*
 carolinensis), 71; *70*
Cat Squirrel, 43, 47; *46*
Catlin, George, 60, 86, 129
 criticism of, by Audubon, 57–58,
 59, 60
 Indian life depictions, 27–29, 58, 59,
 60, 126, 132; *59, 60*
 and upper Missouri, portrayal of,
 59; *59*
"central flyway" (migratory route), 81
Chevalier, John B., 137, 148–51
Chipmunk, labeled *Tamias quadrivit*
 tatus Say, 93; *93*
Chouteau, Pierre, Jr., 50, 80, 151–54
chromolithographs, 131
Cloth Pouch (photograph), *52, 53*
Common American Deer (Fawn). See
 White-Tailed Deer, or Common
 American Deer (Fawn) (J. W.
 Audubon)
Common American Skunk, 47–50,
 141, 147; *48*
Common American Wildcat, 40, 138,
 147, 151, 170; *41, 153*
Common Mouse (J. W. Audubon),
 101, 104; *104*
Common Tern, 22; *24, 25*
copperplate engraving. *See* engraving,
 use of
Costé, Napoleon, 126

Cottontail Rabbit. *See Gray Rabbit or Cottontail Rabbit*
Cougar: Female & Young, The (J. W. Audubon), 138, 141, 144; *145*
Cougar: Male, The (J. W. Audubon), 101, 104; *104*
Culbertson, Alexander, 63, 155, 156, 162

D

Daily People's Organ, 79, 155
Deas, Charles, 29
Douglass's Ground Squirrel (J. W. Audubon), 101
Douglass's Spermophile, 126; *127*
Douglass's Squirrel, 123; *124, 125*
Dunlap, William, 14

E

Eastern Grey Squirrel, 29, 37; *37*
Echinacea Ingustofolia (Sprague), 78; *78*
Encampment of J. J. Audubon and Party, May 26 & 27 & Sept 16, 1843; Missouri River near Great Bend, Sept 16, 1843 (Sprague), *72*
Endicott, George, 144
engraving, use of, 17–18
 versus lithography, 129, 130, 135
 See also Havell, Robert, Jr.; Lizars, William Home
engraving-aquatints, 21, 27, 29
Entomology (Say), 179
Entrapped Otter (Canada Otter), 29, 38, 138; *38*
Esquimaux Dog (J. W. Audubon), 167, 168; *167*

F

fascicles, defined, 129
Fawkes, Walter, 19
Florida Rat (Neotoma Floridana) Male, Female, and Young, 138, 141, 147; *140*
Fort Clark, 58, 60, *60*
Fort Leavenworth, 54, 71
Fort Union, 37, 155–56
 arrival at, 60
 departure from, 65
 described, 80, 81, 86; *62, 80, 82*
 Indians, in region of, 59; *59*
 wolves, in vicinity of, 62, 63, 158
Fort Union on the Missouri (Bodmer), *62*
four-striped ground squirrel, 65
Four-Striped Ground Squirrel, 63; *64*
fox, in *Quadrupeds*, text, 139
Fox Squirrel *(Sciurus niger,* labeled

Sciurus vulpinus), 101; *102*
Franklin's Marmot Squirrel, 167, 168; *167*
Free-Tailed Bat, 107; *109*
fur traders, Audubon's view of, 52

G

"galloping parties," 80
glutton. *See Wolverine*
Godwin, Parke, 47, 139
Goshawk, Stanley Hawk, 166
Gould, John, 19, 142
Grassy Bluffs on the Upper Missouri (Catlin), 58, 59; *59*
Gray Fox, 177, 178, *178*
Gray Rabbit or Cottontail Rabbit, 40–43, 166–68; *42*
Gray Squirrel, 81
Gray Wolf, 62
gray-headed coneflower, 78; *78*
Great Gray Owl, 21, 22; *23*
Greater Prairie Chicken *(Tympanuchus pallidicinetus)*, 84; *84*
Greene, Benjamin D., 151
Grey Squirrel, 36

H

Hare-Indian Dog, 168; *132, 133*
Harlan, Richard, 96–97, 121–22, 123, 151
Harris, Edward, 71, 171; *77*
 bird specimens collected by, 71, 90; *70, 91*
 on Missouri River trip, 50, 52, 63, 76–77, 80, 86
 and *Quadrupeds*, 97, 139, 144, 151, 170
Harris' Finch, 54–55, 57, 86; *57, 120*
Havell, Robert, Jr., 18, 79
 and *The Birds of America*, 21, 22, 73, 120, 121, 135
 and *Quadrupeds*, 135
Head of a Buffalo Calf, 84, 85
Hitchcock, William E., 104; *85, 98, 99, 104*
Hoary Bat, 107, 108
Hondecoeter, Melchior d', 39
House of John James Audubon (W. R. Miller), 47; *47*
Hudson River School, 17
Hudson's Bay Lemming (J. W. Audubon), 105; *106*
Humboldt, Alexander von, 90

I

Indians, 29, 55, 132; *30, 51, 129*
 Audubon's views on, 29, 52, 58–60
 Catlin's portrayals of, 27–29, 57–58, 59, 60, 126, 132; *59, 60*

in Fort Union region, 59; *59*
 travelling on *Omega*, 52, 156
Indians Hunting the Bison (Bodmer), *129*
Inman, Henry, 15
In-ne-ó-cose, The Buffalo's Child, Blackfeet (Catlin), 58, 59; *59*
intaglio process, 130

J

Jackal Fox. See Long-Tailed Red Fox, or Jackal Fox (J. W. Audubon)
Jarvis, John Wesley, 15
Jocko with a Hedgehog (Landseer), 19; *20*
John Auld (steamboat), 54
John James Audubon (J. W. Audubon), 119; *118*
John James Audubon (J. W. Audubon/V. G. Audubon), 11; *10*
Jumping Mouse, or Labrador Jumping Mouse, 81; *83*

K

Kendall, George Wilkins, 170, 171
Kidd, Joseph Bartholomew, 22, 135

L

La Barge, Joseph, 55
Labrador Jumping Mouse. *See Jumping Mouse, or Labrador Jumping Mouse*
Landseer, Edwin, 18, 19, 39, 40
Large-Tailed Spermophile (J. W. Audubon), 175; *131, 175*
Lazuli Bunting *(Passerina amoena)*, 90; *91*
Le Conte's Sharp-Tailed Bunting, 86; *87*
Lear, Edward, 18, 19
Least Flycatcher, 164; *164*
Leather Coat (photograph), *51*
Leclerc, Georges-Louis, comte de Buffon, 13, 36
LeConte, John Lawrence, 122
Leconte's Pine Mouse, 97; *98*
Lehman, George, 17, 22, 25, 77, 135
Leopard Spermophile, or Thirteen-Striped Ground Squirrel, 81, 168; *82*
Lewis and Clark, 57, 126, 154, 161–62
Lincoln's Finch, 81
Literary World, 113
lithography, 130
 versus copperplate engraving, 129, 130, 135
 process of, described, 130–32

See also Bowen, J. T.
Little and Brown, 142
Little Nimble Weasel (J. W. Audubon), 175; *175*
Lizars, William Home, 18, 135
Long, Stephen H., 126, 129
Long-Billed Curlew, 25; *25*
Long-Haired Squirrel, 180–81; *181*
Long-Tailed Mountain Titmouse, 13, 21; *13*
Long-Tailed Red Fox, or Jackal Fox (J. W. Audubon), 101; *103*
Long-Tailed Weasel, or White Weasel (Studio of J. W. Audubon), 137; *137*
Lucy Bakewell Audubon, 15
lynx, in *Quadrupeds* text, 142

M

Magnificent Frigatebird, 21; *23*
Magnolia Warbler, 22; *24, 25*
Mammals of North America (Baird), 79, 115
Mandan Village, Mandan—View of the Missouri above the village whilst the women and children are bathing (Catlin), 60
Maria's Woodpecker, 25
Marmot, 36, 37; *37*
Martin, Maria, 174
 as assistant to Audubon, 22, 25, 77, 135
 as wife of Bachman, 26, 135, 174
Mason, Joseph, 22, 77, 135
McClung, Peter, *16*
McKenney and Hall, 113, 132
McKenzie, Owen, 155
Mercury, 164
Metford, Samuel, 75
Mexican Ground Squirrel (J. W. Audubon), 113; *112*
Mexican Marmot Squirrel (J. W. Audubon), 113, 115; *113*
Migratory Squirrel, 147, 148, 151; *149, 150*
Mill Grove (Audubon estate), 14, 72–73, 156
Miller, Alfred Jacob, 29, 155
Minatarree Village, Minatarree—Seven miles above the Mandans on the bank of the Knife River (Catlin), 60; *60*
Minnie's Land (New York), 43, 58; *47*
 Bachman's visits to, 161, 170
 Godwin's visit to, 47, 139
 move to, 43, 144, 158, 166
 son's homes, at, 25–26
 workroom at, 25, 47
Missouri Meadow Lark, 120; *120*
Missouri Mouse (J. W. Audubon), 158; *158*

Missouri Republican, 80
Missouri River trip, 80, 81, 89; *72*
 bird specimens collected during,
 71, 90; *70, 91*
 commencement of, 26, 50, 52
 costs of, 79
 disappointment in, 27, 59, 84–86,
 155, 158
 duration of, 65, 155–56
 health of Audubon, during, 52,
 79–80, 81, 154–55
 mammal species collected on, 86,
 158
 migratory route followed, on, 81
 participants in, 50, 76–78
 preparation for, 50
 publicity about, 90, 162–66
 purpose of, 72, 90
 return trip, 65, 84, 156–58, 166
Mitchell, D. D., 154
Mole-Shaped Pouched Rat
 (J. W. Audubon), 106; *106*
Morton, Samuel G., 115, 151, 170
Mountain Brook Minks
 (J. W. Audubon), 115; *116–17*

N

National Academy of Design (New
 York), 21, 26
Nicholas Augustus Berthoud, 17; *16*
Nine-Banded Armadillo
 (J. W. Audubon), 174; *174*
*Northern Flying Squirrel (Glaucomys
 sabrinus, labeled Scinropterus
 volucella var. Hudsonius),* 92; *93*
Northern Grey Squirrel, 147, 151
Northern Hare, 161
Northern Hare (Old and Young), 43,
 144–47, 180; *147, 148*
Northern Hare (Winter), 161; *161*
Northern Meadow Mouse
 (J. W. Audubon), 105; *105*
Northern Parula, 22
Nuttall, Thomas, 126, 151
Nuttall's Whip-poor-will, 86, 89; *89*

O

Oakley Plantation (Louisiana), 36
Ocelot, or Texas Leopard Cat
 (J. W. Audubon), 101, 171; *172*
oil, as medium, 17, 135
Omega (steamboat), 35, 52, 55
 delays, 57–58, 154
 departure of, 52
 and Fort Union arrival, 60
 and Indians, travelling on, 52, 156
 migratory route followed by, 81
 and trip speed, 80, 81, 155
Ord, George, 123, 151
Ornithological Biography, 71, 80, 120,
 139–41

Ornithological Collection, 19
Osgood, Samuel S., 25
Otis, Bass, 130
otter, Audubon's interest in, 38–39
Oudry, Jean-Baptiste, 13

P

Pad Saddle (photograph), *52, 53*
painting technique, 21, 29
 and camera lucida, 55, 135, 156
 and design, 22, 29, 138
 and mediums used, 21–22, 28–29,
 135
 and model poses, 21, 29, 40,
 50–52, 62, 138
 separate drawings combined, as,
 43, 135
 and system of squares, 156
 for textures, 21–22, 29, 50
 and use of assistants, 77, 132–35,
 136. *See also specific assistants'*
 names
 and use of lithographers, 43, 135.
 See also lithography
Parkman, George, 137, 138
Passenger Pigeon, 19
pastel, as medium, 12–13, 21–22
Peale, Charles Willson, 17, 123
Peale, Titian Ramsay, 17–18, 96,
 129, 170; *96*
Pennsylvania Academy of the Fine
 Arts, 17, 25
Perronneau, Jean-Baptise, 12
Peter McClung, 16
Philadelphia Academy of Natural
 Sciences, 126, 170
Pirrie, James, 36
planographic process, 130
[Pocket Gopher] "Arrow Rock,
 [Missouri]" (Peale), *96*
Porcupine, 157
Portrait of John James Audubon
 (Sprague), *74*
Prairie Dog–Prairie Marmot Squirrel,
 156; *156*
Prairie Wolf (J. W. Audubon), 166,
 168; *165, 169*
Prong-Horned Antelope
 (J. W. Audubon), 93; *95*
Provost, Étienne, 154

Q

Quadrupeds of North America, The
 as octavo edition name, 107
 success of, 113–15, 177
 See also Viviparous Quadrupeds of
 North America, The

R

Raccoon (J. W. Audubon), 144; *145*
Rafinesque, Constantine, 170
Ranney, William S., 29
Red Texan Wolf (J. W. Audubon), 65;
 69
Red-Tailed Squirrel, 115; *114*
Richardson, John, 122, 123
Richardson's Columbian Squirrel, 148
Richardson's Spermophile, 180; *180*
Ring-Tailed Cat (J. W. Audubon),
 101
Rocky Mountain hare, 55
 See also Townsend's Rocky Mountain
 Hare
Rocky Mountain Sheep
 (J. W. Audubon), *84, 85*
Royal Academy of Arts (London), 18,
 19, 39
Royal Society (Great Britain), 90

S

Saturday Courier, 164–66
Say, Thomas, 179
Say's Least Shrew, 129; *128*
Say's Squirrel, 35, 50–52, 166, 168;
 34, 166
Sciurus macrourus, 52
Sea Otter (J. W. Audubon), 178, 179;
 179
Self-Portrait (J. W. Audubon), 26
Senefelder, Aloys, 130
Sharped-tailed Grouse (Tympanuchus
 phasianellus), 84; *84*
Shaw, Joshua, 17
Silhouette Portrait of the Reverend John
 Bachman (Metford), *75*
Silver Fox. See American Black or
 Silver Fox
Sire, Joseph, 52
Smet, Pierre-Jean de, 54
Smith's Lark Bunting, 89; *88*
Snowy Egret, 17; *16*
Snyders, Frans, 39
Society of Naturalists and Physicians,
 120
Soft-Haired Squirrel, 43, 147; *44*
Solnhofen, Bavaria, 130
Spotted Towhee (Pipilo maculatus),
 90; *91*
Sprague, Isaac, 62
 on Missouri River trip, 27, 50, 76,
 77, 97, 155, 156
 works by, 55, 78, 80; *72, 74, 78,*
 80
Sprague's Missouri Lark, 89
Sprague's Pipit (Anthus spragueii), 86,
 90; *91*
Squires, Lewis M., 50, 63, 76, 77
Stanley, John Mix, 29
Steamboat Yellow Stone, The
 (Bodmer), 129; *129*

Stein, John, 17
Stewart, William Drummond, 155
Stubbs, George, 18, 19
Study of Branch (V. G. Audubon), 43;
 45
Sully, Thomas, 15
Surround of Buffalo by Indians, A
 (A. J. Miller), 29; *30*
Swainson, William, 90
Swift Fox, 58, 60, 97, 158
Swift Fox, 58, 60, 97, 177; *61, 99*
system of squares (technique), 156

T

Tawny and Back's Lemmings
 (J. W. Audubon), 65; *68*
Tawny Weasel (J. W. Audubon), 110;
 111
Texan Skunk, 181, 182; *182*
Texas Jackrabbit (J. W. Audubon),
 101
Texas Leopard Cat. See Ocelot, or Texas
 Leopard Cat (J. W. Audubon)
Texian Hare (J. W. Audubon), 101,
 105; *105*
The Rev. John Bachman
 (J. W. Audubon), *121*
Thirteen-Striped Ground Squirrel.
 See Leopard Spermophile, or
 Thirteen-Striped Ground Squirrel
Townsend, John Kirk, 71, 92, 93,
 126, 137
Townsend's Chipmunk, 177; *176*
Townsend's Ground Squirrel, 177; *176*
Townsend's Meadow Mouse, Vole, and
 Swamp Rat, or Townsend's
 Arvicola, Sharp-nosed Arvicola,
 and Bank Rat (J. W. Audubon),
 137; *136*
Townsend's Rocky Mountain Hare, 55,
 147, 151; *152*
Tufted Titmouse, 22; *24, 25*
Turkey Vulture, 22; *23*
Turner, Joseph Mallord William,
 18–19
"type" specimen, defined, 90

U

Union (mackinaw), 65, 158
United States Exploring Expedition
 (1838–42), 93–96, 151, 170

V

Vanderlyn, John, 15
Victor Gifford Audubon (Huntington),
 26
View of Fort Union on Upper Missouri
 (Sprague), 80; *80*
Virginia Deer (J. W. Audubon), 135;
 134

Viviparous Quadrupeds of North America, The (Quadrupeds), 11, 35
and advent of lithography, 129
animal poses, in, 30, 36, 40, 50–52, 62
animals omitted from, 107
anthropomorphic scenes in, 141
assistants' work on, credited to Audubon, 135
Audubon's artistic contribution to, 101
and Audubon's health, 62–63, 97, 115, 171
Audubon's work schedule, on, 139
and Bachman, as co-author of, 73–75, 122–23, 144
background themes in, 168
compositional problems in, 166–68
conception of, 19
design of, 110–13, 126–29, 132, 144, 148, 168
economy, and effect on, 148–51, 180
funding for, 132
and imperial folio edition, 166, 168–70, 174–77
lifesize drawings in, 132, 138
live specimen paintings in, 97
marketing of, 89, 142, 166
multiple volumes of, 72
octavo edition. *See Quadrupeds of North America, The*
pictorial approach to, 40
popularity of, 30, 107–10, 115, 119, 141
pre-existing drawings used in, 97, 138
pricing of, 148
production schedule for, 132, 138, 142–44, 148, 151, 166
public reaction to, 182
purpose of, 121
reviews of, 107–10, 113, 115, 137, 138, 148
shortcomings of, 30, 74, 76, 92, 115
similar works to, 122, 132
specimen-collecting methods for, 92–96, 137, 151, 156, 170
subscribers' criticisms, on, 101, 113
subscriptions for, 122–23, 132, 144, 148, 151, 170
as team effort, 76, 79, 144
text of, 19, 110, 132. *See also* Bachman, John
use of specimens, for, 21, 71–72, 97, 122

W

Wall, William Guy, 17
watercolor, as medium, 21, 22, 29–30
Waterhouse, Benjamin, 121
Waterhouse, George R., 120
Waterton, Charles, 93
Webber, Charles Wilkins, 137–38, 177, 179–80, 182
Webster, Daniel, 96
Western Meadowlark (Sturnella neglecta), 90; *91*
Western Shore Lark, 89; *88*
White American Wolf (J. W. Audubon), 158; *159*
White Weasel. See Long-Tailed Weasel, or White Weasel (Studio of J. W. Audubon)
White-Footed Mouse, 177, 178; *178*
White-Tailed Deer, or Common American Deer (Fawn) (J. W. Audubon), 171; *173*
Wildflower (Sprague), 78; *78*
Wilkes, Charles, 93, 96, 151, 170
Wilson, Alexander, 14, 18, 36, 119, 138, 179
Wolverine (J. J. Audubon/V. G. Audubon), 101; *100*
wolves, sightings of, on Missouri River trip, 158
Woodchuck, or Eastern Woodchuck, 29, 40, 144, 147, 156; *31, 33*
Wyeth, Nathaniel, 126

Y

Yellow Warbler *(Dendroica petechia),* 90; *91*
Yellow-headed Blackbird *(Xanthocephalus xanthocephalus),* 90; *91*